# LOOKING
# INTO DEGAS

# LOOKING INTO DEGAS

## UNEASY IMAGES OF WOMEN AND MODERN LIFE

### EUNICE LIPTON

*University of California Press*

*BERKELEY/LOS ANGELES/LONDON*

University of California Press, Berkeley and Los Angeles, California
University of California Press, Ltd., London, England
Copyright © 1986 by The Regents of the University of California
Library of Congress Cataloging-in-Publication Data
Lipton, Eunice.
Looking into Degas.

Bibliography: p.
Includes index.
1. Degas, Edgar, 1834–1917—Criticism and
interpretation.   2. Social problems in art.
I. Degas, Edgar, 1834–1917.   II. Title.
N6853.D33L57      1987           760'.092'4          85-31993
ISBN 0-520-05604-3 (alk. paper)
Printed in the United States of America

1   2   3   4   5   6   7   8   9

Jacket painting: Degas,
At the Racetrack, Jockeys,
ca. 1868. Courtesy Weil
Enterprises and Investments,
Ltd., Montgomery.

Jacket painting: Degas, At the Racetrack, Jockeys, ca. 1868.
Courtesy Weil Enterprises and Investments, Ltd., Montgomery.

# Contents

# ILLUSTRATIONS

N.B. Unless otherwise indicated, all works are oil on canvas.

1. Claude Monet. *Boats and Regatta at Argenteuil*. 1874. Musée d'Orsay, Paris.
2. Pierre-Auguste Renoir. *The Luncheon of the Boating Party*. 1881. Phillips Collection, Washington, D.C.
3. Edouard Manet. *In the Greenhouse*. 1879. Nationalgalerie, Berlin.
4. Mary Cassatt. *At the Opera*. 1879. Courtesy Museum of Fine Arts, Boston. Charles Henry Hayden Fund.
5. Renoir. *The Loge*. 1874. Courtauld Institute of Art, London.
6. Hilaire-Germain-Edgar Degas. *Place de la Concorde* [Vicomte Lepic and His Daughters]. 1875. Destroyed during World War II. (Photograph: Durand-Ruel, Paris).
7. Degas. *Degas' Father Listening to Pagans Playing the Guitar*. 1869–1872. Courtesy Museum of Fine Arts, Boston. Bequest of John T. Spaulding.
8. Degas. *At the Milliner's*. Pastel. Ca. 1882. Museum of Modern Art, New York. Gift of Mrs. David M. Levy.
9. Degas. *The Dancing Class*. 1874. Musée d'Orsay.
10. Degas. *Before the Meet*. 1862–1880. Musée d'Orsay.
11. Degas. *The Races*. 1872–1873. National Gallery of Art, Washington, D.C. Widener Collection, 1942.
12. Degas. *Racehorses at Longchamps*. 1869–1870. Courtesy Museum of Fine Arts, Boston. S. A. Denio Collection.
13. Degas. *Racehorses*. Pastel. 1884. Private Collection. (Photograph: Bulloz.)
14. Degas. *Jockeys*. Pastel. Ca. 1880. Hillstead Museum, Farmington.
15. Degas. *At the Racetrack*. 1877–1880. Musée d'Orsay.

Art. Bequest of Mrs. H. O. Havemeyer, 1929. The H. O. Have-meyer Collection.

# COLOR ILLUSTRATIONS

*NOTE:* Numbers in parentheses indicate sequence of black and
white illustrations

# ACKNOWLEDGMENTS

Writing a book is a lonely business. I was lucky enough to have the company of supportive friends and colleagues, and I want to acknowledge and thank them here.

Wanda Corn never seemed to tire of reading this material. Her loving and remarkable gift is a critical voice which is dependably energizing, never censorial. Carol Zemel also read and reread many sections of this book in its various stages. Her questions were always provocative, and her incomparable humor never failed to put things in perspective. Kenneth Aptekar, my husband, has been a great critic and friend, ever clear-headed, direct, and funny. I was also fortunate enough to find the supreme editorial skills of Sue Heineman. Other friends and colleagues who helped along the way were: Marcia Tucker, Carol Ockman, Nina Fortin, David Bensman, Madeleine Rebérioux, Meryl Schwartz, Virginia Reynolds and Lisa Aswad. In addition, the tact and enthusiasm of Stanley Holwitz at the University of California Press, Los Angeles office, were extraordinary.

Various grants have facilitated my work over the years. Among them are: a Faculty Summer Research Support Grant and a Faculty Research Fellowship and Grant-in-Aid from the State University of New York, Binghamton; and an American Council of Learned Societies Grant-in-Aid.

Finally I must thank Linda Nochlin. The passion and intelligence of her writing and her life have inspired me. And the pleasure she has taken in my ideas made all the difference. "Do it, do it!" she'd say. And with so much glee.

# LOOKING INTO DEGAS

Earlier versions of some of the material in this book were published as follows: June 1981 *Arts Magazine,* "Deciphering a Friendship: Edgar Degas and Evariste de Valernes"; September 1980 *Art History,* "The Laundress in Late Nineteenth-Century French Culture: Imagery, Ideology and Edgar Degas"; ibid., reissued in *Modern Art and Modernism,* eds. F. Frascina and C. Harrison (New York: Harper & Row); May 1980 *Arts Magazine,* "Degas' Bathers; the Case for Realism."

# INTRODUCTION

This is a book about the work of Edgar Degas. More than that, it is a book about art, life, and politics. Degas made beautiful and powerful paintings that both interpreted and shaped the realities of his time. In these radiant works lie the traces of some of the most intense social struggles of the nineteenth century; issues concerning women, class, and sexuality are central to their meaning. Although Degas did not set out to chronicle those struggles, it was, I believe, inevitable that he did so.

The analyses in this book are not cool, and readers will find no pretense to objectivity. Rather, they will find a passionate and, I hope, illuminating look at the social implications of some extraordinary paintings.

Degas lived a long life, from 1834 to 1917. He started to paint in 1853 and continued until about 1908. We do not know precisely what happened then, but no works are dated any later. He may have become senile; historians have been respectful, friends discreet. In any case, he worked very slowly (compared to Pissarro or Monet, for example), often painting and repainting the same canvas over many years. He produced a small, brilliant body of work which is as witty as it is intelligent, as elegant as it is incisive.

We can divide Degas' output into three periods: student works (1855–1865), realist paintings (1865–ca. 1890), and post-impressionist or symbolist works (ca. 1890–ca. 1908). This book is about the realist paintings. They are the ones

that evoke modern Paris—images of the streets and cafés, the singers and ballet dancers, the laundresses and milliners. These are the paintings that are both nostalgic and modern. They long for a privileged past in the same instant that they reject its values; they lurch merrily, sometimes nastily, into modern Paris at the very moment that they longingly nod in the direction of tradition.

The ambivalence of Degas' work was his own, to be sure, but it was also a phenomenon of the latter half of the nineteenth century, when tradition and modernity, the values of a preindustrial and a postindustrial world, collided daily. By the 1870s the pace of life had quickened; people darted where formerly they had ambled, and the *flaneur* of the 1830s was swept up in the anonymous crowds of the streets. In 1855 Hippolyte Taine had written: "Europe is on the march to look at merchandise."[1] Everyone hungered for goods, and those who had money angled for profit. People searched streets and shop windows for events and objects to consume. Arcades, department stores, and international expositions became showplaces for what one could buy if rich or covet if poor. An avidity to consume through one's eyes matched the desire to buy. One watched the "display"—the parade of people, goods, and events—from the streets, apartment balconies, and café terraces, at the Opéra and racetrack. Gaslight and binoculars were the accoutrements of this life. But so was alienation. One sat next to people on buses but did not speak to them; one bought objects whose producers one never saw; one longed to possess but not to know.[2]

How did Degas and his contemporaries picture these realities in their work? How did the social and pictorial forms of the early nineteenth century become the new ones of the later nineteenth century, and why and how did these different forms intersect in Degas' paintings in particular?[3] If all art can be said to collude with and construct contemporary values, or to question and perhaps subvert them, what did De-

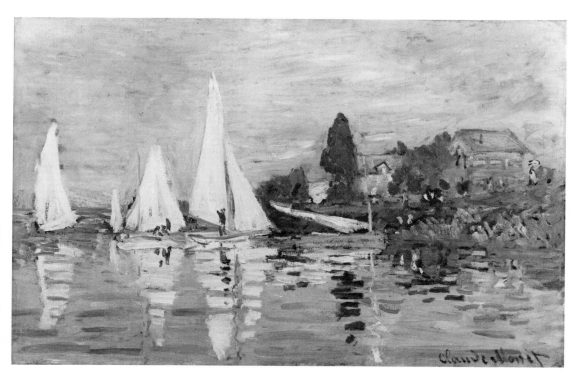

1. Claude Monet. *Boats and Regatta at Argenteuil.* 1874.

gas' work effect? What, for example, did people see when they looked at his laundresses, milliners, and dancers? How did these paintings contribute to keeping women "in their place" or opening up new, less conveniently classifiable positions for them? Difficult as it may be to unravel how works of art function ideologically, it is a central ambition of this book to do just that.[4] In the interest of clarifying this ambition, a cursory look at some work by Degas and his contemporaries is useful.

Monet's painting *Boats and Regatta at Argenteuil* (fig. 1) is reminiscent of the seascapes of the Dutchman Jongkind and the Frenchman Boudin in its layered horizontal organization of space and its unpeopled marine subject matter. But the large horizontal band in the front is daringly vacant, and the dappled brushstrokes, bright light, and disintegration of form are strikingly innovative. The differences in social content between Monet's painting and works of Boudin and

Jongkind are also significant. Monet's image is neither of a harbor nor of the high seas. Neither heroic nor commercial, it is, rather, what might be termed a domesticated seascape. More specifically, however, it is a depiction of Argenteuil, a suburb of Paris, which was both a center of industry and a pleasure spot for Parisians.[5] Monet's painting ignores not only the physical trappings of industry but also their social and psychological products—in this case the tensions produced by precipitous industrial growth. He chose instead that aspect of the town which provided Parisians at leisure with a place to sail, sun, eat, and drink. That is, Monet's image pictures both the past and the present but contains no suggestion of distress. Rather, it enthusiastically embraces the inventions of modern bourgeois life—ready pleasure, increased leisure time for the middle classes, mobility—but denies, or disguises, the accompanying social problems.

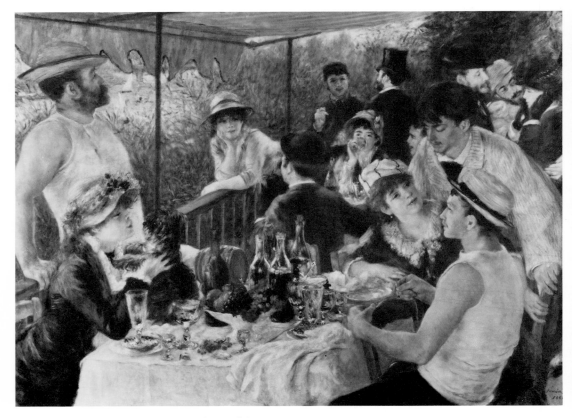

2. Pierre-Auguste Renoir. *The Luncheon of the Boating Party*. 1881.

So too does Renoir's *The Luncheon of the Boating Party* (fig. 2). This painting, like so many of Renoir's works, pays homage to the *fêtes champêtres* of Watteau and Lancret, particularly their amiability, flirtatiousness, and general sensuosity. Even Renoir's feathery brushstrokes and color scheme are reminiscent of the eighteenth-century artists. But the cropping or the perspective of his picture is not, nor is its brilliant luminosity. And the group of people shown is bourgeois and bohemian, not aristocratic. Nineteenth-century social forms and pictorial innovations make the painting modern and avant-garde. It incorporates and celebrates the new; abundance and ease are its subjects, as is individual sensual pleasure. The cost of that pleasure is nowhere to be found in the painting except, perhaps, in its too desperate pleasure-taking. Although the social relations between men and women had changed by the end of the century, this painting shows no awareness of that. Men and women behave according to convention. Everyone is flirting; pretty women listen attentively as robust or dapper young men strut their charms.

While Monet's painting ignores certain aspects of industrialism, Renoir's ignores women's increased social mobility and emerging sexual autonomy. What both artists celebrate is bourgeois life and its values. Indeed, the upbeat energy and verve conveyed by these paintings could certainly be felt on the streets of Paris, but only if one had money. Whether one wandered through the new arcades, down the grand new boulevards, or along twisting old streets, whether one elbowed one's way through the crush of a department store or an international exposition, a dazzling parade of objects assailed the senses, offering themselves up for consumption. At the various Expositions Universelles held between 1855 and 1889, for example, objects from shawls to shoes to calculating machines were displayed. Paris in the latter half of the nineteenth century has been described as

"the city of easily available gratification."[6] This was the world of material plenty pictured by Monet and Renoir.

But it wasn't everybody's Paris. The laundress Gervaise in Zola's *The Dram-Shop* saw a different city:

This part of Paris made her feel quite cheap because it was becoming so grand, being opened up in all directions. The Boulevard Magenta, coming up from the heart of Paris, and the Boulevard Ornano, going off towards the country, had torn a gap in the old barrier [city-limits]. . . . So it was . . . a huge crossing extending to the far horizon along endless thoroughfares swarming with people, on and on in the confusion of building operations. But mixed up with the lofty brand-new buildings there were still plenty of rickety old houses; between facades of carved masonry yawned black holes, gaping kennels exposing their wretched windows. Coming up through the rising tide of luxury the destitution of the slums thrust itself into view.[7]

Renoir's and Monet's pictures revel in the abundance and excitement of modern life; pain is blocked out. Works by Manet, Cassatt, Caillebotte—and Degas—responded differently. Not only did these artists paint the emergence of modern culture—the facts and effects of industry; a strong, inventive bourgeoisie; the excitement of social and technological change—but they also provided a commentary on these phenomena which I construe as critical. By critical I do not mean negative; rather, I mean a viewpoint that looks beyond or behind appearances to social and economic causes. Such a point of view (not necessarily consciously formulated by the artist) questions the most precious assumptions of a culture—its myths and "truths," its ideologies—and tries to comprehend why, and in whose interest, such myths develop.[8]

Manet's *In the Greenhouse* (fig. 3) is an example of such a vision. Although it recalls earlier forms of French realism, it is a most unorthodox painting, particularly because the couple is not behaving according to received social etiquette.

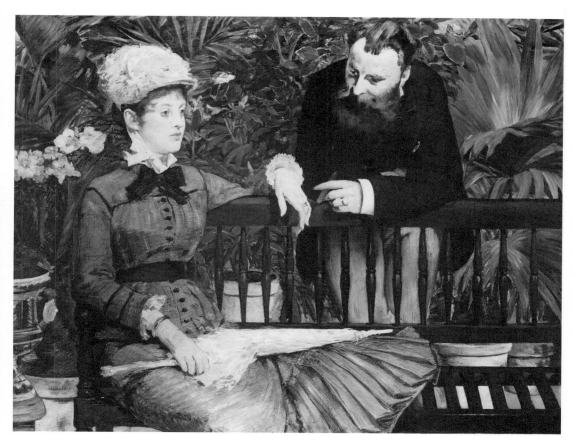

3. Edouard Manet. *In the Greenhouse*. 1879.

They do not talk or flirt. Their social awkwardness is created by the stiff poses, their wooden gestures, and the collapsed pictorial space. The image ends up challenging basic assumptions about couples and also centuries-old ideas about composition.

The questions raised by the Manet are also central to Cassatt's *At the Opera* (fig. 4). Here again, nineteenth-century French realism is the stylistic heritage of this unusual painting. A stark, silhouetted form stands out against a brightly lit and busy theater interior. The aggressiveness of that form is startling, but that it describes an unaccompanied, assertive-looking woman is astonishing. Only compare her to the woman in Renoir's *The Loge* (fig. 5) to see the difference.

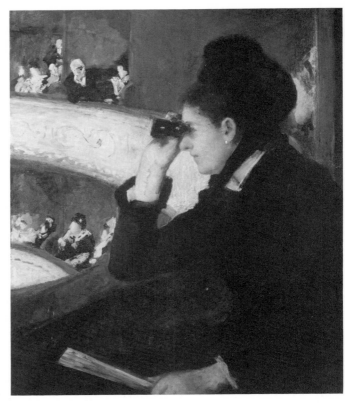

4. Mary Cassatt. *At the Opera*. 1879.

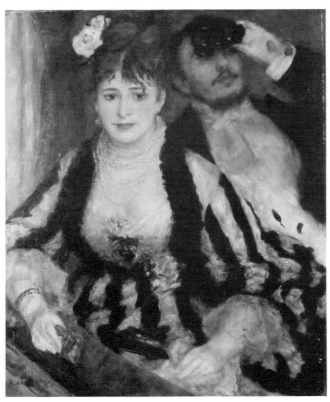

5. Renoir. *The Loge*. 1874.

Cassatt's painting makes us think about single women; that is its critical edge, and that is how it challenged contemporary notions about women as mothers, muses, and embodiments of sexual abundance.

Degas' painting *Place de la Concorde* (also known as *Vicomte Lepic and His Daughters*) (fig. 6) also presents a critical mix of past and present. Although the eighteenth-century Place in the center of commercial Paris is ostensibly the paintings' subject, and one glimpses the boundary wall of the Tuileries in the background and one of Jacques-Ange Gabriel's elegant eighteenth-century mansions on the left, this old and venerable Paris is jostled by the new. The painting's aggressive asymmetry and its vast stretches of emptiness query and unsettle the comforting geometric predictability of the round Place, the garden's walls, the lines of the mansions. An unmistakably urban tension crackles the surface as father and children distractedly rush along the distinctly mod-

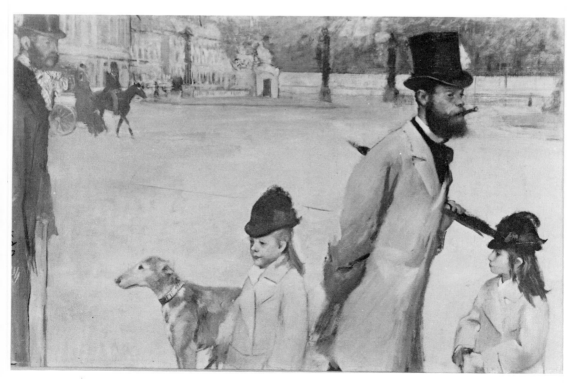

6. Hilaire-Germain-Edgar Degas. *Place de la Concorde* [Vicomte Lepic and His Daughters]. 1875.

ern thoroughfare. The viscount himself embodies both the past and the present. He is an aristocrat with the air of the dandy who ten years earlier would either have been in the country tending the dogs he raised or strolling in the city alone. In 1875 he, like so many of his contemporaries, was still enmeshed in the life of the Paris streets, but this time with his family. The rebuilding of the city by Haussmann and Napoleon III in the 1850s and 1860s had produced a metropolis that beckoned whole families as well as habitual strollers into the streets and cafés, restaurants and parks.

The viscount's existence had further changed in these years because dandies and aristocrats like himself had lost their glamour as they lost their relevance. With the collapse of the Second Empire in 1870 and the establishment of the Third Republic in 1875, such men had become fundamentally passé.

Finally, the contradictory messages of *Place de la Concorde* can be seen in the precisely drawn figures with their respect for a classical Ingresque tradition, on the one hand, and an equally strong fascination with unconventional, off-centered compositions, on the other. Degas' painting, then, is energized by the change and conflict it depicts. It does not merely describe or even accept the busy streets; it evokes their intensity through its forms. Far from polite coexistence, the figures in the painting pull against one another, are chopped by the painting's edge, and have to fend for themselves in arbitrarily emptied urban spaces.

Almost all of Degas' genre paintings express, to varying degrees, the contradictory and provocative pulls of *Place de la Concorde*. Almost all these pictures raise questions about contemporary habits of thought. They have one foot in a disappearing world of privilege and convention embodied by an Ingresque classicism, a preindustrial languor and refinement, and a disdain for the masses. The other foot steps into an increasingly democratized modern Paris expressed by De-

gas in asymmetrical, fragmented compositions, a curiosity about new techniques, and increased familiarity with the working poor.

Consider his racetrack paintings. Until the late 1850s, racing was the domain of the landed rich, and Degas' paintings depicted those people on their land. However, a small number of his images clearly depict Longchamps or Vincennes, opened to the public in 1857 and 1863, respectively. These were racetracks within walking distance of Paris with admission fees that allowed almost everyone in. The embattled coexistence of old-fashioned elite racing meets and the new, more widely attended contests emerges as a theme of these paintings. In addition, the formal language used in the works varies significantly. When the racing images take place on private estates, or the settings are only vaguely defined, the formal language tends toward what might be called a classicizing style, with horizontal planar constructions and an overall sense of unity. When the subjects depicted are at specific race courses near Paris, however, the space in the paintings is more fractured and the compositions asymmetrical.

Degas' paintings of the ballet raise more poignant and radical contradictions. Dance had been a great art form in the 1830s and 1840s, relished by wealthy connoisseurs. Entrance to the dancers' private foyer just behind the stage was coveted and procured by only the richest, most influential nobility and an occasional entrepreneur or bohemian. By the 1870s, however, dance in Paris was no more than light musical entertainment and the dancers just a notch or two above second-rate stage stars. Entrance to the foyer was still coveted but had become a much more ragtag affair involving a far greater cross section of social types. The Opéra's past as well as its continually evolving present resonated in both its habitués' behavior and the way in which it was perceived in the 1870s. Degas' paintings assimilated both aspects, but

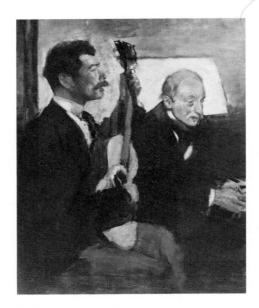

7. Degas. *Degas' Father Listening to Pagans Playing the Guitar.* 1869–1872.

whereas his racing images betray extremely strong attachments to the past, in part through their classicism, the ballet images are more consistently modern, bursting with nervous energy and fragmented forms and spaces.

Depictions of laundresses raise similar questions. Laundering was a very important trade in France, for if people lived above subsistence level, they sent their laundry out. In the public eye the laundress herself was traditionally viewed as a sexy and eminently accessible woman. That fabled, as well as real, accessibility had obvious benefits for lower-class men as well as for upper-class men who "slummed" with coquettish laundresses. These encounters were facilitated by the laundress' habit of picking up and delivering her work at a person's home. Although this etiquette remained in the 1870s and 1880s, and the objectification of the laundress persisted, it was altered by the change in the status of workers which had occurred as a result of both the June Revolution of 1848 and the Paris Commune of 1871. Degas' paintings of laundresses exemplify an upper-class man's lingering sexual interest in, and disdain for, working-class women as well

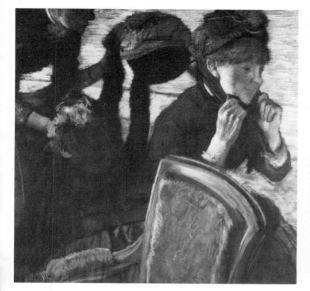

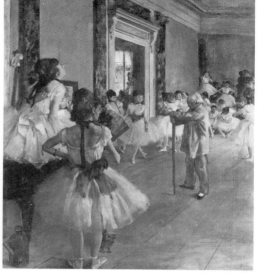

8. Degas. *At the Milliner's*. Ca. 1882.    9. Degas. *The Dancing Class*. 1874.

as his unmistakable admiration. The formal vocabulary Degas used in these paintings is somewhere between the classicizing serenity of most of the racing paintings and the fractured, somewhat caricatured world of the ballet pictures.

Although similar issues arise in Degas' depictions of prostitutes, café-concert singers, and milliners, they do not in his portraits, which is the reason I do not deal with them in this book. Even in a painting as compositionally interesting as *Degas' Father Listening to Pagans Playing the Guitar* (fig. 7), dissymmetry, nervousness, and social ambiguity are kept at a minimum if we compare them to works like *At the Milliner's* or *The Dancing Class* (figs. 8, also see color plates, 9). Spaces in the portraits do not tip haphazardly, nor are bodies arbitrarily cropped, nor do forms grow irrationally larger and smaller. No matter how innovative the portraits are, they remain visually more self-contained and, finally, more conventional than the genre works.

What is particularly compelling about Degas' genre paintings is that their questioning of modern life, with its social confusion and shifting values, coexisted with a respect

for tradition and a life of privilege. Indeed, his paintings are about exactly that ambivalence and, because they are, they both uphold *and* criticize contemporary habits and values. I am not speaking here of Degas' conscious intentions but rather of the ways in which his paintings betray both conscious and unconscious drives, the way in which they are the constructs of the historic moment in which they existed, *and* of the man who made them exist. They embody myriad meanings; they affect their audience in ways Degas intended and in ways he did not. The reader, therefore, will find statements in this book such as: "The paintings are biting in their critique," or "They lodge a critical commentary," or "They enter the debate" on such-and-such a topic. What I mean by this is simply that the paintings are active carriers of meaning. They do not merely reflect society, and they are not merely expressions of the artist's will. In fact, they *almost* seem to exist despite the artist.[9]

I am reminded here of what Frederick Engels noted about Balzac in 1888:

[Balzac] was politically a legitimist. . . . But for all that, his satire is never keener, his irony never more bitter, than when he sets in motion the very men and women with whom he sympathizes most deeply—the nobles. And the only men of whom he speaks with undisguised admiration are his bitterest political antagonists, . . . the popular masses.

That Balzac was thus compelled to go against his own class sympathies and political prejudices . . . that he *saw* the real men of the future . . . that I consider one of the greatest triumphs of realism.[10]

# I

# THE RACING PAINTINGS

## A WORLD OF PRIVILEGE

Horse racing was a tense and festive event in late nineteenth-century Paris. Dukes and duchesses, servants and shopkeepers, doctors, lawyers, artisans, and workers placed their bets. For some, the accomplishments of horse breeding was the attraction; for others, the frisson of the race. But for the rich, whatever their interest in horses, going to the track was also about titillation and display, social and sexual strutting, the nervous scanning and scrutiny of the crowd, and, finally, the simple confirmation of power. For the less pretentious, the tumult of the race was alternately up- and downstaged by the parade of the rich, the once rich, and the newly rich competing with and confirming one another's place, it was hoped, in the spotlight of history. The racetrack, seemingly a mere corner of the pleasure-land of Impressionist painting, was actually a theater in which vivid maneuverings for power took place. Degas' depictions of the track are among his

strangest paintings. They occupy a very peculiar place in the contexts both of vanguard art and of contemporary life in Paris.

Although there has been a tendency to generalize about Degas' racing and ballet paintings, that is, to bracket them together, it is less rewarding to note their similarities than to study their differences. For, if one stresses the cultivated expertise of dancers and racehorses in general, one overlooks what Degas' paintings took note of: the different social milieus of the track and the Opéra, where ballet was performed; the sketchiness of the horses and riders versus the detailed renderings of the ballerinas; and the fact that although both groups of pictures tend to focus on moments of preparation rather than on performance per se, Degas' racehorses and riders languish and dally, whereas his dancers twist and strain.

This chapter is the longest in the book. Degas' racing paintings are the most peculiar and conservative of his work. Their conservatism is expressed through their use of what I call a frieze mode. I distinguish this from a discontinuous mode, which is found in the rest of his genre paintings and in a small group of his racing paintings. Extensive formal analysis takes place in this chapter (and nowhere else in the book) in order to lay out the parameters of a pictorial vocabulary I will use throughout this study. Indeed, Degas' racing paintings are completely anomalous in his work. If one knows his art well, specific racing paintings do come to mind, but more often than not they blur into a group, and one remembers the group rather than specific works. In fact, the racing paintings are the most generalized, that is, the least specific and the most repetitious, of his compositions. Figures tend to be anonymous; locations, vague; narratives, elusive. In addition, Degas' genre paintings in general—his depictions of dancers, laundresses, milliners, and singers—are about women. His racing paintings obviously are not; in fact, they insistently are not, as we will see. Furthermore, pictorial

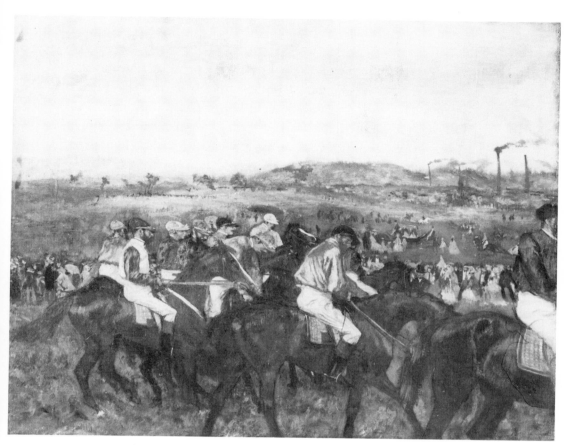

10. Degas. *Before the Meet.* 1862–1880.

structures in the genre pictures are frequently diagonally oriented, asymmetrical, and fragmented, while the racing paintings tend toward horizontality, balance, and a sense of continuum. I am not referring to works like *At the Racetrack, In Front of the Tribunes,* or *False Start* (figs. 15–17), which I take to be exceptional among the racing paintings (and will say why shortly), but rather to images like *Before the Meet, Racehorses,* and *Jockeys* (figs. 10, also see color plates, 13, 14).[1] In these latter works the jockeys are consistently anonymous and function merely as adjuncts to their horses. In addition, locations are frequently unclear. We usually do not know whether the events are taking place at an elegant racecourse like Longchamps or at a more pedestrian one like Vincennes.

Or do the settings represent Degas' friend Paul Valpinçon's estate in Normandy, where horses were bred and trained? A related question involves locating Degas himself at the track. Did he go there often? Can we imagine him, for example, riding near Longchamps with his friend Ludovic Halévy?[2]

Perhaps the most startling thing about works like *Before the Meet* is that they almost determinedly lack Degas' urbanity, habitual wit, and incisiveness. Homogeneity of movement, form, and social type prevails, evoking a world in which everybody knew everybody else, and everything was familiar and predictable. For all its intricate foreground drawing and painterly background drama, for example, *Before the Meet* is an uneventful and oddly unarticulated painting. In it, the imprecisely defined middle and far distances behave as a passive backdrop upon which the "subject" unfolds. Backdrop and subject are separated, but there is no tension; the foreground motif is simply laid down upon the rest of the painting, like the frieze of a bas-relief sculpture. The work is descriptive and generates a sense of ease and self-containment, probably owing to its horizontal divisions and the expectation of continuum created by the riders' movements across the surface. It almost seems as if we are watching an endless roll of riders being cranked out by someone behind the scenes.

In other works, such as *The Races, Racehorses at Longchamps, Racehorses,* and *Jockeys* (figs. 11–14), the figures are also anonymous and have been set down in peremptorily drawn, relatively uninflected landscapes. They share *Before the Meet*'s frieze construction. That is, the figurative motif is drawn in shallow space upon the surface plane of the picture, the background is unimportant, and the two parts seem unrelated, just there, so to speak. In *The Races,* for example, one feels one could peel the subject off the surface. The line of jockeys undulates from left to right, dipping into a small group of gentleman riders in top hats in the center. For all

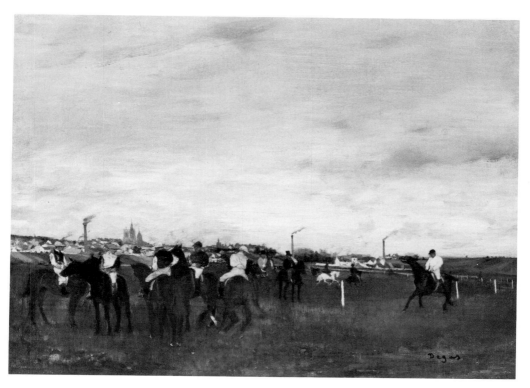

11. Degas. *The Races*. 1872–1873.

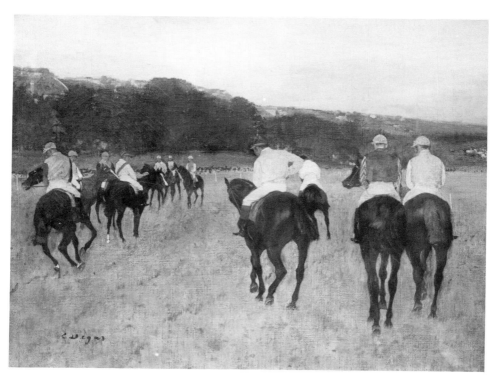

12. Degas. *Racehorses at Longchamps*. 1869–1870.

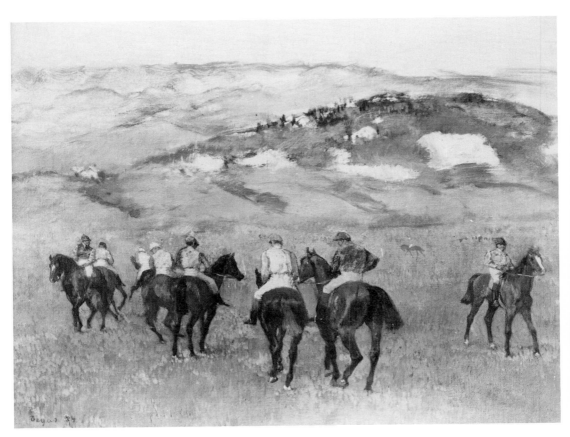

13. Degas. *Racehorses*. 1884.

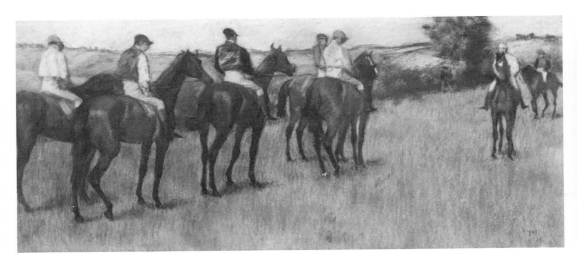

14. Degas. *Jockeys*. Ca. 1880.

intents and purposes the schematically drawn figures simply detach themselves from the background. Smokestacks, church spires, and private dwellings are delicately outlined on the horizon, announcing another existence entirely. But they remain merely background. That is, industrialism and modern life provide a scaffolding upon which the leisured world of horse racing unfolds.

In *Racehorses at Longchamps,* the frieze format functions similarly. A beguiling diagonal of riders at the left meanders into the background, but this leisurely excursion merely brings the viewer back to the surface for no other reason than to *see* the group of jockeys to the right. Likewise, a curving movement in *Racehorses* and *Jockeys* gracefully cuts a swath along the front "shelf" of the painting, but there is no interaction between foreground and background; the jockeys emerge as subjects to the landscape's passive backdrop.

This group of paintings, the frieze-mode paintings, is truly remarkable in Degas' work. They are the most old-fashioned works he made, the most respectful of traditions of both Academic art and of upper-class social habits. Although they represent the majority of Degas' racing images, there is another, much smaller group, painted quite differently—the discontinuous-mode paintings. I am referring to works like: *At the Racetrack, In Front of the Tribunes,* and *False Start* (figs. 15–17).[3] These are agitated, incisive, even aggressively constructed paintings. In them, time and space are discontinuous, and narratives are difficult to read. There is a certain halting, even lurching quality to the compositions, as directional lines zigzag, forms swell and dwindle unpredictably, and compositional holes open up at random. Fundamental rules of perspective are undermined, as Renaissance pictorial organization in general is set on its head. In addition, in contrast to the frieze-mode paintings, locales in these works are usually specific, and a variety of people inhabits them. *In Front of the Tribunes,* for example, shows both riders

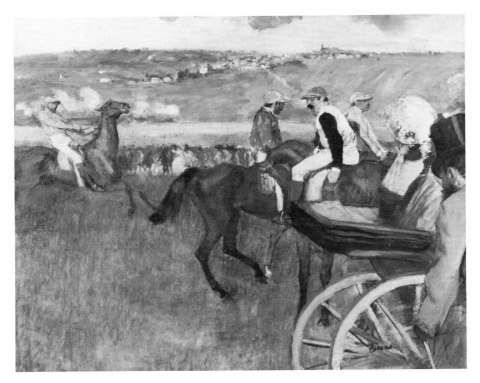

15. Degas. *At the Racetrack*. 1877–1880.

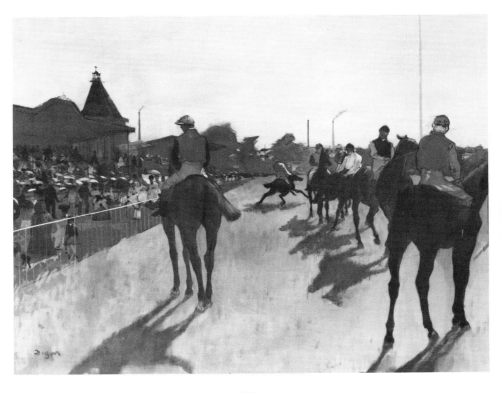

16. Degas. *In Front of the Tribunes*. 1869–1872.

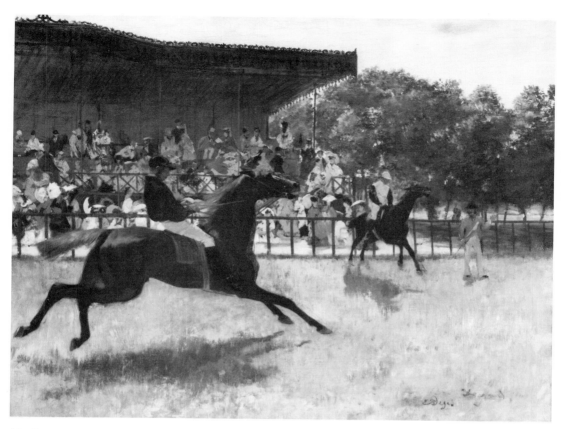

17. Degas. *False Start*. 1869–1872.

and spectators, and nervously straining horses cut into un-
evenly divided spaces. The center of the painting is empty,
and the skittering horse and rider at the farthest edge of that
emptiness are far too small in relationship to the foreground
figures. It is difficult to know what the subject of the painting
is. Is it the row of jockeys to the right, the isolated one to
the left, or the very act of watching, which encompasses the
lively activity of the grandstand as well as all the jockeys?

Similarly disrupted are the form and content of *False
Start*. At the left, a horse and rider lunge across the canvas.
The silhouette formed by the two is alluring but inexplicably
large and dominant in so small a canvas (12 5/8 × 15 3/4"). At
the right, another horse and rider struggle for control; near
them a starter, red flag in hand, gestures; and to the left a

filigreed grandstand projects out over a lively crowd. The mélange of forms, spaces, and activities produces a nervous and unpredictable atmosphere.

The same is true of the most disjointed of this group of paintings, *At the Racetrack.* The bottom left corner is empty, the right is packed; fragments of figures are heaped atop one another at the right, while riding in from the left is an almost whole horse and jockey. Particularized forms such as wheels and hats lure the spectators but do not add up to a comprehensible narrative. The painting, in fact, is loaded with all but indecipherable activity.

The discontinuous-mode racing paintings are only strange in the context of Degas' other racing paintings. In the context of the rest of his work and particularly in relationship to the ballet images, unstable pictorial structure and complex, elusive narratives are the norm. It is this little group of racing paintings, however, which, more than anything else, calls attention to the conservatism of the rest of the racing images. The modernity of these few pictures—their fragmented and, from a Western, post-Renaissance, point of view, their restive and irrational world—insistently calls into question the complacency of the other racing pictures, their harmony, continuity, and stasis. Actually, the fact that that complacency is missing from the rest of Degas' paintings is a gauge of just how radical his work really was. Herein lies my fascination with the entire body of racing paintings, for as a group they wrestle with meaning right before our eyes. They long for an old-fashioned, conventional world of male power, and that nostalgia finds conservative visual and social vocabulary to express itself. Every once in a while, however, the delusion buckles and reveals a bourgeois world of anxiety and profound social change.

What I will try to show in this chapter is just how the two groups of racing paintings enlist the different formal strategies they do in order to convey their distinct but related

social meanings. They "choose" between the country and the city, between social homogeneity and heterogeneity, between maintaining old traditions and creating new ones. This struggle is crucial to the rest of the book, for in ballet painting after ballet painting, laundress image after laundress image, these choices arise over and over again. Ultimately, Degas' work rejects nostalgia; he repeatedly decided to paint the city, to paint workers and the middle classes; to choose women as his main players; to incorporate movement and anxiety; to reject an Academic, classicizing style.

Let us start with a closer look at the frieze-mode paintings. In formal terms, their reference point is classicism, as it was adapted in the mid-nineteenth century. Their classicizing characteristics include the frieze format itself, their temporal unity, and the relatively neutral, idealized settings. Classicism was the dominant style in the Académie des Beaux-Arts and in the 1860s, as earlier, it continued to embody a choice of the Davidian-Ingresque tradition over the legacy of Delacroix or Courbet. This tradition stressed drawing after Greek, Roman, and Renaissance models. In 1820 Anne-Louis Girodet, David's student, had said that the painted copy was "the necessary complement of a classical education." And in 1847, when Thomas Couture wanted to distinguish himself from that tradition, he described his teaching method as opposing "the spurious classical school which reproduces the works of bygone times." Emile Cantrel, a critic for *L'Artiste,* complemented Benjamin Ulmann, the winner of the Prix de Rome in 1859, by saying that he "knew how to give a true antique character to his figures." And Théophile Gautier approved a Prix de Rome entry in 1862 by noting the work's "knowledge of the Masters."[4]

Nineteenth-century classicism was also emphatically moralizing, to wit the following Prix de Rome titles: *The Sacrifice of Abraham, The Return of Tobias* (1855); *Moses Defending the Daughters of Jethro, The Raising of Lazarus* (1857);

*Jacob Blessing His Child, The Death of Laius* (1863), and so on. These paintings were also taken to be expressions of national pride. However, while nationalism and morality were only implied in these titles, they were more specifically delineated in the critical commentary about Prix de Rome paintings and in the numerous military subjects exhibited at the Salon. When the critic C. de Sault wrote about Jean-Léon Gérôme's *Le Prisonnier* (1861, Musée des Beaux-Arts, Nantes) in 1869, he noted the "keenness of observation and the wise, moral commentary of the subject." And Paul Mantz described Jules Breton's *Plantation d'un calvaire* (1858, Musée des Beaux-Arts, Lille) as an "interesting and loyal canvas."[5]

Another group of characteristics stressed by critics who wrote about Academic art and unmistakably classicizing in their roots included "unity," "balance," and "harmony." E. J. Delécluze criticized a Prix de Rome entry of 1859 because "the effect lack[ed] unity." Charles Clément, in 1863, noticed that F. J. S. Layraud's entry had "a remarkable character of unity" and criticized M. Leloir's painting, *Joseph Revealing Himself to His Brothers,* because "the composition [was] not perfectly balanced." In 1856 L. Clément de Ris noted the "balancing" of figures in the composition of the entry of a Monsieur Clément; Delécluze did likewise in the same year with regard to one by a Monsieur Michel. With regard to "harmony," Clément de Ris found that "the general colors" in Clément's version of *The Return of the Young Tobias* were "weak but harmonious." An entry of 1862 was criticized by "P. M." because of the "tragic-comic absurdity of the gestures [and] the discordance of colors"; harmony in the latter apparently was lacking. Related words used in this context were "agreeable," "wise," "tempered," "well-ordered," "correct (*juste.*)"[6]

Degas' debt to the Academy and classicism is documented, but perfunctorily, and only for the purpose of tracing it back to his conscious intention. What I would like to as-

certain is how such inclinations on his part fit into a discourse on classicism in the 1860s and 1870s, and what that adaptation signified.

We know that Degas admired Ingres and that he studied with Ingres' student Louis Lamothe during 1854–1855. We could add that despite Degas' own peculiarities of style, works like the *Spartan Girls and Boys Exercising* (1860, National Gallery, London) and *The Misfortunes of the City of Orléans* (1865, Musée d'Orsay), as well as his numerous copies after Italian Renaissance art done between the 1850s and the mid-1860s, locate Degas in an Academic milieu. In fact his notebooks between 1855 and 1860 contain numerous dialogues with specifically classical references. In 1855 he made a drawing of one of the horsemen from the Parthenon's west frieze (fig. 18) which bears a striking resemblance to the rider in the center right of his *Before the Meet*. In an 1856 notebook, there is a copy of an early sixteenth-century fresco of mounted figures (fig. 19). In notebook 13 (used between 1858

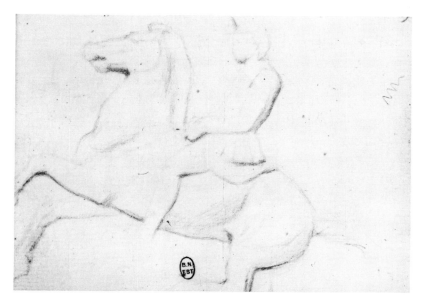

18. Degas. Drawing from Notebook 3. 1855.

19. Degas. Drawing from Notebook 7. 1856.

and 1860), Degas drew a copy of Andrea Castagno's classi-
cizing equestrian portrait of Niccolò da Tolentino. In the
same notebook he made sketches after Alfred de Dreux, a
contemporary specialist in hunting, riding, and racing scenes
who worked in what might be called a diluted and conven-
tional classicism.[7] All of these drawings are characterized
by their classical sense of balance and unity, planar delinea-
tion of space, and frieze formats with vague or va-
cant backgrounds. These are precisely the characteristics I
noted in the paintings *The Races, Racehorses at Longchamps,*
and so on.

The frieze format as a carrier of classicizing character-
istics has significant social ramifications. In these works, men
wander aimlessly and pleasurably on grassy knolls. Because
of the soothing horizontal format, the implied promise of
endless continuum, and the lack of integration with the back-
ground, the structure carries utopian connotations. In a work
like *Before the Meet,* (fig. 10), the figures seem to roll effort-
lessly across the surface. Despite the possible disorientation
created by the spatial compression in the foreground and the

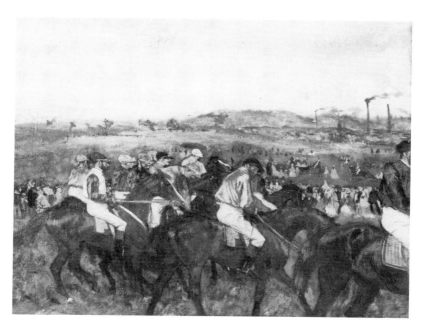

10. *Before the Meet.*

activity of the smoke blustering in the right background, the statement the painting makes is: "Here's the foreground, there's the background; here's what's important, there's what's not." "Existence" in this picture is rational and unencumbered as one plane leads logically and predictably to the next. No reciprocal relationship exists between the planes of the painting, however. They are simply laid down one upon the other.

It is this absence of a dynamic interaction between parts that I would like to address now. For I believe it is just this structure that is so different from the fractured, zigzagging formats of so many of Degas' other works and that is a carrier of an old-fashioned social (as well as pictorial) conservatism. It presents a view of reality which is falsely harmonious. In the late 1860s, but particularly in the 1870s, this view spoke to specific and conservative social goals.

After the Franco-Prussian War and the Commune, and

after the collapse of the Second Empire, the French wanted order above all else. One of the clearest signs of the desire for order was that *everyone* wanted it. In February of 1871, during the Commune, a friend of the Republican leader Léon Gambetta, had said: "Only the Republic can give us peace, work and order." The Royalist leader Frédéric-Alfred-Pierre Falloux said in 1872: "I would take the Republic, for order would be in safer hands under it than under a monarchy." Alfred Thiers, the man who practically established the Third Republic while insisting that he was not a Republican himself, asserted in 1872: "Order? Who could possibly defend it better than myself?" And when the Monarchist Marshal Mac-Mahon was elected president of the Republic in May 1873, this is how he presented himself to France: "With the help of God, the devotion of our army . . . the support of all honest people, we will continue to work for the liberation of . . . territory [from the Germans] and of the re-establishment of a moral order in our country."[8] Order, morality, harmony, authority—these are what the French wanted. No more war; perhaps no more change at all. Maybe progress itself could be slowed down.

A classicizing style was the perfect vocabulary in which to express such longings. The frieze structure provided a pleasurable and nostalgic reference to the past. At the same time, it neither encouraged reflection nor was it disturbing. It turned a spotlight upon the "subject," silently brushing superfluous details into the shadows. The viewer could read the story from the surface, as in a child's picture dictionary, contemporary newspaper illustrations, and much contemporary photography (figs. 20–22).

In fact, photography supplies a useful comparison here. Olympe Aguado's *Olympe Aguado and His Brother Onésime* or Louis-Jean Delton's *Adam-Saloman and His Daughter* are good examples (figs. 21, 22). No attempt was made to actually, dynamically, relate the figures to the backdrops in

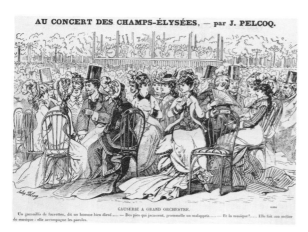

20. Jules Pelcoq. *Au Concert des Champs-Elysées.* 1877.

21. Olympe Aguado. *Olympe Aguado and His Brother Onésime.* Ca. 1853.

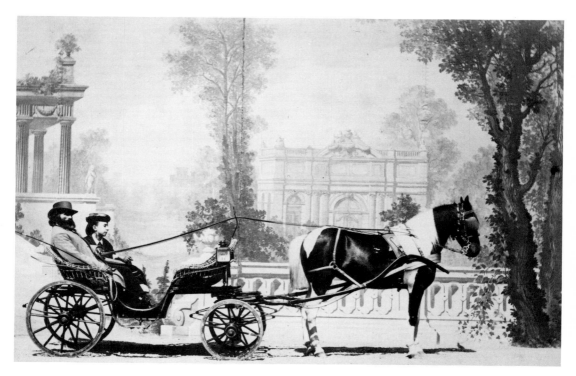

22. Louis-Jean Delton. *Adam-Saloman and His Daughter.* Ca. 1867.

front of which they posed. The relationships are symbolic or anecdotal. People pose rigidly or hover on the shelves of completely artificial spaces. The very separateness of the two parts was intrinsic to the content; it was the people who were important, not the backgrounds, what they were doing, not where they came from.[9]

We could say that the lack of relationship between the two parts separated the "subject" from its experiential roots— that the "event" was taken in, experienced, and discovered to carry emotional meaning, but that it was impossible to determine the meaning precisely or the emotional relationship of part to part. Vacancy, passivity and, finally, alienation pervade these images.[10] That is, a sense of utter and complete separateness prevails among what are fundamentally interdependent and intricately related people, events, and settings. Where one would expect to find intimacy and recognition, there is coldness and disjunction. What one sees, seems to have just "appeared," as if by magic. The disjunction, the alienation, have the effect of seeming at once natural and irrevocable. An utter and unconscious sense of helplessness invades the spectator, who is encouraged to leave things just as they are. This is alienation simply posited, tacitly assumed; it *is* the alienation of its time; the paintings propose no critique.

The majority of Degas' racing paintings embody this alienation. For the disjunction of the frieze from the background—so clean, so complete—can be interpreted as replicating, and promoting, the alienation of commodity production in the form in which it had become entrenched in nineteenth-century society. It reproduces both the absolute distance between a worker and his or her finished product *and,* and this is what is so painfully contradictory, the physical proximity of the worker to his or her product. The male worker—in shoe manufacturing, let's say—glues a heel to a shoe; formerly, he would have made the whole shoe. His

distance, his alienation from the object of his labor is complete; so, of course, is his distance from the buyer. In the past he went to the market himself and sold the shoes to someone directly. Now he has no idea who buys them. Degas' detached riders are laid down atop sketchy knolls rather like those shoes displayed in a shop window, forever isolated from the actual milieu in which they were made. Horses and riders emphatically dissociated from the landscape float in a comparable never-never land.

There were a number of advanced painters of the time who produced works that provide a vivid and profound contrast with Degas' frieze-mode paintings. Most of Degas' own works in fact do the same, but more of that later. In Manet's *Mademoiselle Victorine in the Costume of an Espada* (fig. 23), for example, the model, Victorine, poses in front of a picador

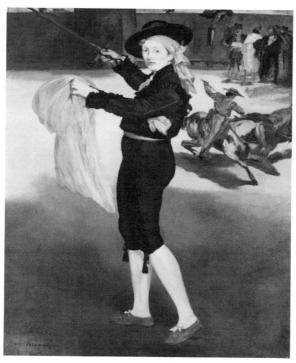

23. Manet. *Mademoiselle Victorine in the Costume of an Espada*. 1862.

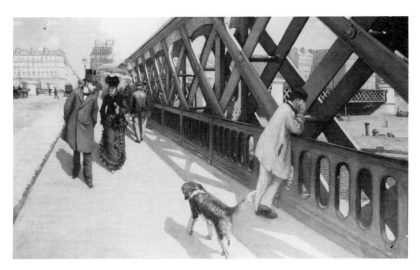

24. Gustave Caillebotte. *The Pont de l'Europe*. 1876.

motif. The imposition of one on the other is obvious. The picador sequence is unreasonably small, given how close it is to the standing woman; it therefore calls attention to the disjunction. What some historians have seen as a failure of Manet's draftsmanship can be read in part as the painting's assertion of distinct realities—on a very simple level, perhaps, of the studio's reality and that of the world of art, and their unresolved, even unresolvable, relationship. Manet's painting does not merely posit the separation that photography, popular prints, and Degas' classicizing paintings propose; it comments upon it through exaggeration, makes one conscious of it, and, by doing so, punctures it, demystifies it.

Another work whose spatial construction functions similarly is Caillebotte's *The Pont de l'Europe* (fig. 24). The spectator is plunged headlong into a space—the street—which dives at high speed into the background. There is no question but that perspective is exaggerated, that the spatial relationship between the couple is off, that he is either too large or she is too small. The painting tampers with just the expectations we most take for granted—or at least with those that

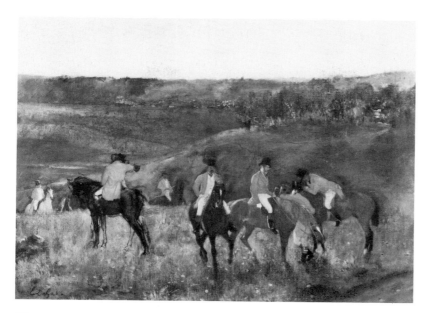

25. Degas. *Departure for the Hunt*. 1864–1868.

were taken for granted in the nineteenth century. How does one walk on a rushing sidewalk? How does one converse with giants or midgets? Why, in this case, does a dog provide the dramatic prelude to human activity? Because both the Manet and the Caillebotte mean to unsettle the viewer, instead of passively accepting what is the disorientation and disequilibrium of daily life, they are perturbing, irritating. In this sense they can be construed as critiques of modern life and of alienation in particular.

Degas' frieze-mode racing paintings offer no similar critique. They are socially and pictorially conservative because of their classicizing qualities and alienated relationships. This conservatism is most baldly evident in their relationship to contemporary hunting, sporting, and military scenes. The bond between hunting and sporting images and Degas' work is underscored by the fact that his early horse paintings (done prior to the racetrack images) depict hunting and the rich on horseback. Examples are *Departure for the Hunt* (fig. 25), *Rid-*

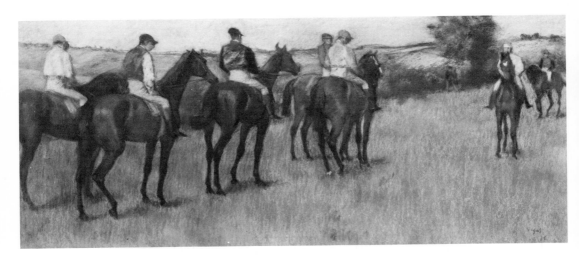

14. *Jockeys.*

*ers on the Road* (1864–1868, Galerie Beyeler, Basel), and *The
Morning Ride* (ca. 1864–1868, Detroit Institute of Arts).
Although the narratives of Degas' racetrack pictures and con-
temporary hunting scenes are different, the pictorial struc-
tures of the works, the social milieus depicted, and the moods
generated are similar. If we compare Degas' *Jockeys* with John
Lewis Brown's roughly contemporary *Rest at the Golden Lion
Inn* (figs. 14, 26) or de Dreux' *Outing in an Open Carriage*
(fig. 27), we find that in all three, the figures are "types,"
more social signals than individuals. In the de Dreux, for
example, a family of landed gentry pauses on horseback, on
foot, in a carriage, as they chat in a forest clearing. An avenue
of trees pierces the right side of the painting, but the pictorial
and social focus of the image is on the surface; a frieze format
is the basic pictorial assumption. Very little activity is de-
scribed in any of these three paintings; all are permeated by
a sense of ease and languor. This is the world of wealth and
privilege. It is no coincidence, I think, that Degas collected
the work of both de Dreux and Brown.[11]

The resemblance of Degas' jockey paintings to military
scenes is also easily pinpointed. Military paintings were very
popular in France in the 1860s, 1870s, and 1880s; as can be

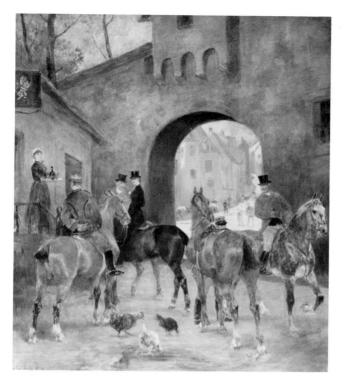

26. John Lewis Brown. *Rest at the Golden Lion Inn*. 1885.

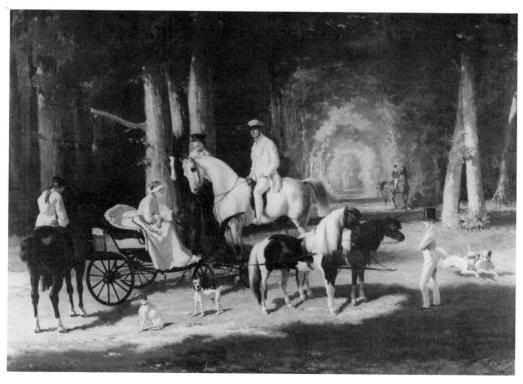

27. Alfred de Dreux. *La Promenade en Calèche*. [Outing in an Open Carriage]. Ca. 1850.

seen in any Salon catalog from those years. Furthermore, it is an easy mental exercise to transform all the brigades and cavalries painted by Jean-Baptiste-Edouard Detaille, Alphonse Marie, Adolphe de Neuville, Jean-Maxime Claude, and Ernest Meissonier into hunting or even racing scenes. Actually, it was a common contemporary assertion that horse breeding was "one of the resources of the national armament"; racing was seen as "indispensable for a country which wants to have a cavalry."[12] The Jockey Club itself commemorated its relationship to the army by calling one of its rooms "Le Camp de Chalons," and its members included military men and hunting specialists.[13] Edgar Ney, for example, was master of the hounds to Napoleon, and General Emile Fleury was the well-known organizer of the Regiment des Guides. A painting that epitomizes the relationship between racing and the army is Alfred-Charles-Ferdinand Decaen's *Revue de Longchamps, le 23 Octobre 1867* (whereabouts unknown).[14] It depicts the demonstration of a cavalry charge in front of the emperor at the Longchamps racetrack.

If we need further evidence that racing paintings were integrally connected to portrayals of the world of the hunt and the military, we find that artists like Brown and de Dreux depicted military, racing, and hunting scenes almost interchangeably. Degas himself confounded racing and military phenomena in a notebook he used around 1859; in it, on a single page, he quoted extensively from an unidentified account of military action, underneath which he drew two jockeys. In addition, between 1864 and 1874, the period when he began the racing paintings, he made a number of copies after Meissonier's *Napoleon at the Battle of Solferino* (1864, Louvre).[15]

To paint horse racing at all in the 1860s and 1870s, then, was to make an allusion to the world of the hunt and the military. But to paint horse racing in a classicizing style was to underscore the social conservatism of both of the latter

with stylistic conservatism. For classicism, as we have seen, was associated with morality, nationalism, and a nostalgia for an idealized past. A preference on Degas' part for classical sources for most of his racing paintings expressly rejected the appetite for Spanish art among some French artists, for Dutch and French rococo art among others, and for a Courbetesque realism among still others.[16] Degas chose a symbology embodied in the litany of government-funded art schools—copies from the Parthenon, triumphal Renaissance marches, equestrian statues—a symbology that was a perfect vehicle for social conservatism.

The conservatism of the frieze-mode paintings, with their homogeneous social content—primarily groups of men on horseback—and their suggestions of sporting and military maneuvers, becomes all the more dramatic when considered in the context of the racetrack itself. Between 1860 and 1890, the track was transformed from a bastion of aristocratic privilege to a place where one found all kinds of people, much like attendance at café-concerts in the center of Paris and along the Champs-Elysées.[17] The racetrack was democratized. That most of Degas' racing paintings embody attitudes that took no notice of this change is significant.

Racing was initiated in France in the 1830s by moneyed, often cultivated, aristocratic Anglophiles. Very often, the same men who cultivated dandy tastes and habits à l'anglaise were those who raised horses. In 1833 these men organized the Société d'Encouragement pour l'Amélioration des Races de Chevaux en France, better known as the Jockey Club. They set down rules to protect and govern the tracks where they met, to ensure breeding standards, and to keep some people in and others out. In 1856, however, with the establishment of racing at Longchamps in the Bois de Boulogne, the sport's exclusivity began to diminish. This was not because Longchamps lacked elegance; it didn't. Rather, it had to do instead with the track's location and entrance fees.

Whereas before 1856, racetracks had been far from Paris—at Chantilly or Deauville, for example—Longchamps could be reached quickly and easily by rail, *bateaux-mouches,* carriages provided by the racetrack, or by foot. Entrance fees were manageable by rich and poor alike. Thus, racing became accessible to more people.

Another factor that undermined the role of privilege at the track was the regularization of betting. Before 1867 and the invention of standardized betting in the form of the *pari mutuel,*[18] it had been a very haphazard affair. With standardization, however, all the horses' names were inscribed on a board, and the bets became uniform. The Jockey Club was against the *paris,* or bets, and Victor Géruzez (known by his pen name, Crafty) probably pinpointed the cause of the club's complaint in 1889 when he said that "the *paris* have brought about . . . an abasement," because they were accessible to all.[19] What he meant was that because the Jockey Club had acquiesced to a government-controlled system of standardized betting, all classes of people could now bet. The club was therefore delighted when betting was banned in 1887. According to one of its spokespeople, Albert de Saint-Albin, a playwright and track enthusiast, racing could now "recover its aristocratic aspect."[20] But that did not happen. When betting was banned, the crowds, which had numbered forty thousand on the lawn on a good Sunday at Longchamps or Auteuil, vanished.[21] The Jockey Club had to face the realization that in order to continue racing at all, it needed the very people it despised. The pari mutuel was permanently established as the exclusive betting form in 1891. The former elitism was gone for good.

Exclusivity was further undermined by the inauguration of steeplechase or obstacle racing at Vincennes in 1863. Unlike Longchamps in the Bois de Boulogne, Vincennes was located in the unglamorous "popular" southeastern section of Paris. Thus, from its inception steeplechase racing had a

negative connotation, since it took place in an undesirable neighborhood. Another apparently philistine characteristic was that steeplechase racing from the start was more obviously a business venture than flat racing, which always managed to preserve something of the gentleman's meet. Crafty quipped that all one needed for a steeplechase course was an investor and a rail connection, and that if it were not for small-scale farming, "the suburbs of Paris would be literally covered with steeplechase tracks." That, he said, was what the speculators had accomplished. In addition, he implied that the emotions aroused by steeplechase racing were more vulgar than those aroused by flat racing, since spectators of the former were titillated by the prospect of a good fall, the more violent the better. Crafty noted that many made a tour of the track beforehand and "tested out the solidity and height of the obstacles. . . . They examine the construction of the walls, test the depth of the river with their canes." In his view there was no chic at this kind of track.[22]

Jockey Club members and other old-time racing enthusiasts desperately wanted to ennoble steeplechase racing and transform it into an elite, refined pursuit. They were therefore heartened when a steeplechase track opened at Auteuil in 1873, back on the other side of Paris in the Bois. They praised its "aristocratic elegance" and claimed it was "to other racetracks what the Comédie-Française is to other theaters."[23] Their hope was that this track would stop the social backsliding that had been taking place. It didn't. Steeplechase racing had left its leveling effect.

But the most obvious place to observe the disintegration of upper-class control at the racetrack was within the Jockey Club itself. Life there during the Second Empire was dazzling. In 1863 the club moved to 2, rue Scribe where that street intersected with the Boulevard des Capucines—one of the elegant hubs of the new Paris—and the place where the ornate Opéra, designed by Charles Garnier, was being

erected at that very moment (figs. 40–44). According to Joseph-Antoine Roy, a recent racing historian, club members—men such as the duc de Morny, Prince Metternich, the duc de Gramont-Caderousse, the comte d'Orsay and the duc de Fitz-James—were considered the "hundred-or-so men who constituted 'glamorous Paris' in 1860." The club was such an integral part of Parisian high life that it was illuminated and decked with flags as if it were a public monument. As Roy describes it, "crowds gathered there between 5 and 6 P.M. after the return from the Bois, while those members who were Deputies in the Chamber arrived with the latest news. Dinner attracted about 60." After the theaters closed, the gambling tables were busy until 3 A.M. Club membership was dominated by the army, the diplomatic corps, and wealthy aristocrats. New money was less well represented by a few industrialists, as well as a dozen regents, and a few directors, of the Banque de France.[24]

Until the fall of the Empire in 1870, Jockey Club members were powerful men. After 1870 they simply did not wield the same political power. For whatever mélange of forces the Republic represented, it was the symbol, and ultimately the embodiment, of the triumph of the bourgeoisie. Therefore, even if club members were deputies in the government after the mid-1870s, they were not as important as they had been. They were less dynamically integrated into the French social fabric. They also lost legislative power with the reestablishment of municipal councils in the countryside, where aristocratic power had formerly dominated. In addition, whereas members of the club had been quite popular after the war with Italy in 1859 because of their reputed bravery, by 1878 the *Grand Dictionnaire Universelle du XIX^e Siècle* reported that they had the reputation of being frivolous and elegant gamblers who were "as apt to discuss the merit of a dancer as the value of a horse." A republican deputy by the name of Edouard Millaud even blamed France's defeat

by the Germans in the Franco-Prussian War on the fact that the leaders of the army were members of what had come to be known as the effete Jockey Club.[25]

The social stature of the racetrack clearly had shrunk by the time Degas started to paint it in the 1860s. Although racing had begun as a pastime for the privileged, it no longer was to the same degree, and although Degas' selection of this subject had its roots in his own privileged background, to have chosen it in the 1860s suggests a need, however unconscious, to confront the disintegration of aristocratic privilege. Yet Degas did not do this. The frieze-mode racing paintings humming with memories of the hunt, military maneuvers, and the French Academy are emblems of aristocratic privilege and power.

Degas' racing paintings represent his second largest group of genre works. Since most of them were made after 1874, when he began, for financial reasons, to need to earn money from his work, one can assume that he thought they would sell well. Because a large proportion of the pictures (25 percent) went to the dealers Ambroise Vollard and Paul Durand-Ruel, we can assume that they were considered marketable. It may well be that the essential conservatism of the pictures suited the art market whether the purchasers were aristocrats themselves or upwardly mobile bourgeois.

Considering the vast number of conservative racing paintings Degas made, it is especially significant that he did a few—the discontinuous-mode paintings—that not only ignore the rituals of aristocratic life and the impotence inherent in alienation but also face and respond to that alienation and to the social confusion and conflict which constituted modern life. Let us look again, and more closely, at *At the Racetrack* (fig. 15). This large painting ($26^2/_5 \times 32^2/_5''$) contains no clear focal point. It seems to be about the general social texture of the event but presented as a compilation of specific, fragmented moments. It is impossible to read the picture as a

continuous narrative. The work eludes immediate comprehension or reading; it is not easily digestible.

On a purely literal level, this lack of focus is enticing. It urges one to choose among the equally interesting and competing events: the skittering horse and jockey at the left; the speeding train beyond them; the bearded, top-hatted spectator to the right; the two women seated in a smart little carriage in front of him; the group of jockeys at center right; the blurred group of spectators in the middle ground. Added together, all these fragments convey a particular social milieu, if an imprecisely defined one; they do not, however, comprise a conventional narrative.

The asymmetrical composition is also disconcerting. It curves from one side of the painting to the other, describing a quarter circle, the inside of which—the bottom left corner—is empty. This emptiness invests the dense right side with a suggestive fullness. One's attention leaps from place to place, confused not only by the variety of literal detail and unfamiliar spatial relationships but also by the strangely deployed forms themselves. For if we describe what is literally *in* the painting, it is peculiar. We find a fragment of a man in a top hat superimposed upon what appear to be outsized yellow wheels; that same man's form both intersects with a bent-back carriage top and leans into two women seated in the carriage; and we see a close-knit yet distinctive trio of jockeys and horses just beyond the carriage. The distinctness and contradictory size of each of these groups abrogate any illusion of three-dimensionality. Except for the train puffing smoke and the rider at the left pulling back on his horse, the traditional formal assumptions of spatial predictability and causality have been eschewed.

Traditionally, Japanese art has been mentioned in relation to paintings like *At the Racetrack* just as it has been discussed in relation to works like Cassatt's *The Letter* (1891, drypoint and etching, Metropolitan Museum of Art) or Ma-

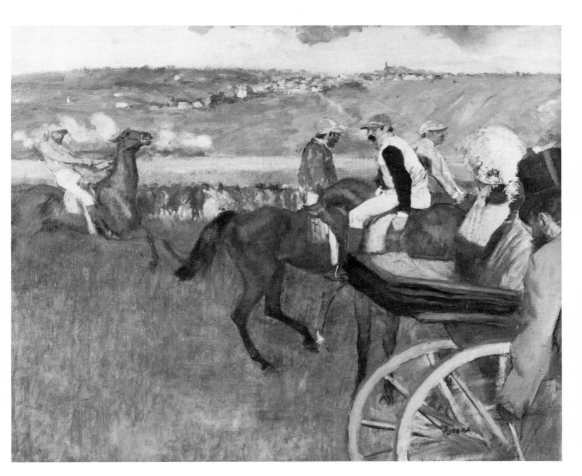

15. *At the Racetrack.*

net's *The Fifer* (1866, Musée d'Orsay). In designating the characteristics of French avant-garde painting derived from Japanese works, most writers have pointed to asymmetrical organization, to the collapsing of three-dimensional into two-dimensional space, and to the slicing of forms by the picture's edges. In addition they have emphasized the scattering of figures across surfaces and the inexplicably empty or oddly crowded spaces.[26]

Although a comparison between French and Japanese art is useful, its possibilities have scarcely been tapped. Here, for example, is Daniel Catton Rich's description of Degas' *The Absinthe Drinker* (1876, Louvre):

The design is among the most brilliant inventions of the artist. From Japanese prints he had learned this zigzag arrangement of lines which, beginning in the bottom of the canvas, is carried swiftly back by the blank table tops. The figures are placed to the right of center and sharply cut by the frame.[27]

Or Gabriel Weisberg on Degas' *Leaving the Bath* (lithograph, ca. 1890):

As one of a series of eight lithographs which concentrated on a single monumental bather, sometimes accompanied by a servant, these prints suggest Japanese prototypes. Women washing themselves, observed from the back, are found in Hokusai's *Manga* and in prints by Ki- yonaga, including Degas' own version of the *Bath House*.[28]

The art historian's tendency has been to underline formal and thematic similarities, but the resemblance between French and Japanese art can be assessed from a completely different vantage point, one that discloses rich social as well as artistic meanings. To draw out its social implications, we must ask what Japan *meant* to France during the last quarter of the nineteenth century. This is a much trickier question than asking what Greece meant, for the West readily appreciated the rich implications of Greek civilization. In contrast the Orient seemed inscrutable at best.[29]

The historian Eric Hobsbawm has connected Japan's im- portance for the West to the discovery of gold in California in 1848. This "brought the United States squarely into the Pacific area," he has written, "and Japan squarely into the center of Western attempts to 'open' its markets." Com- modore Perry, an American, forced Japan to open some of its ports by 1853. In addition, Japan could not ignore Western power after Great Britain humiliated China (the onetime con- queror of Japan) in the first Opium War of 1839–1842. Of- ficial relations between France and Japan were established in 1858. Until 1863 trade was primarily in luxury items, with

France doing most of the buying. In 1861, however, the French realized that they could rebuild their collapsing silk industry by importing Japanese silkworms. The resulting economic dependency constituted a major shift in Franco-Japanese relations, for the French no longer simply admired Japanese taste, they needed Japan. In addition French missionary zeal was determinant. Of the sixty thousand missionaries in India, China, Japan, Korea, and the Pacific in the 1870s, forty thousand were French.[30] The French sphere of influence, therefore, was spiritual as well as economic.

French economic and social involvement in the Far East (as well as the Near East, Africa, and Polynesia) was maintained and legitimized by an enormous body of literature. With regard to Japan, this literature was racist and idealizing by turns. The comte de Gobineau's *Essai sur l'inégalité des races humaines* (Essay on the Inequality of the Human Races, 1854), one of the most influential tracts of its time, is typical in its use of a pseudo-scientific vocabulary. Gobineau takes for granted that it is only a question of time before "Aryans" will begin to "civilize" people of color. He finds that although the "yellow race" is in general superior to the black, its members absolutely lack imagination. He points out, however, that the Japanese are superior to other "yellow people" because they do have a "poetic imagination," which "would be incomprehensible in a pure yellow people." Their imagination, says Gobineau, is a result of their mingling with blacks. Among the elite Japanese, according to Gobineau, there is also a dose of white.[31]

Like Gobineau, Rudolf Lindau, in his apparently enthusiastic and often-cited travel book *Un Voyage autour du Japon* (A Trip Around Japan, 1864), basically assumes Japanese inferiority. Near the beginning, for example, he muses that when two societies clash, it is the less civilized that suffers the most. This, he says, explains Japan's complete renovation of public and private life after its contact with the West. While

Lindau appreciates the intelligence of the Japanese, he notes that "they do not possess a certain penetration, that breadth of views, that creative ability which produces the power of the Western races." Instead, he stresses their "amiable temperament" and "benevolent politeness."[32]

Pierre Leroy-Beaulieu, a late nineteenth-century writer, also comments on the "universal good-will" of the Japanese. He adds that they "possess powers of assimilation in a rare degree" and points to their strong urge to progress, despite what he sees as their simple tastes, such as their admiration of beautiful flowers. Another author remarks on how "avid to learn" the Japanese are. But what seemed to bewilder the French the most was Japanese morality. Lindau found them lewd and quotes Rousseau's comment that "shame is 'a social institution'; it develops with civilization."[33] In the French imagination, Japan was as yet uncivilized.

Overall then, to the French the Japanese were "other"—either mysterious and bizarre (Buddhist, silent, shameless) or graceful and childlike (good-natured, polite, eager to learn). "Civilization" always meant the West; the "progress" that France was bringing to Japan was capitalism. Instead of asking "Who are the Japanese to themselves?" rather the French asked "Who are they to, and for, us?"

The French, of course, benefited enormously from trade with Japan. The lacquers, porcelains, and ivories that only the rich could buy in the 1840s, 1850s, and 1860s became available to the middle classes after the 1867 Exposition Universelle. Although many delighted in that accessibility, connoisseurs like the critic Ernest Chesneau were furious at what ultimately became the bourgeois imitation of Japanese objects. He saw counterfeits everywhere and remarked that even a "black tribal chief wouldn't want such [items]" which, he claimed, were made in France and sold on the rue du Sentier.[34] Edmond de Goncourt showed similar disdain when in 1891, after expressing pleasure over "the beautiful prints

of Utamaro which have for the tasteful amateur's eyes the seductive charm of a work of art," he regretted that now everyone could have them; they had become "vulgar merchandize in the hands of editors desirous of making money and addressing the taste of a low class of people."[35]

Such elitism had no noticeable effect, however, and the marketplace continued to provide Japanese goods. Zola described a display of such items in a department store as "overflowing with old bronze, old ivory, old lacquer; his [the owner's] turnover there was fifteen thousand francs each year, and he was turning the whole Far East, where travellers were ransacking palaces and temples for him, topsy-turvy."[36] A shrine to that appetite, the Ennery Museum, is located in the Hotel Ennery on the elegant Avenue Foch in Paris. In it, endless glass cases are filled with an indiscriminate mélange of Japanese and Chinese dolls, vases, bronzes, lacquer work, jade, and ivory carvings, all of which were collected in the last half of the nineteenth century.

But what did the appetites and prejudices for things Japanese mean when encountered in high art? Contemporary painting, it turns out, also displayed an avidity for collecting and this inclination included both artistic forms, and Japanese goods. In Tissot's *Lady in Japanese Costume* (fig. 28), for example, a woman clothed in a Japanese kimono, with a fan at her waist and flowers in her hair, holds up two Japanese vases. She stands near a window in what looks like a greenhouse.[37] In Marie-François Firmin-Girard's *La Toilette Japonaise* (fig. 29), one again looks at a Western painting of Japanese objects, this time almost an inventory of objects. The focal point of the painting is a figure who appears to be a Caucasian in both facial characteristics and body proportions. As in the Tissot, the structure of the Firmin-Girard painting is Western, but even more stunningly so because of the plethora of Japanese objects on the one hand and the absolute absence of anything integrally Oriental on the other;

28. Jacques–Joseph Tissot. *Lady in Japanese Costume*. Ca. 1865.

29. [After] Marie-François Firmin-Girard. *La Toilette Japonaise*. 1873.

30. Monet. *La Japonaise*. 1876.

drawing, perspective, modeling, and color are all relentlessly Western.[38]

Even when we look at a more subtle and interesting image, such as Monet's *La Japonaise* (fig. 30), similar collecting urges are expressed. In that painting we see a Caucasian woman wrapped in a Japanese kimono whose folds and design quite wittily evoke a man's head. One might construe the use of a Japanese garment here as an ironical

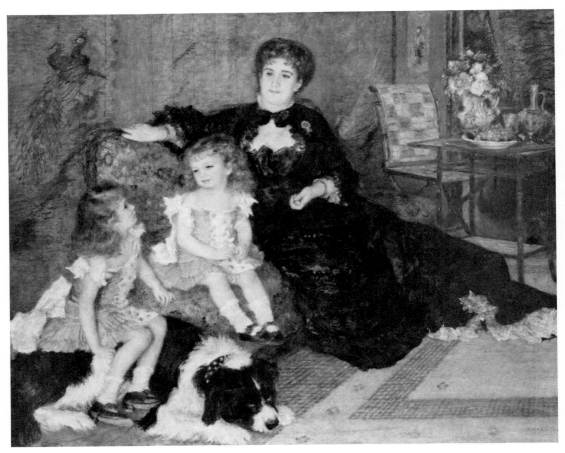

31. Renoir. *Madame Charpentier and Her Children*. 1878.

comment on French taste. Renoir's *Madame Charpentier and Her Children* (fig. 31) also embodies an appetite for collecting Japanese screens, prints, and furniture. Nonetheless, both the Monet and the Renoir behave in what I would call a more humble manner than either the Tissot or Firmin-Girard; neither Renoir's nor Monet's painting pretends to *know* the Japanese, which it could be argued both the Tissot and Firmin-Girard do because of their pretensions to describe Japanese life. All that Renoir's and Monet's works "know" is that the French liked to own Japanese objects.

All these paintings are, to a great extent, about acquiring exotic goods. In this way French imperialism entered the

realm of culture. But what are the implications of using "exotic" forms in a painting, as Degas did in the small, exceptional group of his racing paintings and, of course, in much of his other work?[39] Certainly Japanese formal elements were as incomprehensible to a Westerner as were Japanese objects. The objects could be bought, used, and enjoyed in France but never really "known" insofar as knowing had to do with understanding their relationship to Japanese culture. Similarly, on a formal level, the Westerner who was accustomed to perspective and illusionistic three-dimensionality could not really understand their absence in Japanese art. That is, the Western starting point with regard to Japanese form was alienated; an insurmountable emotional and social distance was built into Japanese form for a Westerner.

Important insights into what the French "saw" in Japanese art are provided by what they wrote about it. Critics emphasize realism consistently: the precision of depicted gestures and movements and the observation of natural phenomena. In 1878 Chesneau noted that the Japanese were not fantasists to the extent that other commentators had supposed: "it is nature, really, which is their model." Théodore Duret in 1882 described Japanese book illustration "in which ordinary life is retraced in all its verity." He observes that the first volume of Hokusai's *Manga* contains "sketches of everything one can see in Japan" and compares these to Daumier's and Gavarni's depictions of scenes from daily life. (Degas, it might be noted, was a great collector of Daumier and Gavarni.) Louis Gonse, editor of the *Gazette des Beaux-Arts* and a famous collector of Japanese art, commented in 1886 on Hokusai's use of "motifs of all sorts, studies of figures, gestures, attitudes, flowers, fruits, insects, butterflies." In discussing Utamaro in 1891, Edmond de Goncourt emphasized the artist's "utter tracing of reality as seen in nature— attitudes, poses, gestures."[40]

In addition, they admired the grace and elegance of Jap-

anese art as well as what was indeed seen by some as its
otherworldliness and dreaminess.[41] Either French critics saw
the Japanese as realistic and elegant—just as, one might say,
the French perceived themselves—or they saw them as
"other"—dreamy and childlike. Both were typically racist
notions.

The one attitude expressed by the French critics that
neither took the form of familiar rhetoric nor of a knee-jerk
response to things foreign was their observation of what I
call "disruptive" formal configurations in Japanese art. In
1876 Duranty described the Japanese eye as "quick, mobile."
Huysmans saw it in 1881 as "quick and nervous." Duret notes
more specifically that the tiny figures in Hokusai's work "are
thrown pell-mell from the top to the bottom of the pages
without any ground to support them" (fig. 32). Chesneau,
pointing in 1878 to a Japanese influence on Félix Bracque-
mond's work, cited "a freedom in the placement of motifs
. . . that is, the arbitrary displacement of centers, the rupture
of equilibrium and balance, the insistent use of what I have
called dissymmetry" (see fig. 33 for an example of the Jap-
anese art he had in mind). He continues by noting in Brac-
quemond the isolation of details in unexpected places, the
"summary modeling," the insistence on imparting the "es-
sential character of a form even at the price of exaggeration."
Burty commented in 1870 that Degas' *Portrait of Mme. Camus*
(1870, National Gallery, Washington, D.C.) had Japanese
qualities insofar as it ·was "sensual and bizarre." In an 1880
review Huysmans describes the "clownish dislocation" of the
dancers' bodies in Degas' paintings and the way they are "cut
by the frames as in certain Japanese images" (see fig. 34 for
an example).[42] Key concepts and phrases are: quickness, ner-
vousness, arbitrary scattering of figures, peculiar perspective,
asymmetry, ruptured equilibrium, exaggeration, dislocation.
One feels a mounting sense of the writers' vertigo.

This focus on disruptiveness in Japanese art calls at-

32. Katsushika Hokusai. *Page of Animals* from the *Manga*.

34. Suzuki Harunobu. *Kayoi Komachi* from *The Seven Fashionable Komachi*. Ca. 1768.

33. Andō Hiroshige. *Village Street in Early Spring with Printseller's Shop.* 1845–1853.

tention to the very way in which Western pictorial space had been organized since the Renaissance. And, indeed, the nineteenth-century critical vocabulary specifically recognized the undermining of perspective in contemporary French art. Paul Veron said as much in 1872 when he wrote that Manet did not care "for everyday bourgeois laws of perspective."[43] Perspective as a structuring device located decisive power in the viewer, and French critics noted, without saying it precisely, that Japanese art, which did not "know" perspective, pulled the rug out from under the Western spectator.

The critical vocabulary used to discuss both realism and disruption in Japanese art dovetailed with what French critics considered "modern" in art. Duranty in *The New Painting* stresses realism saying:

. . . the aim of drawing, in these modern attempts, is precisely that of becoming so intimately acquainted with nature and of embracing it so strongly that it [drawing] will become unexceptionable. . . . By means of a back, we want a temperament, an age, a social condition to be revealed; through a pair of hands, we should be able to express a magistrate or a tradesman.

Further, Duranty enjoins painters to disrupt traditional spatial expectations:

Views of people and things have one thousand ways of being unexpected in reality. Our point of view is not always in the center of a room with two lateral walls receding toward that of the rear; it does not always gather together the lines and angles of cornices with a mathematical regularity and symmetry. Nor is it always free to suppress the great swellings of the ground and of the floor in the foreground; it [one's viewpoint] is sometimes very high, sometimes very low, missing the ceiling, getting at objects from their undersides, unexpectedly cutting off the furniture.[44]

In his review of the 1880 Salon des Indépendants, Huysmans

describes Degas as "a painter of modern life," noting his "prodigious verity" and the "vibrant nervousness" of his works. In an 1881 review, he calls Degas' sculpture *The Fourteen Year Old Dancer* (1880–1881, Metropolitan Museum of Art) "the only truly modern attempt that I know in sculpture," pointing, among other things, to the actual materials—the gauze tutu and silk ribbon—to the girl's ugliness, and to the nervous twisting of her limbs. In 1877 Georges Rivière had termed a café-concert scene by Degas "an extraordinary page of history." So realistic and compelling were Degas' works in his opinion that "after you have seen the pastels of the 'ladies' of the corps de ballet, you can dispense with the actual opera performance." For Rivière, one of the components of Degas' realism was that he "places the figure in the most unpredictable and amusing fashion." And, of course, Baudelaire in his famous essay "Le Peintre de la vie moderne" (1863), entreats artists to paint their own times—contemporary milieus, contemporary gestures, contemporary dress. He states flatly that "Modernity is the transient, the fleeting, the contingent."[45] In the second half of the nineteenth century, "modernity" for the French seemed to imply both the real and the unstable.

It is no coincidence that the critical vocabulary used to describe Japanese art and art that was considered modern are similar in some respects. Some French artists clearly found in Japanese forms an expressive visual language for their daily experience of life in Paris. An emblem of this experience was the extreme physical renovations set in motion by Baron Haussmann's rebuilding of the city. For example, before the implementation of his program, one had to walk down seven steps to enter the Eglise Saint-Roch on the rue Saint-Honoré, but after, up twelve. Disruptive in another way was the inherent (and constant) mobility of modern society: the relentless circulation of goods and the drive for expanding markets; the migration of thousands of people from the coun-

try to the city in what Eric Hobsbawm has called "the greatest migration of peoples in history"; the increased and speeded up traffic on the streets; and so on. Edmond de Goncourt spoke for many when in 1861 he described his times as "this world, these people, this rising generation—which one would swear had been brought into the world after a vaudeville, between two deals on the Stock Exchange."[46] Accepted and comforting social structures were disrupted. Agoraphobia, anxiety, neurasthenia, and hysteria were only the most overt responses to these changes in social life.[47] Recall Chesneau's reflections on the "arbitrary displacement of centers," the "rupture of equilibrium and balance," and the "insistent use of dissymmetry" in Japanese art, or Duret's depictions of figures thrown "pell–mell" from top to bottom with no support. Were these critics not commenting on the disequilibrium in their own daily lives—its dissymmetry, its ruptures, its dislocations? Japanese form provided a perfect vocabulary for this experience. Because of its perceived fragmentation, it carried the anguish, *and* the excitement, of modern European life.

In addition, artists could use Japanese forms with impunity. Their foreignness and, for the French, their elegance masked what the forms were actually "doing" in a painting. That is, these forms disguised, at the same time that they disclosed, the anxiety produced by contemporary social change. Furthermore, because their forms were foreign and puzzling, they forced the viewer to engage with them in a way that familiar, classical forms could not.[48] Degas' own commentary on some very different but to him equally exotic forms is illuminating in this regard. In a letter written from New Orleans in November 1872, he wrote: "I like nothing better than the negresses of all shades, holding in their arms little white babies, so white, against white houses." In a February 1873 letter he commented: "There are some real treasures as regard drawing and color in these forests of

ebony. . . . And then I love silhouettes so much and these silhouettes walk." In another part of the November letter he had mentioned "the contrast between the lively hum and bustle of [business] offices with this immense black animal force."[49] Degas chose to emphasize form and color—"forests of ebony" and "silhouettes"—over something he felt was far less controllable, namely "animal force." His language both disguised and described his anxiety in the face of the large numbers of blacks he encountered, undoubtedly for the first time in his life, in New Orleans.

I have been trying to show how disruptive form and space in Degas' discontinuous-mode racing paintings are intrinsic to modern life and the alienation inherent in it. I have stressed disruption as a carrier of the anxiety produced by alienation. In my discussion of the frieze mode, however, I have also said that the passivity implicit in the frieze subject's relationship to its background was a product of the same social malaise. The two types of racing compositions were produced by the same historic moment but express very different attitudes toward that moment. The frieze form, on the one hand, takes alienation as a fact and reproduces it through the passive siting of the subject upon the background. Therein lies its conservatism; it simply accepts what is there. The disrupted form, on the other hand, embodies the movement, the nervousness, the social fact of anxiety produced by alienation. Disrupted forms answer, respond, act; they see the historical moment, if you will, and act upon it, refusing the paralysis that bourgeois ideology imposes. These forms do not accept that social structure simply *is*, that it is natural and absolute and therefore must remain so; they assume the possibility of change.

Georg Lukács has made a similar point in regard to the differences between Zola and Balzac. He found the former's writing gray and ineffectual, even in its intensity. Zola's literary voice, Lukács says, was outside events; it recorded,

watched, judged, but did not interact or struggle. "What [Zola] . . . puts in the place of Balzac's ideas . . . is the undialectic conception of the organic unity of nature and society; the elimination of antagonisms" (much like Degas' frieze form, it seems to me). Balzac, according to Lukács, "could dig down to the very roots of the sharpest contradictions inherent in bourgeois society" and, with his "bred-in-the-bone dialectic and prophetic fervor . . . [expose] the contradictions of capitalism."[50] This is what the discontinuous-mode paintings do; they give you the racetrack, the former place of exclusive upper-class power, but they also give you the conflict and tension of that milieu.

Earlier, I said that Degas' Japanese-influenced racing paintings eluded easy reading; moreover, I contended that in them spatial and social predictability and causality were eschewed. It is clear to me that *formal* complexity, in particular, Japanese forms, were used by Degas (and by others) to express *social* complexity. Perhaps this is what Duranty perceived when he noted the "Chinese silhouette" in Degas' *Portrait of Mme. Camus* and called her "The Socially Ambiguous Lady"[51]

If we return to our comparison of *At the Racetrack, In Front of the Tribunes,* and *False Start* (figs. 15–17) with the frieze-form works *Before the Meet, The Races, Racehorses at Longchamps,* (figs. 10–12) and so on, we find that in the former, the social content is indeed more complicated and "modern"—more heterogeneous—than in the latter. First of all, a greater variety of people appears in the former. Occasionally, we see a starter with his red flag,[52] and spectators sit or stand on the lawn, in grandstands, or in private carriages. In addition, there are towns in the distance, puffing smokestacks, and rushing trains. It is true that in the classicizing racing paintings smokestacks sometimes appear in the background, but they are essentially unrelated to the other parts of the compositions, providing only the merest whisper of another world. By contrast, in the discontinuous-mode

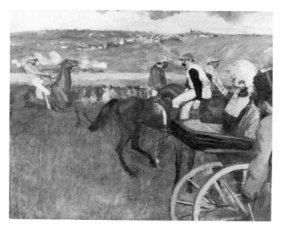

15. *At the Racetrack.*

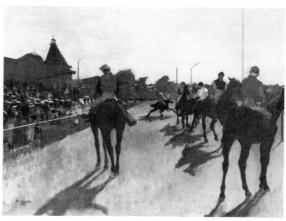

16. *In Front of the Tribunes.*

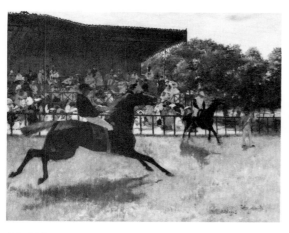

17. *False Start.*

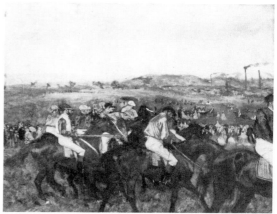

10. *Before the Meet.*

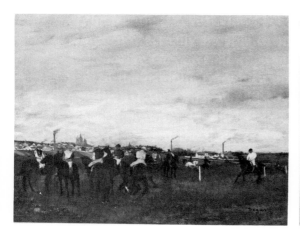

11. *The Races.*

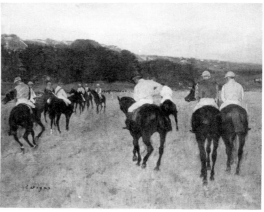

12. *Racehorses at Longchamps.* 1869–1870.

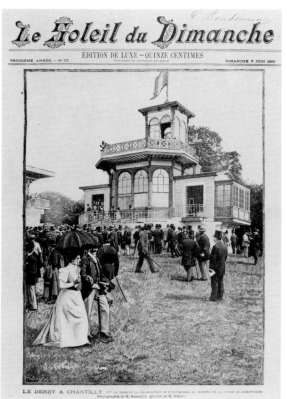

35. Marcilly and Doghy. *Le Derby à Chantilly*. 1890.

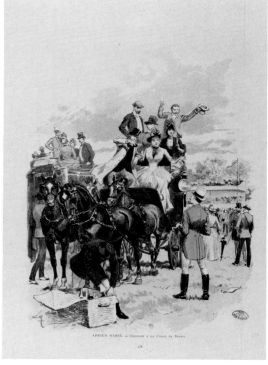

36. Adrien Marie. *Courses à la Croix de Berny*. [Races at Croix de Berny.] 1885.

paintings they are integrated into the compositions as typical social phenomena.

The social complexity of these paintings can be appreciated further by analyzing their very strange commentary on women. Coquetry was a primary subject in contemporary verbal and visual racetrack imagery. When Constantin Guys penned a scene of the races, flirtation was taken for granted, as it also was in Edmond Morin's *Spring Races* (1864, Bibliothèque Nationale).[53] Flirtation is likewise a given in newspaper illustrations such as the June 8, 1890, cover of *Le Soleil du Dimanche;* "The Lawn at Longchamps on a Racing Day," in *L'Illustration* of June 7, 1873; or Adrien Marie's *Races at la Croix de Berny* (figs. 35, 36). One of the most vivid examples of the power of sexuality at the track is the nearly forty-page chapter in Zola's *Nana* (1880) that takes place at Longchamps. A highlight of the chapter is the courtesan Nana's entry:

When she had made her appearance at the entrance to the public enclosures, with two postilions jogging along on the left-hand horses, and two footmen standing motionless behind the carriage, people had rushed to see her, as if a queen were passing. She was wearing the blue and white colours of the Vandeuvres stable in a remarkable outfit. This consisted of a little blue silk bodice and tunic, which fitted closely to her body and bulged out enormously over the small of her back, outlining her thighs in a very bold fashion.[54]

But where are the women in Degas' racing paintings? They are barely there. In works such as *Carriage at the Races* (1873, Museum of Fine Arts, Boston), or in the background of *Before the Meet* (fig. 10) and *Jockeys at Epsom* (ca. 1860–1862, Private Collection), women are either depicted with children or are almost completely illegible.[55] There are two instances that are altogether different, however, and both relate to the discontinuous-mode paintings. In *At the Races* (fig. 37), we are given a close-up view of two women conversing, very like closely cropped views of actors in eigh-

37. Degas. *At the Races*. Ca. 1878.

teenth-century Japanese prints.[56] Not only is the viewpoint
startling but the women's veils smudge out their features—
a decided visual shock.[57] The other racing painting that offers
a comment on women is as extraordinary. It is called *At the
Racetrack, Jockeys* (fig. 38). The state in which we see it now
is significantly different from the way Degas left it at his
death. At that time the content was barely legible, and the
woman, for all intents and purposes, was simply not there.
However, when the painting was cleaned in 1960 she emerged
next to a top-hatted gentleman with a walking stick.[58] He
appears elsewhere in Degas' work and is, in any case, con-
ventional socially and pictorially. She most definitely is not.
She stands forward, legs astride, looking out with binoculars.

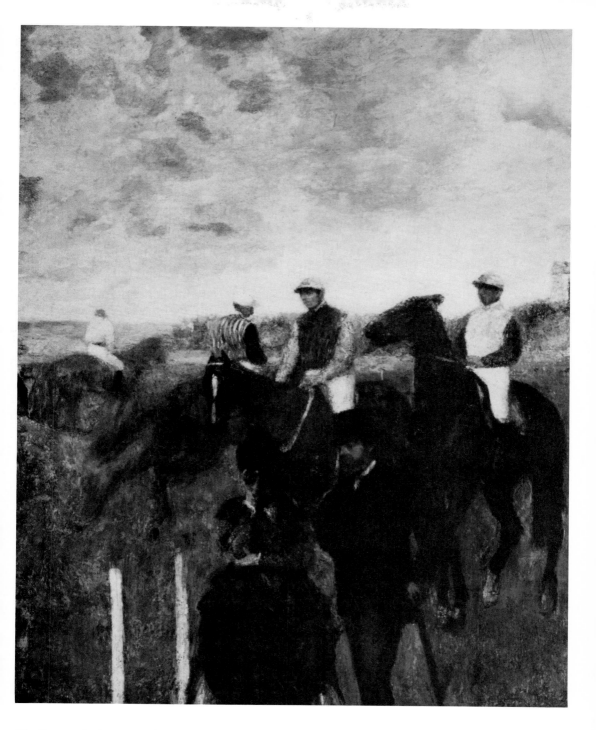

38. Degas. *At the Racetrack, Jockeys.* Ca. 1868.

What did this woman signify? And what did Degas' removing her from *At the Racetrack, Jockeys* mean?

Standing frontally, iconically, and staring out through binoculars, this woman was an imposing personage whose monumental form and act of bold looking expressed tremendous power, power which at the time was by definition male.[59] Although one occasionally finds a woman in contemporary paintings who resembles her in gesture—most extraordinarily, perhaps, in Cassatt's *At the Opera* (fig. 4)—such a woman was a rare phenomenon, and understandably so. For even if it has become a cliché to say that women in nineteenth-century sexual discourse were objects of male sexual fantasy—Venuses and Floras—or mothers or whores, it is nevertheless true. When Denis Poulot, a manufacturer-turned-writer, asked in 1870: "What is [woman's] mission in society?" he was able to answer himself: "Only one great saintly mission: to be married and a mother." Another typical response came from Edmond de Goncourt, who asserted that "women shouldn't try to understand men, they should charm and please us, as would an agreeable animal."[60] Both men were expressing the same prejudices. There was no place in their social continuum for Degas' powerful female spectator. But the fact that he created her at all is important, for it indicates that she "existed."

If nineteenth-century sexual ideology was so insistent on the role of woman as mother or whore, it was already so because cracks had developed in its armor. These cracks took the shape of anxiety-inducing ambiguity. Ladies and "less-than-ladies" had begun to look more and more alike, as is indicated by the following dispute which takes place in Zola's *Ladies' Delight* between two department store salesmen.

"A tart? No, she looks much too genteel. . . . I should think she must be the wife of a stockbroker or a doctor, well, I don't know, something in that line."

"Oh go on! She's a tart. . . . It's impossible to tell nowadays, they all have the airs of refined ladies."[61]

A complex web of social phenomena produced this alteration in behavior and shifting of moral values. In part they were a result of the availability of inexpensive and attractive clothing (through manufacturing) to all women. In addition, women of different classes assimilated one another's gestures because of increased contact and shared cultural references. Partly, the change was the result of the embourgeoisement of culture in general, the attenuated product of the democracy set in motion by a century of revolution in France. This democratization was exactly what George Moore, the snobbish English artist, complained about when he wrote: "Universal uniformity is the future of the world, the duke, the jockey boy, and the artist are exactly alike; they are dressed by the same tailor, they dine at the same clubs, they swear the same oaths . . . they love the same women. Such a state of things is dreary enough, but what unimaginable dreariness there will be when there are neither rich nor poor, when all have been educated."[62] Although Moore was not referring to women specifically, this leveling, as he saw it, was unmistakably unpleasant.

This social ambiguity unnerved people at the track as well as elsewhere. Crafty observed that in the past, "certain people" were not allowed to enter the paddock, or weighing-in enclosure, but that "it is difficult now that women who are of this [elite racing] world and those who are not adopt the same style to enforce [exclusionary] instructions which would not make people angry." In the words of the modern historian Alain Corbin, "if the clandestine prostitute inspired such terror . . . it was because in appearances she was a woman or girl like any other, she mixed in all milieus and because of that she was seen to constitute a moral and sanitary contagion."[63]

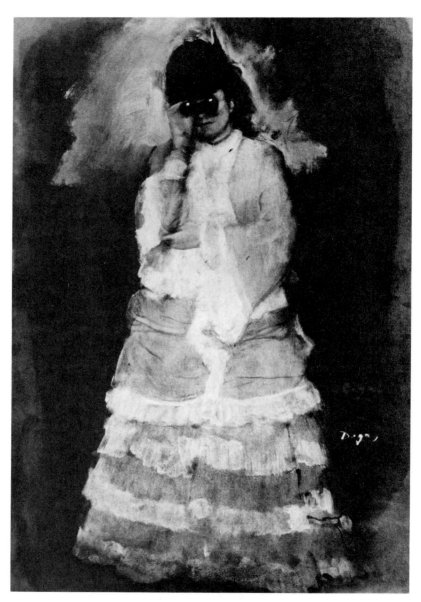

39. Degas. *Woman with a Lorgnette*. Ca. 1877.

Degas' woman with the binoculars could be taken as that fear embodied and exaggerated. One can speculate that he removed her from *At the Racetrack, Jockeys* both because

she was not yet a pervasive social reality and because she was potentially horrifying to bourgeois sensibility. Nonetheless, that she lingered in his mind is suggested by several small sketches depicting her alone (fig. 39).[64] In addition, there is a pencil drawing entitled *Edouard Manet at the Races* (ca. 1865, Metropolitan Museum of Art) which includes on the left a very lightly drawn woman with binoculars.

Given the extent to which Degas' classicizing racing paintings turn their back on social change, it is small wonder that women were evacuated from them. That they existed at all as a possible subject in the discontinuous-mode works seems equally understandable, however. Degas' two kinds of racing paintings demarcate significant social differences in late nineteenth-century France. Although they collude more with conservatism and privilege, avoiding risk and confusion, in a few cases they expose the raw nerves of modern life. If most of the works suggest pleasure in the privileged habits of the past, echoing the values of a ruling elite which, by the 1870s, had become an anachronism, in some the dialectic of modern social life pulls ever so slightly in another direction.

Once again, Lukács writing on Balzac comes to mind, this time in his essay on "The Peasants":

What makes Balzac a great man is the inexorable veracity with which he depicted reality even if that reality ran counter to his own personal opinions, hopes and wishes. Had he succeeded in deceiving himself, had he been able to take his own Utopian fantasies for facts, had he presented as reality what was merely his own wishful thinking, he would now be of interest to none and would be as deservedly forgotten as the innumerable legitimist pamphleteers.[65]

Degas' frieze-mode paintings, I believe, represent "wishful thinking." In these works, Degas' wit and pictorial inventiveness are missing. In order to picture what on some level

he knew to be an anachronism—social stasis—Degas es-
chewed what in most of his works was a critical response to
contemporary life. In none of his other genre paintings was
he so conservative. On the contrary, in those works the mod-
ern world tumbles in with all its contradictions.

# II
# AT
# THE BALLET
## THE
## DISINTEGRATION
## OF GLAMOR

Degas loved the ballet, as did many an artist of his time, and he painted it more than any other subject.[1] In his *catalogue raisonné* on Degas, Paul-André Lemoisne lists six hundred such works. Degas probably knew they would sell well, for it was no secret that ballet dancers were popular. Beautiful, talented, and sexually independent, they were undeniably the type of woman about whom fantasies were made. Furthermore, many of the same people frequented both the ballet and the racetrack and were possible buyers for images of both. Jockey Club members, for example, had the choicest boxes at the Opéra and were among the best-known "protectors" of the dancers.

In addition, much like the racetrack, dance in the 1870s had a memorable and elitist history but an unimpressive, increasingly prosaic present. It is generally accepted by dance historians that, as Ivor Guest has written, "in the last three decades of the 19th century . . . [ballet] had lost its vitality

and had sunk to the level of a minor form of entertainment." Boris Kochno, another dance critic, marveled that it was "during this epoch of decline that the ballet dancers found their painter [Degas]."[2]

With dance, then, as with the racetrack, Degas selected to paint a social event of past grandeur, one that had dwindled, by the time he started to paint it, to the merest semblance of its former self. There was, apparently, something in the tension between past, but still resonating power and its contemporary prosaicizing if not dismantling, that attracted him. Clearly, it attracted others as well, for he made a living from the ballet and racing paintings.[3] Both social phenomena provided brilliant prisms through which to see, dazzlingly and distinctly, molten aspects of contemporary social life. One might enjoy or be appalled by these events; Degas' ballet paintings responded both ways. But, as we shall see, they are much more consistently images of conflict than are the racing paintings.

Unlike dance today, which is an independent art form, ballet in the nineteenth century was performed almost exclusively as an accompaniment to opera. By the 1870s, ballet had become a variety of light musical entertainment. Some attribute the decline to the advent of toe shoes and the subsequent dwindling of men's roles, but probably more important was the disintegration of a discriminating audience. In any case the term "decline" refers to the art itself, not to its trappings—the glitter of Charles Garnier's Opéra, the building in which it was performed—nor the pretentiousness of much of its audience.

"Garnier's Palace," as the Opéra was called, was an impressive, if also ostentatious building (fig. 40). It combined on its exterior a mélange of classical structure with baroque ornamentation, not unlike the Arc du Carrousel (1806–1807) and the 1850s addition to the Louvre. The Opéra's interiors shimmered with gilt, glass, and mirrors. Staircases poured

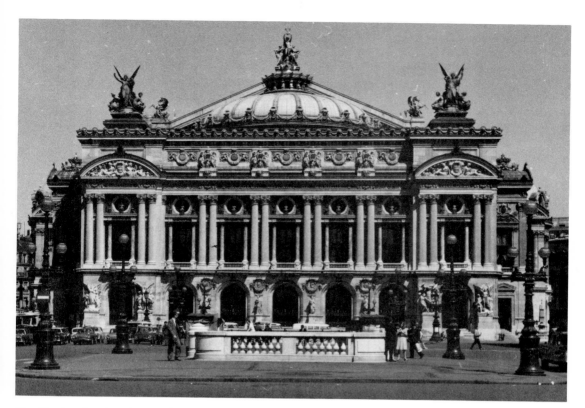

40. Charles Garnier. Opéra, facade. 1861–1875.

from one story down to the next. Putti, angels, gods, and muses rolled across ceilings and walls; plush burgundy velvet draped the stage and cushioned the seats. August Bournonville, the renowned nineteenth-century Danish choreographer, was amazed at this opulence and remarked that in the construction of the Opéra, "materials almost as costly as St. Peter's in Rome were used."[4]

Foyers, staircases, loggias, and boxes provided endless locations in which to be seen, emphasizing that display was a *raison d'être* of the building's existence (figs. 41, 42). The main staircase, for example, was a perfect foil for the fabled French fashions of the day. So too were the enormous gold-encrusted grand foyer (fig. 43) and the more private but still penetrable boxes in the auditorium—eminently penetrable to judge from the myriad illustrations and paintings that exist

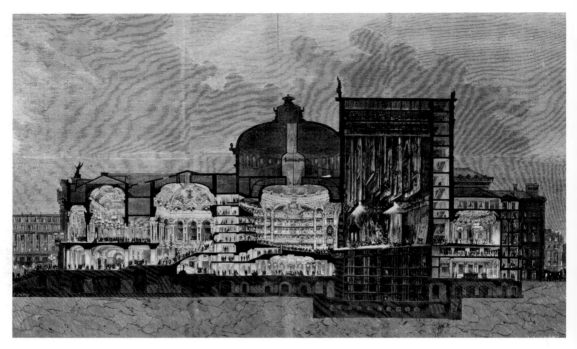

41. Garnier. Opéra, cross section.

of men peering through binoculars into those boxes. Works such as Renoir's *The Loge* (fig. 5) or Degas' *The Ballet from Robert le Diable* (1872, Metropolitan Museum of Art) come to mind. Even the stage was raked, or tipped forward, in order to show more than would otherwise have met the eye (see cross-section, fig. 41).[5] To create a surfeit of sensation everywhere was the building's intention.

Behind the stage was a glittering private room that recapitulated the public promenade of wealth and possession. This was the dance foyer (fig. 44), the place where dancers stretched, practiced, and chatted with lovers before, during, and after performances. According to Georges Montorgueil, a nineteenth-century journalist, this small, intimate room was frequented by *abonnés* (men who had seasonal tickets to the Opéra) "in black clothes and white ties . . . almost as they frequent certain other places of easier access." (Montorgueil was referring to brothels.)[6] Like the grand foyer, the dance foyer shimmered in gold and crystal and was decorated

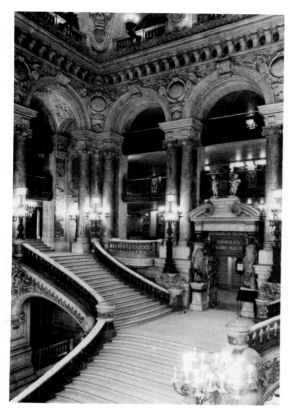

42. Garnier. Opéra, Grand Staircase.

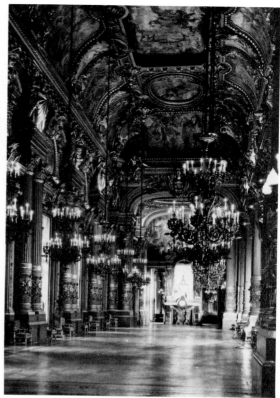

43. Garnier. Opéra, Grand Foyer.

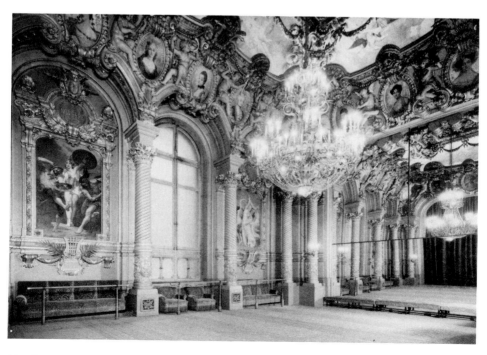

44. Garnier. Opéra, Dance Foyer.

45. Paul Baudry. Opéra, Grand Foyer, ceiling detail. 1872.

with flamboyant, melodramatic paintings. The one sobering note in the room was the raw wooden floor, which, like the stage, sloped, in this case downward to a mirror. These characteristics announced that the dance foyer was also a workplace. Indeed, had the floor been polished and flat, rather than untreated and raked, the room might simply have been an arena for flirtation.

The Opéra was an emblem of culture and wealth or, to be more exact, newly accrued bourgeois wealth. It was hoped that it would also be an emblem of power. Much of the contemporary response to the building was, in fact, nationalistic. One critic exclaimed over what he felt to be the recognizable French physiognomies of Paul Baudry's figures in

the grand foyer (fig. 45). Another enthused that Baudry's paintings were an "honor to our century and our country. . . . [The decorations are] a victory for France . . . a French masterpiece like this amidst all the mediocrity of European art will bring as much honor to us as a victory on the battlefield."[7]

Small wonder such words were used, considering France's ludicrous defeat in 1870, in six weeks, to Prussia. It had to be obvious at that point that the most industrialized country, in this instance Prussia, and not the most cultivated, France, as it considered itself, was the most powerful. Pride in the Opéra was just one of a number of efforts by which France tried to recoup its glory, part of its defensive attempt to picture itself at least as the modern Athens to Prussia's Sparta.

This was a vain and hollow effort, however, when the focus was dance. The refinement of the audience can be measured by that of the frequenters of the dance foyer. It "was reserved exclusively," writes a modern dance historian, "for the men who held the reins of fashion, and in particular for the members of the select Jockey Club, who occupied seven of the proscenium boxes . . . and who regarded the Opéra as a sort of fief."[8] By 1875, however, as we have seen, Jockey Club members were political anachronisms with little real power.

Everything related to the dance was for show, even the dancers. Their talent was less important than their looks, and everyone knew it. As one dancer put it: "What's the use of doing yourself so much harm, when you can please just as well with much less effort? If you haven't a good figure, you must use your talent, but if you are pretty and well formed, that makes up for everything." Another woman who had left the ballet put it more crudely: "As soon as she [a dancer] enters the Opéra her destiny as a whore is sealed; there she will be a high class whore."[9] The aura of the ballet dancer in

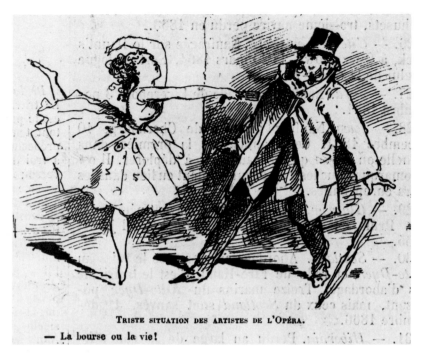

TRISTE SITUATION DES ARTISTES DE L'OPÉRA.

— La bourse ou la vie!

46. Anonymous. *Triste Situation des Artistes de l'Opéra.* [The Sad Situation of Dancers at the Opera.] 1874.

the 1870s and 1880s was very much like that of the movie star today. (She was perceived as sexy, lively, a little dangerous and, above all, public.) This image can be found in contemporary memoirs, newspaper illustrations like *The Sad Situation of Dancers at the Opera* and prints like *Riches and Love* (figs. 46, 47), picturesque literature, autobiography, and painting. In Léon Comerre's *A Star,* for example, the dancer brazenly confronts the spectator, tutu fanning out about her, hands on hips, legs provocatively crossed (fig. 48). Another dancer—*La Zucchi* (1883, Bibliothèque, Opéra, Paris), painted by Georges Clairin, one of the decorators of the Opéra—poses with one hand on her hip and the other on the flats behind her, with a somewhat disheveled still life nearby. In *Backstage at the Opera,* Jean Béraud, Degas' friend, painted the casual flirtatiousness of *abonnés* and dancers as

47. Anonymous. *Une Fortune et un Coeur.*
[Riches and Love.] 1856.

48. Léon Comerre. *A Star.* 1882.

49. Jean Béraud. *Backstage at the Opera.* 1889.

well as the easy proprietariness of the top-hatted, tail-coated men (fig. 49). Sex, pleasure, and power are all subjects in these paintings.

The public knew that the dance foyer was the milieu in which the dancers' sentimental life unfolded. Public aware-ness of the room can be gauged by its appearance on the January 30, 1875, cover of *Le Monde Illustré,* just three weeks after Garnier's building opened (fig. 50). The image was drawn by Edmond Morin, one of a number of artists who depicted contemporary life among the rich, known as *la vie élégante.* The subject is the casual flirtation of the foyer about which Degas' friend Ludovic Halévy wrote in his notebook in 1863: "all around us coming and going were the twenty-five pretty girls of the *corps de ballet.* . . . 'This,' M. Auber said to me, 'is the only room that I love. Pretty heads, pretty shoulders, pretty legs, as much as one could wish for. More than one could wish for.'"[10]

# LE MONDE ILLUSTRÉ

## JOURNAL HEBDOMADAIRE

**ABONNEMENTS POUR PARIS ET LES DÉPARTEMENTS**
Un an, 24 fr.; — Six mois, 13 fr.; — Trois mois, 7 fr.; — Un numéro, 50 c.
Le volume semestriel, 12 fr., broché. — 17 fr., relié et doré sur tranche.
LA COLLECTION DES 18 ANNÉES FORME 36 VOLUMES.

*Directeur*, M. PAUL DALLOZ.

**BUREAUX**
**13, QUAI VOLTAIRE**
**19ᵉ Année. Nᵒ 929 — 30 Janv. 1875**

**DIRECTION ET ADMINISTRATION, 13, QUAI VOLTAIRE**
Toute demande d'abonnement non accompagnée d'un bon sur Paris ou sur la poste, toute demande de numéro à laquelle ne sera pas joint le montant en timbres-poste, seront considérées comme non avenues. — On ne répond pas des manuscrits envoyés.

*Administrateur*, M. BOURDILLIAT. — *Secrétaire*, M. E. HUBERT.

LE NOUVEL OPÉRA — FOYER DE LA DANSE

Dessin de MM. Scott et Morin. — (Voir les nᵒˢ 926, 927 et 928.)

50. Edmond Morin. *Le Nouvel Opéra—Foyer de la Danse*. 1875.

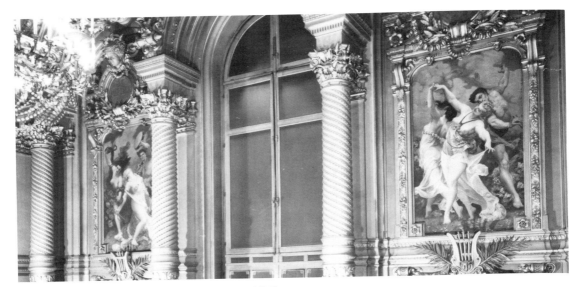

51. Gustave Boulanger. *La Danse Bacchique*. 1875.

Garnier himself remarked that the foyer "receives min-
isters, ambassadors, *abonnés* and some journalists," and "is
meant above all to serve the swarm of ballerinas coquettishly
and picturesquely costumed." He recommended judging the
room only when the dancers were in it, for, he said, "there
is a real harmony between the walls of the foyer and the
dancers."[11] This was quite a revealing statement, for the walls
are covered with paintings of voluptuous, bombastically ges-
turing women participating in allegorical dances of war, rural
life, revelry, and love (fig. 51).

Although they in no way resemble Degas' paintings of
ballet dancers, these decorations do invite comparison, in part
because they were painted by Gustave Boulanger in 1874,
the very year that Degas exhibited his images of dancers for
the first time.[12] The most striking difference between Degas'
*Dancer Leaving Her Dressing Room* and Boulanger's *La Danse
Bacchique,* (figs. 51, 52) for example, is probably the overtly
sexual nature of Boulanger's "dancer" compared with the
asexuality of Degas'. The inviting sexuality of the former is

52. Degas. *Dancer Leaving Her Dressing Room*. Ca. 1881.

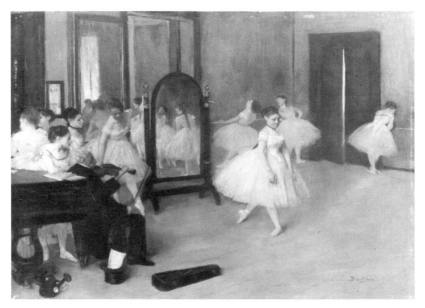

53. Degas. *The Dancing Class*. Ca. 1872.

created not merely by her partial nudity but by her throwing herself forward in space as if into the viewer's imagination. The sexual neutrality of Degas' dancer is assured not only by her dress but also by her awkward hesitation between her own space—her dressing room—and ours, the other side of the threshold. The aloofness, the sense of remove, of Degas' dancer is enhanced by the diagonal boundary of the foreground, which pushes her out of our imagined grasp. Boulanger's figure, on the other hand, is located parallel to our space. In addition, the theatricality of gesture in the Boulanger work is countered by the awkward self-containment of the Degas. Boulanger's dancer, and painting, invite and flirt with the spectator; Degas' does not seem to care.

What could Degas' awkwardly exiting *Dancer Leaving Her Dressing Room* or the studious atmosphere of his *The Dancing Class* (fig. 53) have to do with Boulanger's "dancers" or, for that matter, with the entire ballet world we have been considering? Degas was a habitué of Garnier's building.[13] He

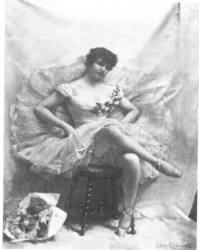

48. *A Star.*    54. Degas. *The Star.* 1875.

climbed its stairs, chatted in its foyers, listened and watched from its auditorium and boxes. He also drank in its bars, wandered through its corridors, caught glimpses of it all in its mirrors. What, then, was the relationship between his paintings and the Opéra and the world of glitter and commerce it represented?

Let's consider Degas' *The Star* of 1875 with Comerre's *A Star* of 1882 (figs. 54, 48). Obviously, there is the difference in the setting: Degas' painting depicts an event on stage, Comerre's dancer is posed backstage. In addition, the latter's painting offers a familiar and comforting space in which the

dancer perches almost as if she were on a shelf. In Degas' painting, in contrast, the spectator hovers dizzyingly above the scene, and the dancer is bizarrely splayed out below. Comerre's ballerina is rooted foresquare in place as she brazenly challenges the spectator. Degas' woman, precarious and fleeting, eludes us. What, simply put, of the sexual allure in Comerre's work in contrast to its apparent absence in Degas'? Display, bombast, and flirtation become in Degas' image, discretion, understatement, and sexual neutrality.

The contrasts deepen if we consider other aspects of the Opéra's world. In addition to sexual allure, exhibitionism, and acknowledged male proprietariness, two other less obvious but nonetheless important aspects of the dancers' lives are frequently noted in contemporary references: their alleged low parentage and their reputed childhood poverty. Nestor Roqueplan, onetime director of the Opéra, claimed that the dancers were "almost always from the working class, and with rare exception, of unknown father." The dancer Berthe Bernay presents her childhood in the early 1860s in these words:

My parents, who were not well off, lived at Belleville [a working-class district in the east end of Paris]. . . . Nearly all my little companions . . . lived, like me . . . in the same sort of district. . . . Winter and summer, my mother used to wake me up at half past seven in the morning to go to work. . . . Needless to say, omnibus fares were beyond my small means, and I had to walk. . . . I used to have lunch in the Rue Richer with my mother off the modest ration we had brought. . . . Finally, when the performance had finished at midnight, I set out for home.

The last line of Degas' own sonnet "Little Dancer" reads: "She remembers her race, her descent from the street."[14]

What we have, then, is an image of the dancer as an attractive, sexually available woman who has risen from poverty and questionable parentage. So far, a sense of her work

is completely missing. Search as one will, the dance literature and contemporary memoirs do not provide information about the strain (or pleasure) of the dance for the performer. However poor its quality in the 1860s, 1870s, and 1880s, ballet still required hours and hours of tortuous practice. Thus, despite the paucity of written evidence, one believes the comte de Maugny, who wrote in 1889:

The life of a dancer was in fact far less wild than was commonly supposed. Classes, rehearsals and performances took up most of their days and evenings. Thus gallantry could only be a secondary pastime, and in most cases, necessarily took a reasonable form. . . . The ballerina is fated to be the steadiest and most tranquil of the *demimondaines*.[15]

The "myths" about ballerinas' parentage and poverty are similarly questionable. The family backgrounds of the dancers working in France were roughly of two kinds. Some had fathers in the military, and others had at least one parent in the theater. For instance, Eugénie Schlosser was the daughter of a drummer in the national guard; Fanny Cerrito's father was a second lieutenant in the army; and Amina Boschetti was a daughter of a general in the Austrian army. Carlotta Grisi came from a theatrical family; Fanny Elssler's father was a musician and copyist for Haydn; Marie Taglioni came from a ballet family; Emma Livry's mother was a dancer; and the father of Blanche and Suzanne Mante was a professional violin and bass player as well as a photographer.[16]

Concerning the dancers' finances, simple deductions from contemporary social data tell us that they could not possibly have been poor. Although it was commonplace for a child to be trained or apprenticed for a short period with no salary, no impoverished nineteenth-century French family could afford to have both a mother and a child who brought home no money. Since mothers usually attended their daugh-

ters during classes and rehearsals and backstage during performances, a case cannot be made for dancers having been poor. Furthermore, although the pay schedule for dancers was low through the mid-teens, it was substantial after the initial apprentice years.

From the age of seven to ten, a dancer earned two francs a day if she was in a performance (one franc in Paris in 1870 bought about one pound of meat; one and a half francs, a dozen eggs or a little less than a pound of butter).[17] According to the dancer Bernay, in 1869 a performer in the second quadrille (at approximately age thirteen) could earn six hundred francs a year and, after passing an examination, seven to nine hundred a year. This was approximately what ironers and seamstresses earned. When the dancer entered the first quadrille (in her mid-teens), her income went to eleven hundred francs, and as leader of the corps de ballet she could earn twelve hundred.[18] In the late 1870s and 1880s, when she was less than thirty years old, Bernay's salary went from fifteen hundred up to sixty-eight hundred francs! Georges Duveau, the French labor historian, gives the following information on what working children earned during the Second Empire for between ten and fifteen hours work a day:

[Their salaries] oscillated between 50 centimes and 2 francs [a day, or between 121 and 486 francs a year]. In the coalfields of the North . . . children who went down into the tunnels earned from 50 to 80 centimes. . . . In Sedan, in the textile industry, a child earned 75 centimes. . . . In Limoges, in the porcelain works, he earned 60 centimes, in Creusot, in metallurgy, from 1.50 francs to 2 francs. In Paris, in the clothing house of Dusautoy, a child earned from 1 to 2 francs.[19]

Because the children described here neither derived pleasure from their grueling work nor had any future to dream about, the young dancers' lives were incomparably richer.

What these statistics indicate is that the public commen-

tary on dancers distorted crucial details and circumstances of their lives: the nature of their work, facts about their birth, and facts about their finances. Two prejudices, I believe, produced this commentary. The sexualization of their profession resulted from their being women on display; the emphasis on poverty and low parentage derived from the notion of the dancer as artist. At first this might seem contradictory, for an emphasis on her sexuality and frivolity would seem to preclude a view of the dancer as an artist. Yet the image of poverty and mysterious or low parentage, or even the illusion that the dancer did not really work, dovetailed with contemporary attitudes about artists—their charm and ease, but particularly their conquering of harsh material odds. The Impressionists, for example, have consistently been depicted in this light, whereas even the most superficial search produces evidence of their middle-class backgrounds and lifestyles.[20]

Unfortunately, because of contemporary inability to see the reality of the dancers' working lives, it is difficult to find information on them as workers. No labor or health reports exist for them, for example, whereas one has such documents for laundresses, milliners, embroiderers, prostitutes, and other working-class women. One is left with few material facts about the dancers' lives and an abundance, by comparison, of picturesque fantasy. Nevertheless, from the sparse data we have, we can see that dancers were essentially lower middle class and earned more than a decent wage. They worked hard and may have been among the most independent women of their times. Yet, although most prints, paintings, and memoirs of the time ignore this information, Degas' paintings of dancers do not. What is so interesting and important about his works is that they are deeply ambiguous; they both do and do not adhere to prevailing prejudices; they both support and subvert the commonly held stereotypes of the ballet dancer and her life.

55. Degas. *Dancer from the Corps de Ballet*. Ca. 1876 or 1896.

Contemporary critics of Degas' work showed their awareness of the stereotypes. In 1877 a writer calling himself A.P. in *Le Petit Parisien* described Degas' ballerinas as "vice-ridden." Paul Mantz in 1881 found the sculpture *Fourteen Year Old Dancer* to be "almost frightening . . . a flower of precocious depravity . . . fathers are heard exclaiming: Heaven protect my daughter from this! . . . [This is] a schoolgirl destined to become a woman whom diplomats will wildly entreat." Jules Claretie in the same year commented on "the seductive peculiarities" of the dance world which Degas painted.[21] However negative these comments may seem, they

also indicate the writers' tacit assumption of the titillating aspect of the subject.

Degas' letters bespeak his own familiarity with the sexual allure of the dancers. Writing to his friend the basoonist Désiré Dihau in 1872, he commented on the "roguish air" of one of the dancers and regretted "very much not being quite introduced."[22] But the most telling indication that he shared his contemporaries' assumptions and stereotypes concerning the dancers' sexuality is a photograph that he made, probably before 1876.[23] It is a studio work in which a dancer is posed in front of a drop cloth (fig. 55). Her legs have vanished, as has most of her face. The focus of attention is her upper torso. Her neck, shoulders, arms, and breasts are delicately and provocatively presented. And as her flimsy camisole slips from her shoulder, we glimpse what seems to be the aureole around her nipple. If she were simply naked, we would be looking at a studio nude; it is the contrast between dress and undress that makes the image titillating.

This conception of the dancer, one that acknowledges her sexual being, appears in Degas' paintings as well, but more covertly. The most obvious signs are the women's lovers. They are the tailcoated, top-hatted men in *The Star, The Ballet Rehearsal, The Curtain* (figs. 54, 56, 57), a fan

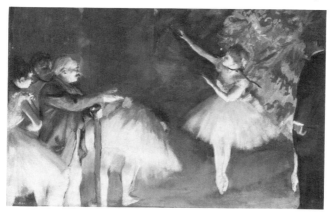

56. Degas. *The Ballet Rehearsal.* 1875.

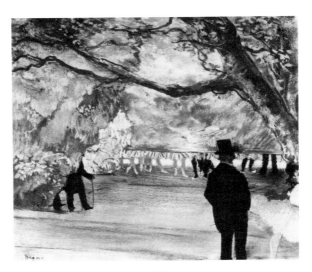

57. Degas. *The Curtain*. 1881.

entitled *Dancers* (ca. 1879 Durand-Ruel Collection, Paris), and, most obviously, the *Cardinal Family* monotypes (ca. 1880).[24] But Degas presents the persona of the alluring dancer in ways that suggest not only her sexual availability but her relationship, conceptually, to the Opéra—a world of display and possession. It is the specific pictorial and narrative devices he uses in these works that evoke this relationship—the ways in which he "gives" or "shows" the women to us, the spectators.

Scholars have often used the word "voyeurism" to describe Degas' vision. They have made little of this concept, however, interpreting it almost as a physical point of view rather like Monet's location in Nadar's studio when he painted *Boulevard des Capucines* (1873, William Rockhill Nelson Gallery of Art and Atkins Museum of Fine Arts, Kansas City).[25] What needs to be considered instead are the conceptual implications of Degas' voyeurism. For what he did consistently was to take intrinsically private moments and make them public. Traditionally, this has been dismissed as "civilized" lechery, peering through keyholes at naked women.

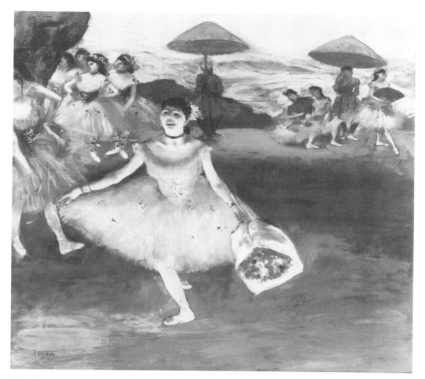

58. Degas. *Curtain Call*. Ca. 1877.

But what was Degas inviting his public to see? First of all, his paintings are rarely of performances. Rather, they depict scenes in classrooms, backstage, or on stage during rehearsal. And even when they are of performances, prominent parts of the paintings reveal views behind the flats that a spectator would not actually be able to see if he or she were in the audience. In *Curtain Call,* (fig. 58), for example, the far right part of the painting (in which the dancers are in position, if casually) shows what would be seen if one were sitting in the auditorium.[26] To the left, however, a whole other scene takes place as if the dancers were on a revolving stage and readying themselves for the next act. We would not be able to see them if we were in the audience, for they are involved in a "backstage" or private moment. In *The Dancer in Green*

59. Degas. *The Dancer in Green.* Ca. 1879.

(fig. 59, also see color plates), the sharp diagonal motion and tangle of limbs rivet our attention, but almost immediately the green dancer's left hand (which humorously or aggressively blots out another dancer's face) leads our eyes into the background. There, a group of dancers seems to be relaxing nonchalantly. Again we are given both public *and* private backstage details.[27]

In Degas' paintings that are not of performances, the disclosure and detailed scrutiny of private moments are phe-

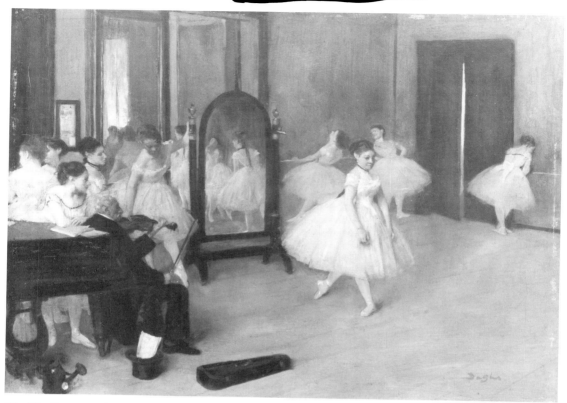

53. *The Dancing Class.*

nomenal. One critic in 1877 put it succinctly: "For those who are partial to the mysteries of the theater, who would happily sneak behind the sets to enjoy a spectacle forbidden to outsiders, I recommend the watercolors of Mr. Degas. No one has so closely scrutinized that interior above whose door is written 'the public is not permitted here.'"[28] In *The Dancing Class* (fig. 53), for example the girl at the center right practices a step; others to the right are stretching; two dancers to the left of the violinist thoughtfully watch the dancer practicing. Both groups represent an unselfconscious absorption, and are oblivious to any observer; indeed, both would be stunned to know they were being looked at. The woman to the left of the mirror is likewise privately absorbed, and those at the rear left are involved in a distinctly private exchange. Sim-

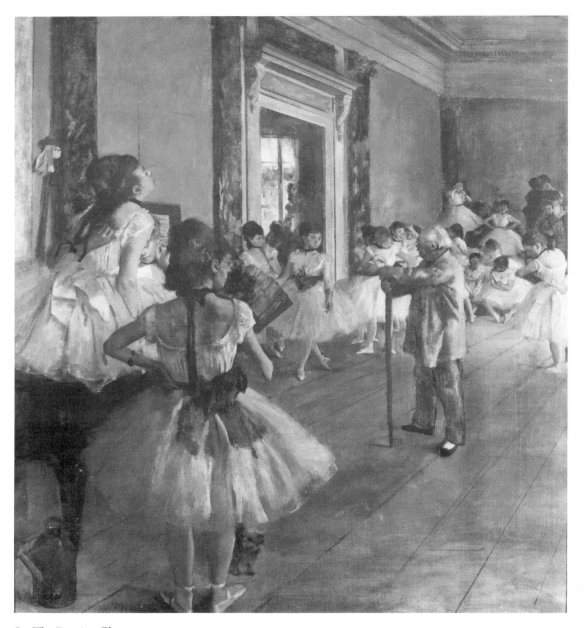

9. *The Dancing Class.*

ilarly, in the Musée d'Orsay's *The Dancing Class* (fig. 9), one
dancer performs for Jules Perrot, the teacher; another to the
right seems to be adjusting her bodice, while between her
and Perrot two dancers sit chatting like chums in a café; at

the back of the painting, two dancers and their mothers are straightening out costumes. Finally, to the far left, a woman indecorously scratches her back.

By disclosing these private moments and myriad others, Degas gave the spectator access to a world that was beyond his reach, the world accessible only to men of privilege—the *abonnés* or, in Degas' case, the well-connected artist.[29] To see what others could not see was to have power. In other words, Degas' acts of disclosure in these paintings, the "look" that he gave to the spectator, permits the latter to share that power. Degas essentially was titillating his bourgeois audience by showing it a world to which its members did not have access but which they yearned to possess.

The relationship between seeing and power in Degas' ballet paintings can be extended by observing the small format and delicacy of what is perhaps his first complete ballet work, the Metropolitan Museum's *The Dancing Class* (fig. 53).[30] Even if one had only a passing acquaintance with Degas' work, one would nonetheless be struck by the size and precision of this painting, which measures only 10⅝ by 17¾ inches. Its detail, brushstrokes, and composition invite close scrutiny; it should be held in one's lap. In a word, the painting induces a private rapport with the viewer.[31] The small size, the refined execution, and the nature of the subject matter suggest a relationship between this work and depictions of *la vie élégante* by artists such as Lami, Morin, Guys, and Gavarni.[32]

These artists, who worked between the 1830s and the 1860s, depicted in watercolor and small format scenes of parks, cafés, the racetrack, the Opéra. Their patrons were aristocrats such as the duc d'Aumale (the proprietor of the magnificent estate at Chantilly where one of the most elegant racetracks in France was located), the comte du Murinais, and the Goncourts. In 1837, for example, Lami made a watercolor of the dance foyer (fig. 60). In it, tapering, wispy

60. Eugène Lami. *Foyer de la Danse*. 1837.

figures skid and whirl across the floor as dancers and their
suitors seem to assault the very act of flirtation. Another
example is Gavarni's lithograph *In the Wings* (ca. 1850), which
describes a more sedate, even prosaic exchange backstage
between an elegantly top-hatted gentleman and a quite robust
ballerina.[33] Admittedly, Degas' works are always more sober
and bourgeois than Lami's, Gavarni's, or Morin's, but their
aristocratic roots are visible. In fact, a savvy spectator could
probably have "tasted" the privilege of *la vie élégante* in the
Metropolitan Museum's *The Dancing Class*. Although Degas
went to a large format in his ballet paintings soon after, I
suggest that for some spectators, traces of the privileged,
gentlemanly life—a life of at least remembered social
power—lingered and reverberated in the later, larger works
as well.

Another way in which the ballet paintings might induce
a sense of power in spectators is the dancers' homeliness. It
is a commonplace assumption that ugliness and poverty are
partners. Whether one thinks of Le Nain's peasants, van
Gogh's *Potato Eaters* (1885, Rijksmuseum Vincent van Gogh,
Amsterdam) or the catalog of characters in Hugo's *Les Mis-
érables* (1862), poverty and ugliness are confounded. And

although Daumier ruthlessly caricatured the middle classes, his depictions of the poor almost always assume their facial and bodily flaccidity and coarseness. In addition, if one looks at such middle-class weeklies as *Paris Illustré, Le Journal Amusant,* and *Le Monde Illustré,* the poor are presented as either ugly or, in the case of markedly moral young women, pure and innocent. Middle-class figures are always attractive, even if they behave foolishly. For example, one can watch the physical transformation of a lower-class woman worker in the pages of *Le Journal Amusant* from March 2, 1867 (figs. 69–75). In the beginning she is pure and pretty in a world of ugly and unsavory characters. As she climbs the social ladder (through prostitution), she becomes elegant and sophisticated. When she (inevitably?) topples back into poverty, she simultaneously becomes ugly. Louis Chevalier, who has analyzed in depth the notion of ugliness as characteristic of the poor, has found that in ancien régime literature, descriptions exist of the poor as "flabby, pale, short, stunted." Balzac describes Parisian workers as "a people of ghastly mien, gaunt, sallow, weather-beaten . . . exhumed people . . . [of] hellish complexion . . . [and with] contorted, twisted faces." Although the image of workers changed after the June Revolution of 1848 and they became almost beautiful, and certainly robust and sturdy, for many middle-class observers ugliness lingered, perhaps was clung to, as an insignia of poverty.[34]

Without associating poverty specifically with ugliness, one critic after another remarked upon the ugliness of Degas' dancers. In 1880 Charles Ephrussi, art critic and owner of the *Gazette des Beaux-Arts,* wrote: "[Degas] chooses a type of skinny dancer with uncertain shape, disagreeable and even repulsive features . . . the painter remains distinguished in his evocation of the figures' ugliness." Albert Wolff admired Degas' drawing in an 1881 article in *Le Figaro,* but said that "the ballerinas . . . are still purposely shown as horrible and

ugly!" Paul Mantz commented on how, "tired, she [the ballet dancer] arches her back and stretches her arms behind her. Terrible, because she is without thoughts, her face—or rather her chin—points forward with an animal impertinence. . . . Why is she so ugly?" And Huysmans wrote in 1880: "Another one of his paintings is lugubrious. In an immense room in which exercise takes place, a woman rests, her jaw in her fists, an image of imbecility and fatigue."[35] Depicting dancers as ugly was double-edged, however. It allowed Degas' audience to condescend to the women as lower class and maintained the myth of their poverty. But it also admitted, through the association of ugliness with poverty, that these were in fact working women and not merely decorative objects.

We have just seen the extent to which Degas' images supported prevailing prejudices, thus making his work eminently salable. Yet there are equally numerous and perhaps more compelling ways in which these pictures subverted contemporary values. Again, we must examine Degas' display of inherently private moments. The mundane details of a dancer's workday could only have been recorded by a person who had privileged access to an exclusive world. But what happened when this privilege was "given" to the spectator? On one level the latter may well have reveled in this entrée and identified with its associated power. On another level, however, he participated in something completely different. For in these private moments he saw events that emphasized the dancer as a working person, absorbed in her own activity, in the midst of a community of other women like herself. Thus, a demystification of the dancer as an object of display and desire took place.

Degas' works accomplish this demystification in a number of ways. One is through their extremely revealing social observations. His paintings tacitly assume, for example, that the women are actively involved in a communal effort, which

61. Degas. *Waiting*. Ca. 1882.

sometimes requires group participation but more often simply provides an ambience of shared work. Although in the history of art there are innumerable instances of women together, what they are usually doing is attending to each others' toilettes or taking care of children. Degas' attention here to a work reality that generally went unnoticed in his society is remarkable. Another important aspect of the work environment that Degas noted is the presence of the dancers' mothers. In *Waiting* (fig. 61) and the *Mante Family* (ca. 1887, Rogers Collection, New York), mothers share the tension and anxiety of waiting and preparation. In the Musée d'Orsay's *The Dancing Class,* (fig. 9) the women watch, chat, or put finishing touches on makeup and costumes. In *Mme.*

*Cardinal Backstage* (monotype, ca. 1880), a mother monitors her daughter's love life.

Although other observers of events at the Opéra remarked on the mothers backstage, their comments tended to be humorous, or even a little nasty. When Ludovic Halévy describes the *mamans* during examinations, he paints a comic frenzy:

> Moving hither and thither about the stage, in a state of nervous agitation, are the *coryphées* and the members of the quadrilles, all in short white skirts, with large coloured sashes tied in small bows behind them. Then, all around, restless, bewildered, breathless and purple-faced, are mothers, mothers, and yet more mothers—more, I am sure, than there are dancers![36]

The comte de Maugny stresses the mothers' roles as guardians of their daughters' virtue:

> Epic scenes took place there [backstage]. I have seen damsels departing triumphantly on an admirer's arm after a good quarter of an hour's parley with *maman*. I have seen some disappear surreptitiously behind their duenna's back, leaving her prey to an epileptic agitation; and others carrying on brazenly beneath their very nose and receiving a volley of blows that would have frightened a street porter.[37]

By comparison, Degas' depictions are more serious and respectful. They exude an aura of matter-of-factness with regard to the mothers, who are simply caught up in the overall atmosphere of work.

Another striking way in which Degas' compositions curb the appetite for display which is so dynamic a part of the ballet-dancer stereotype is through his use of mirrors. Whereas in Western art in general, mirrors reflect women looking at themselves, Degas' almost never do. What one sees instead are reflections of dancers working. Frequently one also sees views of Paris in windows reflected in the mir-

62. Degas. *The Rehearsal*. 1879.

rors (figs. 53, 65). Bringing the city into the room in this way also prosaicized the dancers and dramatically distinguished their real and ordinary routines from their much advertised sexuality.

In one particular instance, Degas' close attention to details of work and mundane realities may have served to trick art historians in a rather amusing way. The steep diagonals of the floor planes in paintings like the Musée d'Orsay's *The Dancing Class, The Dancer in Green,* and *The Rehearsal* (figs. 9, 59, 62) have traditionally been identified as a strictly formal device and associated with Degas' interest in Japanese art. Although this interpretation is viable, it omits the fact that the floors of both the stage and dance foyer *did* incline, as we

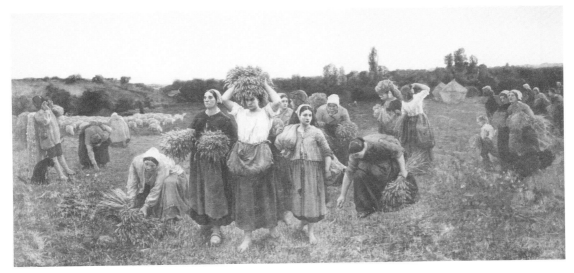

63. Jules Breton. *Recall of the Gleaners*. 1858.

have seen, and that Degas probably found just the right formal device—the dramatic diagonal—to fit an observation of physical reality, or at least the memory of that reality which lingered in the minds of dancers and observers.

One of the most persuasive ways in which Degas communicated an atmosphere of work in these paintings, however, is through his drawing technique, the way in which he defines forms in his paintings. Although many French nineteenth-century depictions of work exist, most artists edged real labor out of their paintings entirely by means of their drawing styles. In his *Recall of the Gleaners* (fig. 63), for example, Jules Breton crisply outlined the women who appear to glide gracefully through a field. Their harmonious and measured steps, their manicured clarity, their well-behaved, almost lyrical demeanor belie the drudgery of their work. Similarly, through the classical simplification of his drawing technique, François Bonvin depicted serene contemplation, not labor, in his *Woman Ironing* (1858, Philadelphia Museum of Art).[38] Millet did the same in his *Gleaners* (1857,

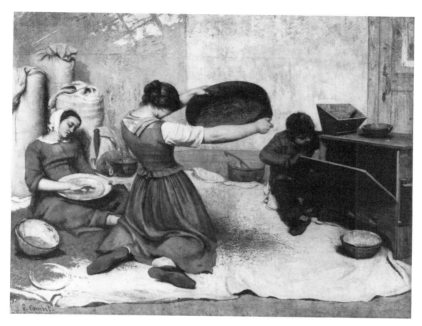

64. Gustave Courbet. *Women Sifting Corn.* 1853–1854.

Louvre); his drawing is far more indebted to classical harmonies than to a knowledge of aching backs.[39] Therefore, although the subject of peasants laboring was a provocative one for a bourgeois Parisian audience, idealization made these paintings palatable and purchasable. A discomforting subject was successfully neutralized.[40]

In a painting such as Courbet's *Women Sifting Corn* (fig. 64), however, academic idealization has vanished. The figures are awkward; there is no sense of classical unity. Each person is absorbed in his or her own activity, be it sifting, musing, or scavenging. Drawing, figure types, and narrative disjunction have produced a painting in which traditionally maintained relationships or social spheres break apart and in which, in this case, labor enters the sanctum of art.

Degas' works, in a very different style, do the same thing. He loved to draw and did it brilliantly. One knows, one can observe, how much he admired Ingres. But we have

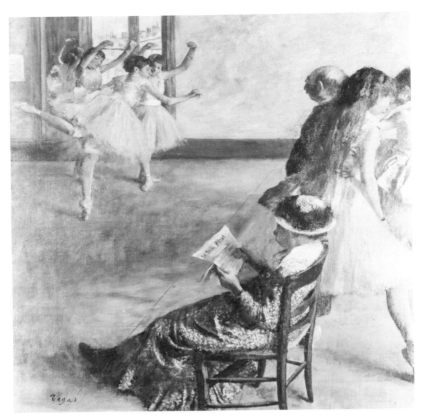

65. Degas. *The Ballet Class*. Ca. 1878–1880.

noted that he also admired and avidly collected Gavarni and Daumier.[41] In a work like *The Ballet Class* (fig. 65, also see color plates), the imprints of both Ingres and caricature are evident. The former's linear precision and sharp edges can be seen in the seated foreground figure as well as the dancer in the left corner practicing an open arabesque. But the gestural shorthand and exaggeration of caricature are obvious in the enormous size of the dancer to the right, the relaxed, expressive slouch of the seated figure, and the concentrated gaze of the teacher. In such a work, classical unity vanishes as distinct and not necessarily sequential moments in time collapse into one. Other classical qualities such as harmony, repose, grace, and statuesque monumentality dwindle as the immediacy, awkwardness, and tension of the working moment come to the fore.

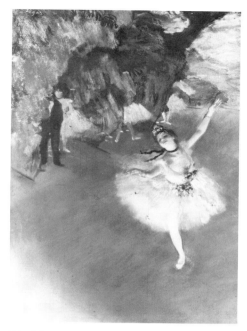

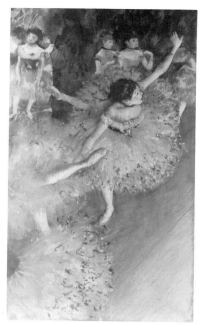

54. *The Star.*              59. *The Dancer in Green.*

In one ballet painting after another, Degas decorously, even elegantly, expressed the indecorous through his drawing. In *Rehearsal* (fig. 62) a precise, fine Ingresque line locates the dancers in space and evinces their corporeality. But this convention is nearly sabotaged by the compressed violinist stuffed into the left corner, the fragments of limbs afloat at the right, and the caricature-like reduction of the dancers' facial features. Similarly, in a work like *The Star* (fig. 54), caricature-like elements are clear: one of the dancer's legs is missing; she "touches" some flats far behind her; she is fairly "assaulted" by the disembodied legs of dancers backstage. These reductions, compressions, jokes, could not be further from a tradition of classicism, yet the drawing of the dancer herself is exquisite and the obvious product of classical training.

One of the most vivid examples of the movement and tension of the work milieu in Degas' ballet paintings is his *The Dancer in Green* (fig. 59). The performers slide down a precipitous incline, arms and legs flying. The adjectives so

often used by contemporary critics of Degas to describe his work seem particularly relevant here: "nervous," "twisting," "awkward," "lugubrious." In his ballet paintings, Degas did what the poet Paul Claudel ascribed to Baudelaire: he "combined the style of Racine with the style of a journalist of the Second Empire";[42] classicism and realism, together subverted the notion of the dancer as frivolous and charming.

Equally subversive is the commentary on male authority in these paintings. First of all, the teachers. Jules Perrot, the renowned former dancer and instructor shown in the Musée d'Orsay's *The Dancing Class* (fig. 9), is an imperious figure, solidly rooted in place with the help of his stick. However, the complexity of the composition, especially the enormous size of the two dancers at the left and the intense oblique angle of the floor, turn him into a mere marker in the floor's path. The teacher, probably Eugène Coralli, in *The Ballet Class* (fig. 65) is only the weaker half of a double-headed form of which the largest part is an oversized dancer.[43] But perhaps the most humorous and charming of these depictions is the *Rehearsal in the Dance Foyer* (fig. 66). The teacher, a dark, Rorschach-like silhouette to the left, demonstrates a step. The dancers twirl across the canvas, leaning this way and that, one volatile silhouette joining up with another. The teacher's authority is subsumed by this design; no hierarchy of power is asserted here. In Vincente Palmaroli's *The Dancing School* (fig. 67) the teacher is represented quite differently. Foreground, middle ground, and background are clearly defined, and the erect, darkly clad teacher dominates the scene. He virtually looms up against the light background of delicately clad dancers. Not only does Degas' painting question authority in the form of a male teacher but also rejects the norms of an artistic style based upon perspective and verisimilitude.

The *abonnés* dressed in formal black garb and top hats present in these paintings are enigmatic personages. In *The*

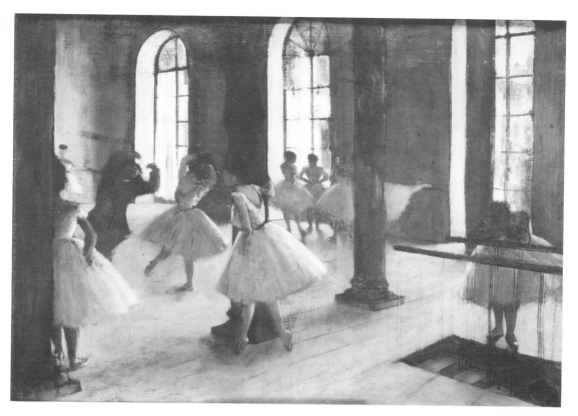

66. Degas. *Rehearsal in the Dance Foyer.* 1875.

67. [After] Vicente Palmaroli. *The Dancing School.*

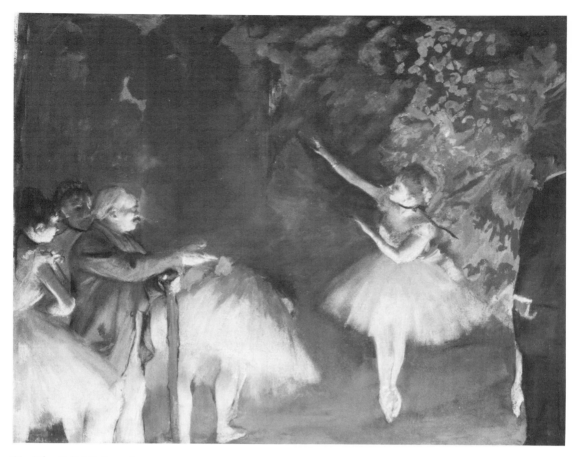

56. *The Ballet Rehearsal.*

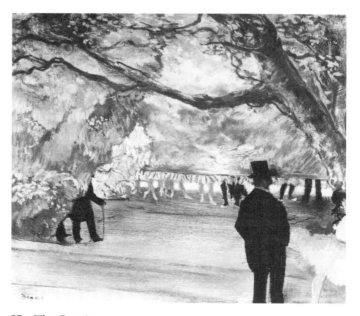

57. *The Curtain.*

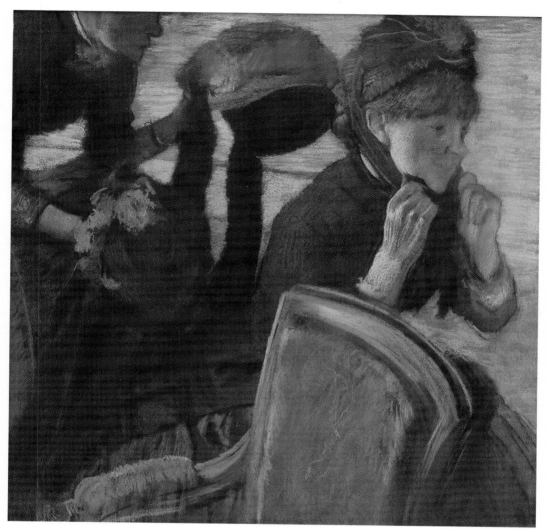

I Degas. *At the Milliner's.* (fig. 8).

COLOR PLATES

*(Note: Numbers in parentheses indicate sequence of
black and white illustrations)*

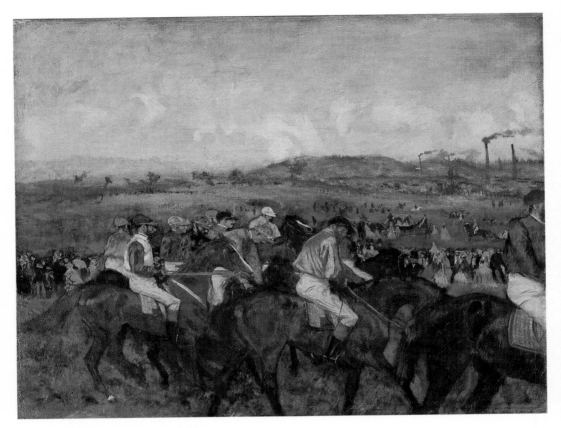

II Degas. *Before the Meet.* (fig. 10).

III Degas. *The Dancer in Green.* (fig. 59).

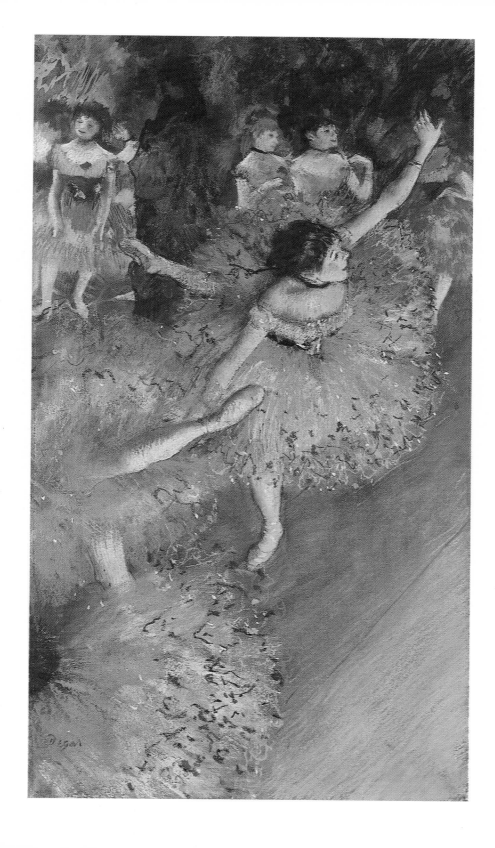

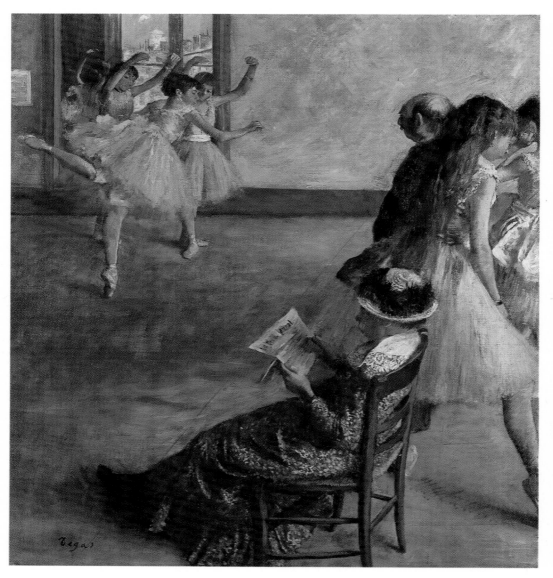

IV Degas. *The Ballet Class.* (fig. 65).

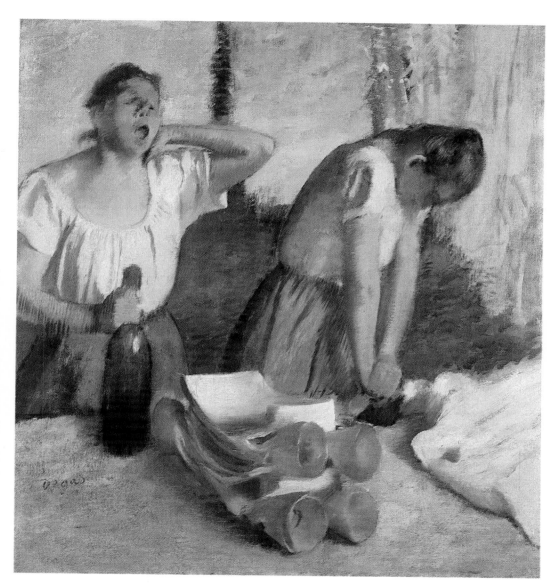

V Degas. *The Ironers*. (fig. 88).

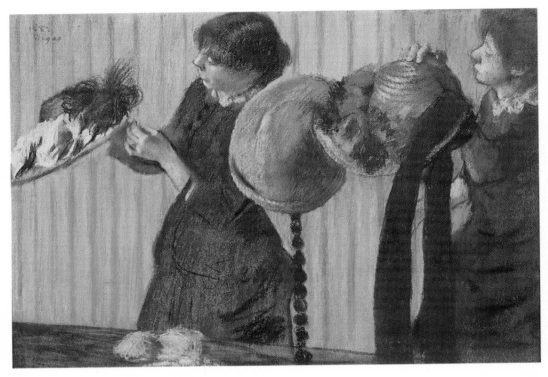

VI Degas. *The Milliner's Shop*. (fig. 96).

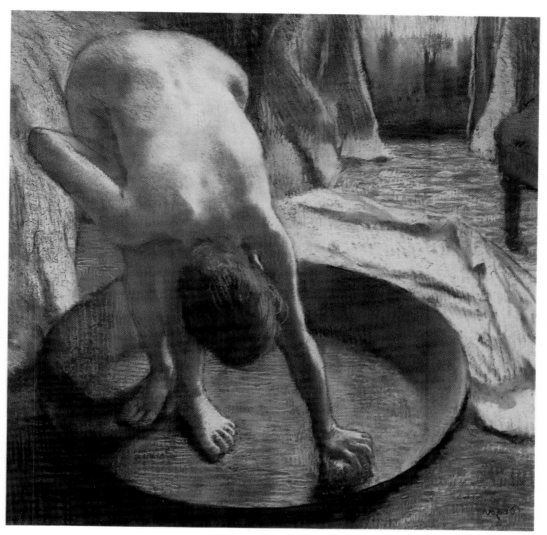

VII  Degas. *The Tub*. (fig. 106).

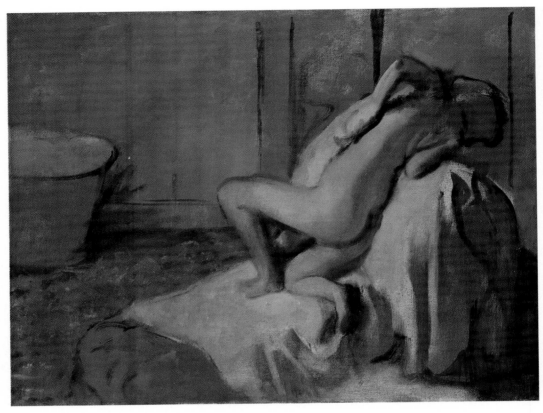

VIII Degas. *After the Bath, Woman Drying Herself.* (fig. 118).

*Star* (fig. 54), the male figure seems both there and not there. Tucked inconsequentially into the left corner, he is marginal but so vividly black and truncated that one cannot miss him. In *The Ballet Rehearsal* (fig. 56), the *abonné* is also marginal, pushed to the right edge of the painting, with what appears to be an unceremoniously appendaged extra limb. Even more awkward, wooden, and unglamorous are the men in *The Curtain* (fig. 57).

We must remember who the *abonnés* were in real life. Comte Fleury in the late 1860s portrayed one, the Prince de Galles, as being "as assiduous at the track . . . as in the dance foyer." Another, the duc Ludovic de Gramont-Caderousse, he termed an "arbiter of elegance . . . on the turf or in the wings." A dance historian has noted that "the President of the Jockey [Club], the Vicomte Paul Daru, irreproachable alike in manners in dress, would stride about the Foyer de la Danse like a Sultan in a seraglio."[44] If the power of these men was dwindling, they were nonetheless commanding presences. Yet Degas' depictions of them do not demand respect. On the contrary, his paintings marginalize, truncate, and caricature them. Remarkably, none of his contemporaries commented on this.

What *did* people notice? As we have seen, they emphasized the dancers' ugliness and their immorality. In addition, writers discussed the works' "modernity." Edmond de Goncourt, for example, wrote that Degas had "fallen in love with modern life, and out of all the [possible] subjects . . . he has chosen washerwomen and ballet-dancers." Frédéric Chevalier noted that Degas' work possessed an "absolutely Parisian and modern sentiment." And Huysmans referred a number of times to Degas' "real concern for contemporary life."[45]

Critics also found the works disturbingly realistic. One even called the paintings "frighteningly realistic"; another described their "disquieting sincerity"; someone else observed that they were "a startling but acutely exact impres-

sion." According to Huysmans, Degas "implacably rendered the awkwardness of the dancer, deformed by the mechanical monotony of her professional leaps. . . . His realism is of the kind . . . which certain Primitives imagined." It is a "terrible reality," he claimed.[46]

Why was it so "terrible"? And can we construct an interrelationship among "ugliness," "immorality," "modernity," and "terrible reality"? Georges Rivière wrote: "Realism is sad. It accentuates . . . the ugliness that it finds everywhere as being the incontestable expression of truth." And Charles Baudelaire, referring to Daumier's *Rue Transnonain* (1834), explained: "It is not what you would call caricature exactly, it is history, it is reality, trivial and terrible."[47] It would seem that for those who felt threatened by the modern world of innovation and shifting social values, the term *modern* was confounded with ugliness and immorality. Furthermore, many felt that their lives were invaded by the people who in their minds carried the contagion of modernity—workers. Middle-class Parisians increasingly felt outnumbered by them and threatened by imminent conflict with them, especially since revolution had been a fact of life all century long. One newspaper asserted in 1874 that Paris was a "formidable workers' city [and] the permanent home of insurrection and civil war." Hobsbawm is certainly correct when he points out that "if it [the Commune] did not threaten the bouregois order seriously, it frightened the wits out of it by its mere existence."[48]

Huysmans' "terrible reality," I believe, was this reality: France irreversibly dominated by capitalism—by movement, change, insecurity and, it was feared, the working classes, with their immorality, their vulgarity, their ugliness, and their power. Degas' reality was so "terrible" because it was ugly and unstable. It was additionally disconcerting because it dignified what the middle classes wanted to consign to the moral rubbish heap, namely working women and espe-

cially—for the purposes of this chapter—ballet dancers. In Degas' paintings of the latter, objects of sexual gratification and purchasable pleasure became working people. Furthermore, powerful men were marginalized, and in a larger sense, it was more than men's position at the Opéra that was questioned. As paradigms of power and authority, they were emblems of a vanishing order. Therefore, when a critic today writes that it was the "time-honored aspect of the ballet [which] undoubtedly . . . appealed to the mature Degas, a man of strongly conservative character who cherished old customs and attitudes,"[49] I must disagree. For Degas' ballet paintings, far from being about what was "time-honored," captured the disintegration of that very world and the anxiety it produced. We cannot find a ballet painting—look at *The Dancing Class, The Ballet Class, The Rehearsal, The Star, The Dancer in Green*—whose focus is not dispersed, whose viewpoint is not dizzying, whose figures do not slide uncontrollably about, whose figural definitions do not verge on caricature. This is modernity and change and not maintenance of a status quo. Which is not to say that Degas would have put it this way. Not at all. He probably would have stressed the appeal of tradition and good taste. His racing paintings had indeed reiterated the "time-honored" aspects of the milieu they pictured; social tension rarely surfaced in them. The classicizing drawing, the planar divisions of space, as well as the emblematic anonymity of the riders insured a tone of convention and conservatism. Not so the ballet paintings. The old world of the dance and Opéra were gone, like so much else, and that is what I believe Degas' ballet paintings are about.

# III
# IMAGES OF
# LAUNDRESSES
## SOCIAL
## AND SEXUAL
## AMBIVALENCE

Degas' depictions of laundresses seem at first to return to the conventions of the racetrack paintings. The compositions are simple, often exceedingly so. A mood of serenity, even dreaminess, suffuses the work. We observe hardy, absorbed women contentedly ironing in cozy, sundrenched corners. We can almost smell the clean clothes, sense the pleasure of a task well done and all of it at home, far from the world's troubles. The fragmented, nervous energy of the ballet paintings is gone. But something is wrong here. The vision is too rosy. Who are these women, after all? Degas, the realist, painted what he saw, and he didn't see women ironing in cozy corners. Furthermore, nobody in the 1880s in Paris would have bought a painting of an ordinary and familiar woman ironing at home—a painting of a peasant woman or other menial worker, yes, but not one's wife, mother, sister, or daughter. In fact, French middle-class women did not do their own ironing in the nineteenth century. These contra-

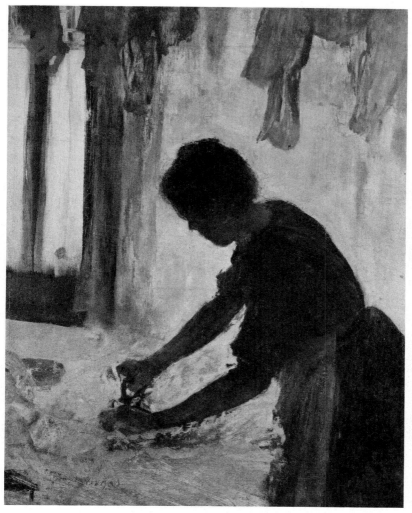

68. Degas. *A Woman Ironing*. Ca. 1874.

dictions made me wonder what sleight of hand, what ide-
ological disguise produced these gorgeous images?

The rhetoric of traditional art history has wrapped
Degas' ironers in a warm, illusionistic glow. Light, form,
gesture are what we have been directed to "see" in them.
The entry in the Metropolitan Museum's catalog for Degas'
*A Woman Ironing* (fig. 68) is typical:

It has been suggested that he [the artist] knew the passage in Goncourt's novel *Manette Salomon* (1867) that describes the picturesque effects of a laundry. To Degas, however, there would have been incentive enough in the possibilities this subject offered to study the exact motions and gestures that always interested him and to experiment with lighting in the work room.[1]

But remember Edmond de Goncourt's statement in 1874 that Degas had "fallen in love with modern life, and out of all the [possible] subjects . . . he had chosen washerwomen and ballet-dancers."[2] Goncourt knew something art historians do not know; he knew that the two subjects—dancers and laundresses—belonged together and that both were quintessentially modern.

It turns out that images of laundresses were a commonplace in nineteenth-century French middle-class culture. Whether one thumbed through *Le Charivari,* visited the annual painting and sculpture Salons, frequented the theater, read best-selling novels, or coveted pornographic photographs, the laundress was everywhere. Most often she was a washerwoman—robust, hardworking, sometimes a drudge; frequently she was an ironer—pretty, street-elegant, flirtatious (fig. 69). Contemporary picturesque literature presented laundresses[3] this way:

[They] . . . are clean, coquettish, and often really pretty. . . . It cannot be said that their souls are as immaculate as the linen they iron. These girls have a shocking reputation for folly and grossness. . . . They haunt the outskirts of the city, are inveterate dancers, descend sometimes to the lowest forms of prostitution, and are also given to drink.[4]

An interesting visual gloss on this commentary by Octave Uzanne can be seen on pages one through seven of the March 2, 1867, *Le Journal Amusant* (figs. 69–75). One watches a pretty suburban laundress as she begins practicing her trade

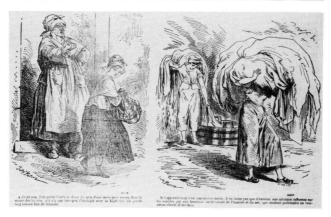

69–75. Pelcoq. *Les Blanchisseuses Parisiennes.* [Parisian Laundresses.] 1867.

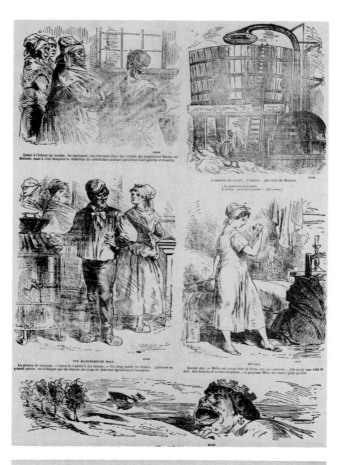

Quant à l'éducation morale, les anciennes s'en chargent dans des termes qui épataient Racine ou Bossuet, mais à côté desquels la rédaction du catéchisme poissard paraîtrait bien pâteau et éventé.

L'exercice du rutter... à lessive... pas celui de Bocrace.

« La pauvrette sur ci petite
Et la mer... pas sur si grande ! » (Air connu.)

Le garçon de semaine. — Lave et repasse à ses heures. — Un loup parmi les brebis... galeuses en grande partie, ne dédaigne pas de donner un coup de dent aux agnelettes à l'occasion.

UNE BLANCHISSEUSE MALE

Quinze ans... Mélie est venue hier de Paris voir ses parents... elle avait une robe de soie, des boucles d'oreilles bapaline... et pourtant Mélie est moins jolie qu'elle.

RÊVERIE

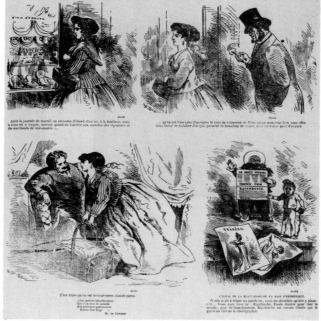

Après la journée de travail, on retourne d'abord chez soi, à la banlieue; mais la route est si longue, surtout quand on s'arrête aux montres des bijoutiers et des marchands de nouveautés...

... qu'on est bien près d'accepter le titre de citoyenne de Paris qu'un monsieur bien mis vous offre sous forme de mobilier d'acajou panaché de beaucoup de soyer, avec un travail payé d'avance.

C'est alors qu'on est sérieusement classée parmi :

« Les petites blanchisseuses,
Qui s'en vont le samedi
Aux pratiques parisiennes
Porter leur linge. »

L'IDÉAL DE LA BLANCHISSEUSE EN FAIT D'ESTHÉTIQUE.

Si elle a mis à séjour un pancarton, voilà les divinités qu'elle y placerait... Vous avez bien là Rigolboche. Faute étoilée pour tout le monde, pour la blanchisseuse, Rigolboche est encore l'étoile qui la guide au ciel de la chorégraphie.

H. DE CLENSON

in Paris. She admires beautiful objects in shop windows, becomes rather stylish, meets rich men to whom she delivers laundry, dances at public balls with abandon, prostitutes herself, gambles and loses. Finally she becomes a ragpicker. All this is presented in an accessible, familiar visual vocabulary.

Perspective and foreshortening define space and form; literal details tell us about milieu and dress, and an expressive shorthand vividly evokes gestures. The laundress seems to become a figure in a morality tale.

Uzanne's text notes that laundresses quarreled ferociously and used a most "remarkable vocabulary." Georges Montorgueil, referring to their love of dancing, feared they might abandon laundering to become performers at the neighboring café-concerts.[5] Zola was concerned with the laundresses' social-sexual habits as well, but from a different perspective. He moralized and proselytized. In fact, the laundresses' moral code (or lack of it) motivated much of his narrative in *The Dram Shop* (1876). For all the attention he paid to the mundane details of working-class life and the ravages of alcoholism, it was the sexually titillating content of his novel that drew the critics' wrath—and probably attracted the book's numerous readers as well.[6] The novel tells the story of Gervaise, a laundress, whose taste for good food and drink lead her to moral degradation, sexual promiscuity, and financial ruin. Gervaise so loses her moral compass that she sleeps—in turns, under the same roof, and before her daughter's eyes—with her former lover and her husband.

Throughout the book, Zola draws our attention to laundresses' social-sexual habits. A man passing a laundry shop, for example, "would glance in, surprised by the sounds of ironing, and carry away a momentary vision of bare-breasted women in a reddish mist." Coupeau, Gervaise's husband, comments provocatively that Clémence, a virtuoso ironer of men's shirts, spent all her time "in" men's shirts.[7]

Laundresses were also a popular subject in the Salons. From 1865 to the end of the century, at least one and sometimes as many as six paintings with titles such as *The Queen of the Laundresses, Washing in the parc de Grandbourg, At the Washhouse, Lady's Maid Ironing,* and *Laundresses*[8] were exhibited. These depicted both washerwomen and ironers. One

finds the hardest workers among the images of washer-women; Daumier's *The Laundress* (ca. 1863, Metropolitan Museum of Art) comes immediately to mind. A common scene, however, was a view of a group of women washing linen along the picturesque banks of a river. Examples are Pissarro's *Laundering, Pontoise* (1872, Musée d'Orsay), Sisley's *Laundering at Billancourt* (1879, Roger Varenne Collection, Geneva), Meissonier's *Washerwomen of Antibes* (1872, Musée d'Orsay), and Léon Lhermitte's *The Washerwomen* (1883, wherabouts unknown).[9] Particularly in Impressionist paintings, the theme of work was subordinated to the atmospheric surroundings.

More often than not, the representation of real toil was displaced by nostalgia and a sense of well-being as drawings adhered to academic recipes for gracefully bending figures rather than awkwardly straining ones. Among the images of ironers, depictions of hard work are rarely found, and virtually all of these figures directly or indirectly flirt with the spectator.[10] In Joseph Caraud's *Lady's Maid Ironing* (fig. 76), we gaze into a domestic interior hung with intimate apparel. While the maid is absorbed in her task, we are invited to lose ourselves in the physical allure of her décolletage.[11] In Edouard Menta's *Laundress* (fig. 77), we observe a similar scene, this time in a commercial setting. We are allowed to peer into the shop through a keyhole-like entrance. Outside, irons heat on a small stove while freshly starched petticoats and bonnets billow nearby—a buoyant advertisement for the work being done within. Inside, a pretty young woman bends over her ironing. She leans heavily forward as one hand maneuvers a voluminous garment and the other wields the iron. It is so hot that she clasps the iron's handle with a piece of cloth, and she has undressed down to her stays and chemise. The scene is picturesque, an image of a hardy young woman engaged in what appears to be a relatively pleasant activity.

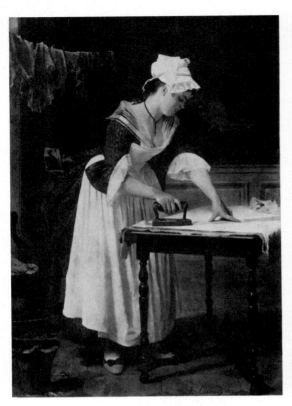

76. Joseph Caraud. *Soubrette Repassant.*
[Lady's Maid Ironing.] 1872.

77. Edouard Menta. *La Blanchisseuse.*
[Laundress.] 1896.

As we have seen with the 1867 *Le Journal Amusant* chronicle, the laundresses' loose morality, while merely suggested in paintings, became explicit in newspaper illustrations, popular prints, and photographs of the day. When laundresses were depicted in *Le Charivari* of April 12, 1859, for example, it was their flirtatiousness and easy morals that emerged as characteristic (fig. 78). In the caption the following exchange takes place:

My girl, I've heard that the young man who lives across the way has kissed you!! . . .

That's true, mother; but it's because he saw that his shirts were very well ironed, . . . and he gave me a kiss for the trouble. . . .

78. *Dialogues Parisiens.* 1859.

79. Alfred Grevin. *Fantaisies Parisiennes.* 1876.

> If he's happy with his linen, it isn't you he should kiss, it's me,
> . . . I run this establishment.[12]

Alfred Grévin's cartoon for *Le Charivari* of May 25, 1876, creates a similar ambience (fig. 79). A gentleman stands musing near the door; two very pretty young ironers work at a table nearby with a petticoat of voluptuous proportions covering the wall behind them. And then we read the proprietress' instructions: "Since Monsieur has no one to do his linen, one of you young women can easily go to his house tomorrow morning and pick it up. . . . What time does Monsieur get up?"[13] One can imagine the pretty young woman entering the customer's room early next morning. Indeed, Grévin himself drew such a follow-up image for George A. Sala's book *Paris Herself Again, 1878–1879* (1880); from the rear we see a shapely young woman passing through the door into someone's apartment.[14]

LA REPASSEUSE.

Mon mouchoir m'étouffait, voyez je suis en nage.
Il n'est rien d'échauffant comme le repassage?

80. Anonymous. *La Repasseuse.* [The Ironer.] 1837.

Earlier prints were even more explicit. In *The Ironer* (fig. 80), an old woman enters, surprising a younger woman ironer who has just (none too successfully) hidden a suitor under the bed. The young woman, taken aback, attempts to pull her kerchief back into place. Her iron lies facedown, unnoticed, on a piece of unfinished work. A framed image just above her head shows a pristine bourgeois lady sitting contemplatively in nature, further emphasizing the ironer's questionable behavior. Below the print is a legend: "My handkerchief was asphyxiating me; see how I am perspiring. There's no hotter work than ironing." Considering the way in which laundresses were usually depicted, small wonder that the model who comes to pose in Henri Meilhac's and

81. Anonymous. [Ironer.] Ca. 1875.

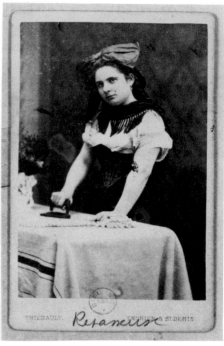

82. Anonymous. [Ironer.] 1873.

Ludovic Halévy's play *The Grasshopper* (1877) worries that a relative of hers, a banker who is about to arrive at the painter's studio, "would not be pleased did he know I came to pose as a washerwoman like this."[15] Ironers were so predictably alluring that when the fledgling photography business looked at them, they were seen as erotic objects. A stereoscopic photo of the 1870s and so-called *carte de visite* (or visiting card) of 1873 are conventionally pornographic (figs. 81, 82). That is, their settings are mundane, ordered, and a bit too spotless, with unexpected and titillating disclosures of anatomy.

Both the abundance of laundress images and the emphasis, especially among images of ironers, on sexuality are striking. One wonders why these particular female workers were so present in the public imagination. A partial answer

lies in their conspicuousness. The laundry industry occupied one-fifth to one-third of the population of Paris and its suburbs. The women were seen throughout the city picking up and delivering their clients' laundry and laboriously transporting it to and from the washhouses.[16] In addition, the windows and doors of their excessively hot ground-floor shops were thrown open so that any passerby—as Zola noted—could easily see them working, semi-undressed in the heat. In most cases this visibility cut across class lines because of the social structure of Paris. For despite the increasing ghettoization of the poor in the eastern part of the city and in the industrializing suburbs, Paris remained remarkably integrated. The organization of many apartment buildings contributed to that integration: shops and concierges' quarters occupied the ground floors; the most prosperous tenants lived on the lower floors and the poorer ones higher up.[17] However much the building's layout schematized and heightened class distinctions, it also fostered intimacy.

In fact, sexy laundresses had been a popular subject in paintings and prints since the eighteenth century. A reason for their popularity was their mode of work—vigorously removing dirt and stains from clothes and linen, often by stamping upon them, skirts aloft, at a time when underpants did not exist as an article of clothing.[18] In addition, that they washed intimate apparel lent their activity a certain sexual allure. Still, their popularity in nineteenth-century France should be taken seriously on its own terms. It was, indeed, part of a larger phenomenon: the vast increase of workers in Paris in general and the many complicated ways in which the working poor were entering middle-class life and consciousness. Working-class women seemed to be everywhere: employed in cafés, restaurants, all kinds of boutiques, and department stores; traipsing the streets between work and home; enjoying themselves in cafés, café-concerts, and dance

halls. Moreover, as we have seen, they were becoming increasingly hard to distinguish from middle-class women.

Yet none of this explains middle-class fascination with sexually provocative details and narratives. The distortions in the laundresses' public image become all the more striking when one studies contemporary labor reports (themselves a measure of middle-class fascination with working-class life). From these we learn explicit facts about laundresses' lives. Hours were long, wages low, and working conditions miserable. They worked up to fifteen and even eighteen hours a day, starting at 5 A.M. and continuing until 11 P.M. And a laundress, according to these reports, considered herself lucky to work those hours, because she was not always able to find employment.[19]

The tasks of the ironers and washerwomen were quite different. The former, working in small indoor spaces, maneuvered six- to seven-pound irons, often in devastating heat. They spent their time either carrying out demanding precision work on bonnets, blouses, and shirt fronts—of which they were quite proud—or doing boring and repetitive work on sheets, tablecloths, and curtains. The monotony of the latter (the most abundant type of work) plus the endless hours had a stupefying effect. The sweltering, claustrophobic quarters of the ironer contrasted with the washerwoman's world, the city streets and washhouses. A washerwoman trekked through the city with twenty to thirty pounds of linen at her hip. She arrived at the washhouse only to face the additional stress of competing with other women for work space. The other side of that competition, however, was comaraderie; as the women worked, they gossiped and argued. Alliances constantly shifted, but no one could doubt the mood of communality that filled washhouses and ironing shops alike.

Sharing work, however, did not compensate for low pay and wretched work conditions. Although ironers, the skilled laborers of the trade, earned more than washer-

women, neither was adequately paid. In 1881 a typical Parisian laundress took home an average of 3.25 francs a day (thirty centimes purchased about a kilogram of bread; two francs, about a kilogram of fresh meat). Certainly there were laborers who earned less. Lacemakers, for example, made approximately three francs a day and ordinary seamstresses earned two. But a teacher in a Catholic school made about fourteen francs a day, and a well-paid Parisian department store employee earned seventy. An owner of a cotton-spinning factory accumulated five thousand.[20]

A woman who earned 3.75 francs a day and was able to find work 260 days out of the year—which was unusual—might spend her year's income as follows:

| | |
|---|---|
| Food | 670.00 francs |
| Rent | 150.00 |
| Clothing | 110.00 |
| Linen | 93.60 |
| Shoes | 23.00 |
| Heat and light | 12.65 |
| Laundry | 66.00 |
| Miscellaneous | 50.00 |
| | 1,175.25 |

Even with these minimal costs, a working woman's expenses exceeded her earnings by some two hundred francs, making it necessary for her to go into debt or supplement her income through prostitution.[21]

Labor reports also inform us about diseases indigenous to the trade such as inflammation of the abdomen and throat, bronchitis, and tuberculosis. Ninety out of a hundred ironers lived in only two rooms, one for ironing, one for sleeping. Quarters were cramped, and in most cases there was no kitchen. The women prepared food and ate in the rooms in which they also counted, marked, and sorted dirty laundry.

The stench was awful. Dust and other particles released during sorting contaminated the air, which was constantly heated by the furnace keeping the irons hot—a perfect breeding ground for germs.[22] Laundresses, like other workers, drank a lot. It was generally thought to help them work; certainly it was a relief. Encouraged by their employers, they began drinking—mostly wine and brandy—at about 11 A.M. and continued all day. Wine merchants facilitated this custom by setting up canteens at the door of public washhouses and sometimes inside the washhouses themselves.[23]

Since we have no firsthand reports from laundresses, the closest we can come to the reality of their lives is through the labor reports. It is important, however, to appreciate the prejudices a labor inspector would have brought to his job, including assumptions about laziness, criminality, and promiscuity. Nonetheless, it seems clear that laundresses worked very long hours and were underpaid, sick, and frequently alcoholic. What happened to this reality in the images we examined earlier? Why did middle-class culture, most particularly in its visual forms, insist on seeing these women almost exclusively in sexually alluring terms? We know there were other aspects of their lives that could have generated a good story or an engaging painting. The answer to this question is embedded in the prevailing ideology of the French urban middle classes.

The discrepancy between prevalent cultural images of laundresses and the actual conditions of their lives is a very clear instance of ideological distortion. The harsh reality of the commercial laundress' daily life was concealed; rather than being seen as a hard worker, she became both a sex object and the butt of class prejudice. These stereotypes, however, were not pure fabrications. In the instance of the laundresses' transformation into sex objects, for example, we know that the women picked up and delivered laundry in what could become the provocative intimacy of bachelors'

rooms. Women who worked in devastating heat did in fact violate middle-class standards of dress and "ladylike" conduct; as we have seen, they were semi-undressed much of the time. And many were undoubtedly part-time prostitutes. In a word, their sexual attitudes were less circumscribed than those of French middle-class women.

Of course, our notion of what constitutes ladylike behavior derives from received and unquestioned definitions of family life in which a woman's work takes place in the home, where she presumably is revered and protected. The laundresses' work, however, took place outside the home, and its very nature exposed them to public scrutiny and sensuous delectation, both of which were translated in cultural terms into sexual accessibility. Middle-class women were, for the most part, insulated from such inspection by virtue of their class position. This insulation from public scrutiny is crucial, since it is the accessibility of knowledge about a given action, and not the action itself, that often determines a phenomenon such as "bad reputation."

But why did prevailing prejudices emphasize the sexuality of working-class women? Who stood to gain from this point of view? We could argue that it accomplished two things: it neutralized middle-class fear and guilt toward workers, and it rationalized exploitation. It has, I believe, everything to do with middle-class awareness and trepidation of the working poor in the nineteenth century. An astounding change had occurred in the image and reality of workers during the 1800s. At the beginning of the century, according to Louis Chevalier, they were seen as a "horde of savages." In the face of the working-class revolt of 1793, Victor Hugo asked: "What did these shaggy men want, who, ragged, howling, ferocious, with bludgeon upraised, pike a-tilt, rushed on the old Paris?" In 1840, Eugène Buret, author of *De la Misère des classes laborieuses en Angleterre et en France*, (Working-class Poverty in England and France), wrote:

If you venture into those accursed districts in which they [the poor] live, wherever you go you will see men and women branded with the marks of vice and destitution, and half-naked children rotting in filth and stifling in airless, lightless dens. Here, in the very home of civilization, you will encounter thousands of men reduced by sheer besottedness to a life of savagery.[24]

After the Revolution of June 1848, however, these prejudices shifted, almost to their opposites. During the Second Empire, Dr. Louis-Désiré Veron wrote in *Memoires d'un bourgeois de Paris* (Memoirs of a Bourgeois of Paris, 1853):

The young worker who does not indulge in drink is strong, elegantly lithe, free in his motion, supple of gait; his hair is thick; his head is well set on his shoulders. The limbs are well developed mainly by the swell of the muscular frame. The teeth, the primary digestive apparatus, are healthy, strong, deeply rooted and, for the worker, a formidable and powerful weapon. The chest is broad; the pectoral muscles stand out; the walls of the stomach are not thickened by cell tissue nor overloaded with fat; the spine is very flexible and the muscles attached to it well developed and very powerful. How few wealthy young men resemble these athletes of labor![25]

Workers became—both in their own eyes and in those of the middle classes—robust, powerful, free. But for the middle classes, they were still dangerous, even more dangerous, perhaps, because they were more human. They went to cafés, bars, and restaurants; they were often perceived angrily but admiringly as being "allergic to employer authority";[26] some held passionate political opinions and were known to be political organizers. They had been on the barricades in 1848 and 1871, and they might be again. Or, as Walter Benjamin put it, the Commune of 1871 "dispel[led] the illusion that the task of the proletarian revolution [was] to complete the work of 1789 hand in hand with the bourgeoisie."[27] Fantasies about class solidarity were gone. If the proletariat seemed

more civilized than it had been, it was also clearly less manageable. In fact, attempts to control it became both more codified and more desperate. For example, a law of 1854 (only repealed in 1890) required every industrial laborer (as distinguished from a self-employed artisan and peasant) to carry a *livret,* a certificate which gave his or her name, description, place of employ, and even, occasionally, employers' comments. Without a *livret,* a worker's freedom of movement was curtailed.[28]

One way to control workers, or one's fear of them, was through legal means; another was through contempt. An example of this was a comment made in the early nineteenth century about the origin of the proletariat: "they form a class of subhumans which has come into being by crossing robbers with prostitutes." Edmond de Goncourt essentially agreed when, in 1891, he deplored "the weakness of present-day governments in the face of the working-class scum." And Daniel Halévy, Degas' young friend and the son of Ludovic Halévy, expressed a similar sentiment in 1897: "the masses have always been the enemy of society."[29]

A more specific form of bourgeois disdain involved sexualizing the poor. In the case of the commercial laundress in nineteenth-century middle-class culture, the emphasis on her sensuality and the persistent moral condemnation meant that she did not have to be taken seriously. Guilt about the quality of her work life, or fear of her potential anger, was side-stepped. She posed no dangers. She could not possibly be Eugénie Suétens, the laundress accused of setting extensive fires during the Commune.[30] Far from being dangerous, the laundress remained a brute, if sometimes coquettish, sexual animal.

As long as laundresses were seen as immoral, they apparently deserved to earn less and to live in squalor. This selective redefinition of the conditions of their lives legitimized their exploitation—"one gets what one deserves." It

is no accident that ideologies such as Social Darwinism became prevalent at this time; "survival of the fittest" was a convenient hanger for class prejudice.

Degas, of course, could not escape his culture's ideologies, but his images of laundresses, like his ballet paintings, provide a critical commentary on those assumptions at the same time that they collude with them. Once more, I must insist, however, that it was not his conscious intention to do this. He painted and drew ironers and washerwomen over a thirty-three year period (ca. 1869–ca. 1902). In all, excluding his notebook sketches, there are twenty-seven works.[31] Only nine depict washerwomen; the majority represent ironers.[32] Unlike his portraits of women of his own class, Degas' images of laundresses are usually more generalized than specific, more genre than portrait. The laundresses stand in a limited variety of poses and settings. All are simply drawn with a minimum of physical and contextual details. The washerwomen lean away from the baskets of linen balancing at their hips. (The most famous of these is the *Two Laundresses* (1876–1878, Sachs Collection, New York.) The ironers are similarly uncomplicated. In addition, they are all in a state of semiundress. Most incline in the direction of their work and have lost or vague profiles, as in *A Woman Ironing* (fig. 68).[33] The settings are spare, even empty, except for hanging laundry or naked architectural supports (evidence of a commercial locale). The most specifically drawn, and therefore exceptional among the ironers are a painting and a pastel, both entitled *The Ironer* from about 1869—one figure is in three-quarter profile, and one looks at us full-face (figs. 83, 84). Another type of image of ironers is the double or multiple image (also suggesting a commercial space). These compositions are the most graphically descriptive and show ironers stretching, yawning, chatting, or simply working together (figs. 88, also see color plates, 90).[34]

Initially what stands out in all of these works is their

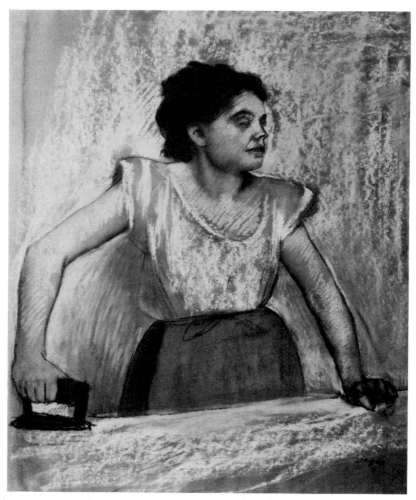

83. Degas. *The Ironer*. Ca. 1869.

genrelike depiction of lower-class women working in commercial spaces. In addition, they are more abstract, atmospheric, and evocative than descriptive in a literal sense. But nothing much seems to be happening in them. Or are we so inured to looking at these works simply as beautiful objects that we do not see the "events" taking place? Degas' very choice of laundresses or, more particularly, commercial iron-

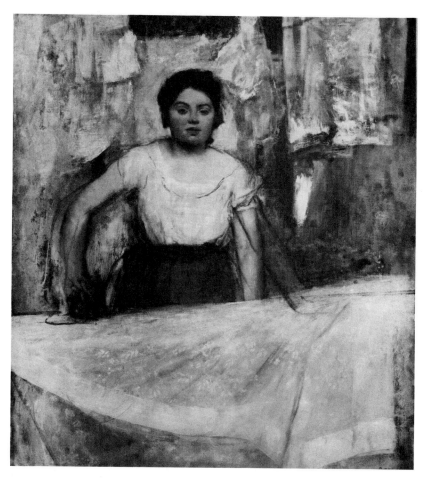

84. Degas. *The Ironer*. Ca. 1869.

ers, was itself provocative, since these women were freighted
with sexual meaning for a middle-class viewer.

Laundresses had a special meaning to Degas; he not only
painted and drew them but also described them in writing—
and not indifferently. The letters he wrote to his friends in
Paris when he visited his relatives in New Orleans in 1872
are chatty and descriptive, with flashes of witty, sometimes
near-passionate longings for home. Those longings are of
interest. He wrote, for instance, to the painter Tissot: "Every-

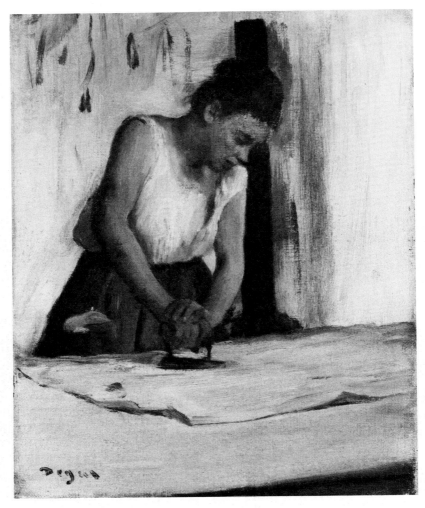

85. Degas. *The Laundress*. Ca. 1873.

thing is beautiful in this world of the people. But one Paris laundry girl, with bare arms, is worth it all for such a pronounced Parisian as I am." And, again, in a letter to Henri Rouart: "I shall leave it all without regret. Life is too short and the strength one has only just suffices.—Well then, Long live fine laundering in France."[35] Fresh linen and robust laundresses evidently unleashed vivid and delicious memories of

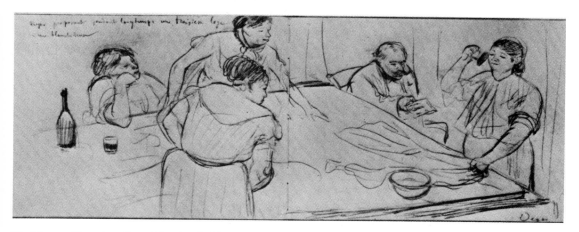

86. Degas. Drawing from Notebook 28. 1877.

home for Degas. Given his dandyism and his upper-class origins, Degas' interest in lower-class women was not exceptional.

But, one might protest, Degas' images of laundresses have nothing to do with sex. Let us take a closer look. In *The Ironer* (fig. 84), a young woman looks out at us immobilized, as if momentarily stunned. Her face is sensual and distinctly drawn with its slightly open, full-lipped mouth, languid eyes, and faintly swollen lids. In *The Laundress* (fig. 85), the woman's face is flushed as she leans intently into her work; we are startled to notice not only her high color but her unbuttoned bodice. She is working, but she is seductive too. While these two images are only indirectly sexual in content, one work does exist in which sexual references are more explicit. In Degas' Notebook 28 (fig. 86), there is a drawing in which a man sits at the corner of a table around which four ironers are standing and sitting. The man is Degas' friend the composer Ernest Reyer; Degas' cryptic inscription at the top left reads "*Reyer proposant pendant longtemps une troisième loge à une blanchisseuse.*" (For a long time, Reyer has been suggesting a third box to a laundress.) The man holds a piece of paper, perhaps announcing a the-

atrical or operatic performance to which he is inviting one of the laundresses to share a loge, or box. Or perhaps "troisième loge" is metaphorical, implying a third place in his amorous life. Whatever the precise meaning, the implication is flirtatious.[36] That Reyer was associated with sex in Degas' mind is supported by another notebook page of about the same date. On it Degas wrote his own signature and copied those of Delacroix, Doré, Ingres, and Reyer; around Reyer's is a graffito-like drawing of male genitalia.[37]

All this would be interesting but irrelevant as history if Degas' own contemporaries did not see the sexual content of his work. But they did. Huysmans, who increasingly emerges as the most astute and imaginative of Degas' critics, referred in 1880 to the sexual allure of the latter's working-class women, putting his own observations into the commonly accepted descriptive terms for laundresses and working-class women in general: "how charming some among them are . . . with a special beauty, made of lower class vulgarity and a grace! These tramps who iron or carry linen . . . are ravishing, even divine." In the 1920s Gustave Coquiot, probably Degas' most arrogant and nasty supporter, described the latter's laundresses as "old and young sloppy wenches of the iron," adding that the public saw the laundress as "a 'young and desirable' ironer of shirtfronts waiting for an old rich man."[38]

Yet if sexual allure was built into Degas' images, closer scrutiny betrays his observation of work as well. At first the images do seem very removed from the overworked women or harsh conditions described in the labor reports. The figure in *A Woman Ironing* (fig. 68), for example, appears quietly absorbed by her task. Light, color, brushstrokes dazzle our eyes; the distillation of a particular gesture compels us; the ironer's line of vision, as well as the movement of her body, draw us into her work. Far from seeming weak, sickly, or alcoholic, she appears confident and decisive. A similar case

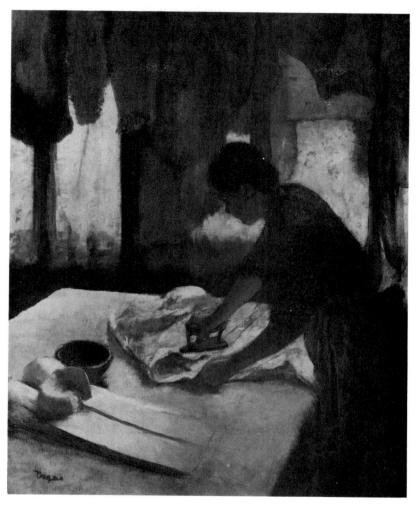

87. Degas. *Woman Ironing.* 1882.

may be made for the figure in *Woman Ironing* (fig. 87). The accoùtrements of work are there: a spacious worktable, a shirtfront, and hanging laundry, but the colorful atmosphere and self-contained absorption scarcely evoke modern industrial malaise. And even in *The Ironers* (fig. 88), where the yawn and stretch of the bodies might induce emphathetic physical responses in the spectators, the light pastel hues, the

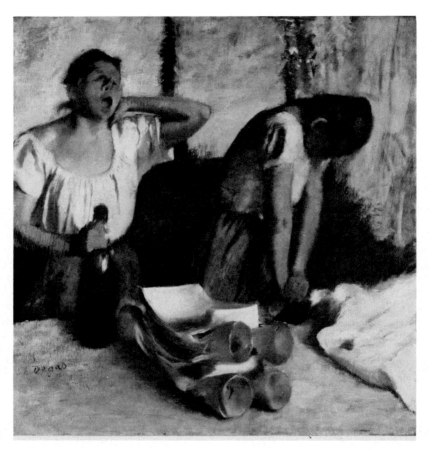

88. Degas. *The Ironers*. Ca. 1884.

decorative, sharp lines of the bodies, the whimsically detailed, almost anthropomorphically alert starched collars, militate against any sense of discomfort. The sheer beauty and decorativeness of these works may well be a gauge of Degas' insensitivity to, or even his trivialization of, a very harsh work reality. But the beauty of these paintings constitute only one layer of the works' meaning.

On the left in both *The Ironers* and *Two Laundresses* (fig. 89), a woman grips a bottle whose function is unclear until we take another look at the notebook drawing already dis-

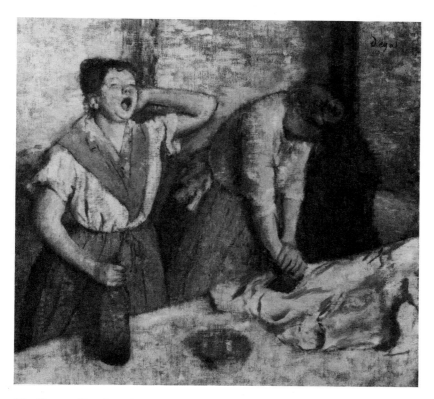

89. Degas. *Two Laundresses*. Ca. 1884.

cussed. The bottle contains wine, and the laundress is drink-
ing.[39] Degas the realist, who noted the architectural setting,
the irons, and water containers, also saw the bottle, but he
would no more depict a drunken laundress than a tubercular
one. In his hands alcoholism is neither a disease as described
by the labor reports nor the degenerate habit denounced by
Zola. It is simply a fact. But the bottle is only one sign of
the drudgery of the laundresses' work life. Whether in *A
Woman Ironing, Woman Ironing,* or *Ironers* (fig. 90) the simple
repetition of gestures and the relatively uncluttered contexts
urge us to focus on the bending female forms. Their silhou-
ettes have the flavor of infinitude, as if the figures were locked
or sewn into place forever. Degas has here distilled the iron-

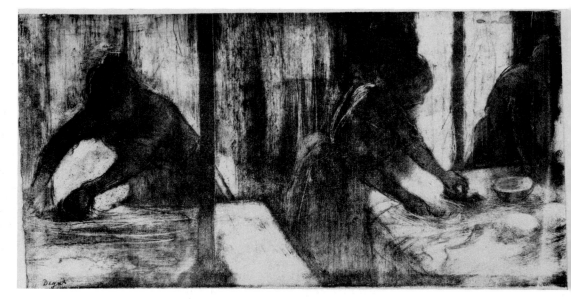

90. Degas. *Ironers*. Ca. 1880.

er's most expressive feature: the woman's body bent over her
work. A similar gestural expressiveness occurs in *The Ironers*
and *Two Laundresses*. In both works the woman to the right
tucks in her head and rolls all her strength into her torso and
out through her pressing arms and hands. The other woman
does the opposite; her body unfolds, she stretches and yawns
while firmly gripping a wine bottle. Again the body language
is congealed and pared down, the forms riveted into place.

Through a delimited and explicitly vocational repertory
of gestures, Degas has captured for our eyes the repetitious
and ritualistic aspect of ironing. His drawing and spatial con-
structions suggest the women's solitude, their withdrawal,
their fatigue. His contemporaries noticed that the laundresses
were working as well. In 1880 when Huysmans described
Degas as "a painter of modern life," he illustrated his state-
ment by referring to Degas' paintings of "laundresses in their
shops, dancers at rehearsals, singers of the café-concert . . .
cotton merchants. . . ." Other critics were more contemp-

tuous. In 1890 Gustave Geffroy pointed to the laundresses "presiding over the dirt of humanity" and becoming "apoplectic in over-heated rooms." The painter Georges Rouault described Degas' ironer as "that gross laundress who yawns while leaning heavily on her iron or who guzzles straight from the bottle." Rivière described the women drenched from the heat, slaking their thirst with red wine. "They are graceless and dehumanized," he said. "The laundress is an animal, a beast of work, not a human being."[40] Thus, a sense of both labor and class was evident to nineteenth-century viewers to whom the lower class signified the vulgar, the subhuman, the animalistic. Degas' paintings did not present the women that way, but for contemporary spectators their prejudices were more powerful than the palpable reality of the paintings.

In addition to recreating a sense of work exhaustion, the structure of Degas' laundress paintings reconstitutes another important aspect of contemporary experience—the nervousness and anxiety of life in modern Paris. In both *The Ironer* and *The Laundress* (figs. 84, 85), we regard the protagonists at a distance across deep and activated spaces, as well as from discomforting vantage points. The tables are pushed just far

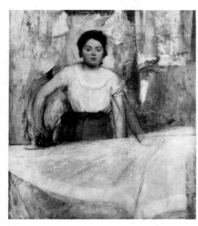 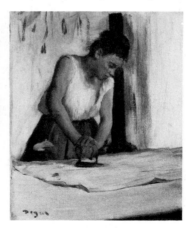

84. *The Ironer.*    85. *The Laundress.*

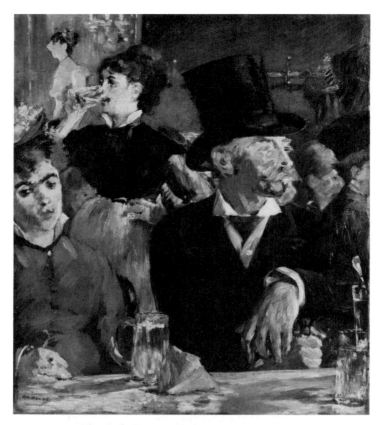

91. Manet. *The Café-Concert*. 1878.

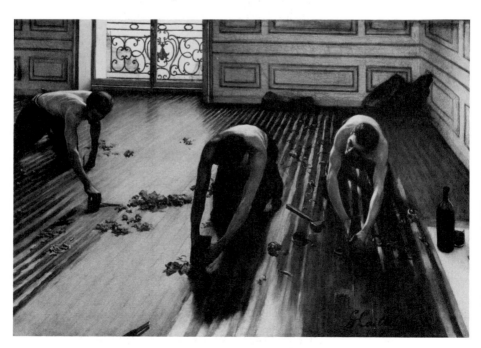

92. Caillebotte. *The Floor-Scrapers*. 1875.

enough away from the picture plane to create an acute angle. In *The Ironer,* a delicately sprawling lace curtain spreads out and falls, close to us, down the picture plane; in *The Laundress* another curtain, tablecloth, or sheet ripples restlessly on the table's deep diagonal surface. The path to the subject in both paintings is unusually obstacle-ridden, and the angles are exclusionary and bewildering. In works like *The Ironers* and *Two Laundresses,* (figs. 88, 89), the pictures' edges crop the content unexpectedly, and disequilibrium is produced by sloping diagonals. In addition, there is an arbitrary foregrounding of some objects and backgrounding of others.

Once again, as in the discontinuous-mode racing paintings and the ballet images, characteristics of Japanese pictorial structure—fragmented and truncated forms, collapsed spaces, off-centered compositions—emerged as a major conduit of social and psychological instability. One wonders whether that pictorial language was being used yet again to disguise, and also present, a discomforting subject: in this case, women who were more dangerous than they formerly had been because of both their social ambiguity and the generally increased power of workers in French society.

I am struck again at how much Degas' formal vocabulary is like Manet's and Caillebotte's and unlike Renoir's, Monet's, or Morisot's. In Manet's *The Café-Concert* (fig. 91), for example, a sense of motion has been created by fragmenting figures on the picture's edge; by catching them in the midst of awkward gestures (the waitress with a beer glass at her mouth, the singer between dramatic gestures, the girl at the left musing sullenly); by the motion of the brushstrokes and the diagonal run of the counter. Everybody, on the go or not, is swept along in what we know, we can practically hear, is the noise and activity of the café. In a related manner Caillebotte's *The Floor-Scrapers* (fig. 92) refuses us the comforting illusion of a story as the men flow down the floorboards, and gorgeous silhouetted forms and elegant patterns

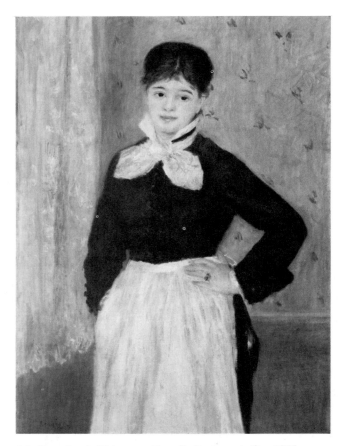

93. Renoir. *A Waitress at Duval's Restaurant*. Ca. 1875.

call attention to themselves. The painting does not withdraw into the kind of classicizing spaces and narrative unities of such contemporary images of working women as Renoir's *A Waitress at Duval's Restaurant* or Morisot's *In the Dining Room* (figs. 93, 94).

We cannot say what was the intended purpose of the visual vocabulary Degas—or Manet or Caillebotte—used. But we *can* say that in the laundress works, Degas produced deeply ambiguous images, which in some ways nourished and in other ways subverted prevailing prejudices. In this sense they are very much like the ballet paintings and quite

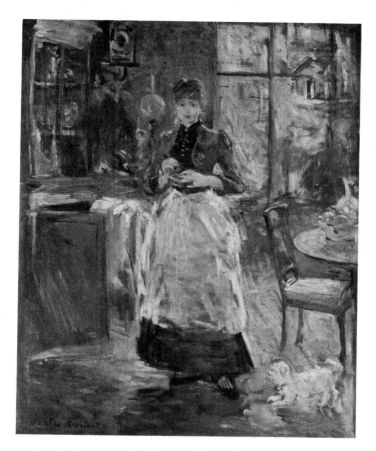

94. Berthe Morisot. *In the Dining Room.* 1884.

different from the majority of racing images. They are at odds with modernity, but modernity is their voice. Their stake in their past is expressed primarily through their subject matter, but their formal vocabulary transforms their literal subject—the laundress—into another type of woman. She signified sexual objectification, but she was also potentially threatening. These are not merely pretty pictures. They are, as Edmond de Goncourt said, exemplars of "modern life"; they are at once exciting and risky. In this context, Degas' frieze-mode racing paintings seem decidedly conservative, almost relentless in their commitment to a status quo. It

begins to appear that when Degas' genre images are about work and women, they are modern, and when these two elements are lacking, and nostalgia for the past predominates, the paintings lose their bite and incisiveness. This theory is borne out by Degas' images of bathers.

# IV
# THE
# BATHERS
## MODERNITY AND
## PROSTITUTION

Prostitution has been a subtheme in this book. Even the racing paintings, in which female figures are scarcely evident, bear traces of the disturbing ambiguity of certain women at the racetrack. In the ballet world, the issue of prostitution—albeit of a genteel kind—was more pervasive; the dancers were obviously coveted and sexually available, but not marriageable—at least not to the *abonnés* who strolled the foyers. With the laundresses we encountered the nearly ubiquitous assumption that working-class women were primarily sexual creatures. In discussing the laundresses the issue of sexual ideology was raised in order to suggest the profound renovation it was undergoing. For if laundresses prostituted themselves, it was not by explicit profession but as a result of the need to supplement their primary income. Although this was not a new phenomenon at the end of the nineteenth century, what *was* new was the anxiety these women induced in the middle classes.

Increasingly, as we have seen, so-called "loose" women were confused with "good" women and, far worse, from a

middle-class point of view, "good" women were behaving dubiously. Remember how Crafty had bemoaned precisely this confusion at the racetrack in 1889? In 1895, the newspaper *Le Journal* lamented that life wasn't what it used to be and that girls had become "flirtatious, brazen and easy-going to the point of impertinence."[1]

As social codes came unhinged, prostitution became less easy to define as did women's correct behavior generally. While many of Degas' images embody this confusion, his most blatant treatment of the subject is in his milliner and bather images. For, unbeknownst to later twentieth-century eyes, the milliner was considered a "tart" and the naked woman with a basin, a prostitute. Degas painted both, but as usual the works presented the viewer with ambiguous messages. In this chapter, I will show, first, that what I have just asserted is true: that both women were perceived as immoral; second, that Degas painted them in such a way as to minimize, even undercut, their immorality; and finally, that his neutralizing of sexual content is precisely what was happening socially. Assertive and ambiguous sexual behavior among women had become more universal, cutting across class lines, and therefore was becoming ordinary.[2]

Registered prostitutes who were either streetwalkers or brothel inhabitants were regulated by French law and for centuries had had a specific and recognizable position on the margin of society. Working women like milliners[3] and laundresses, however, were harder to define precisely. They lived in unstable financial situations which frequently put them in the position of needing men to pay for their entertainment, clothing, housing, and so on. Frequently, this was a matter of exchanging personal—usually sexual—favors for occasional financial support. At times that already blurred area of moral behavior became more obviously prostitution.[4] For our interests the blurriness is important. Women who became reliant on occasional prostitution were not regulated by law;

they came and went through the city wherever their work took them, as they had for centuries. But by the 1880s these women had become less obviously marginal and therefore increasingly unnerving. The milliner in particular—unlike the laundress and most other working-class women—had a middle-class patina, for she relished and mimed the gestures and attitudes of the middle-class women she served. She was also proud of her work in a way many working-class women were not. Because hats were considered the crowning touch to a carefully arranged ensemble, milliners often perceived themselves as artists. In a 1911 play by Louis Artus entitled *Les Midinettes* (The Young Milliners), Julie, a young milliner, complements her prospective lover by saying, "He has taste. He would know how to design hats." In addition, she is so confident and assertive that her client's husband says to her, "My, but you're not timid."[5] When in the mid-1880s Degas began to paint milliners, he decided to depict a provocative subject indeed.

In keeping with a general tendency to emphasize form over content, traditional art historical discussions of Degas' depictions of millinery shops have focused on the eccentric compositions and the lush beauty of the painted hats. Yet there is not a single painting of a millinery shop by Degas which does not include some reference to the milliner, and frequently it is she who is the central figure. That is important, for it was in her role as worker that she was understood by contemporaries to be an occasional prostitute. In *The Millinery Shop* (fig. 95), for example, Degas' modiste, sewing-glove in place, admires or puts a finishing touch on one of her creations. In *The Milliner's Shop* (fig. 96, also see color plates) and *Two Milliners* (ca. 1890, Durand-Ruel Collection, Paris), the women work attentively. Sensitive insight into the concentration and pleasure of such work is provided by the pastel *The Milliner* (ca. 1882, Metropolitan Museum of Art).[6]

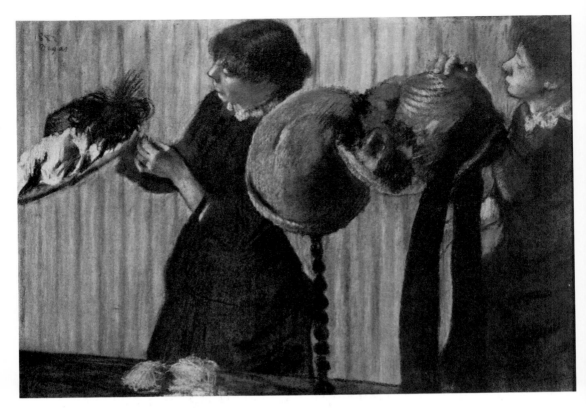

96. Degas. *The Milliner's Shop*. 1882.

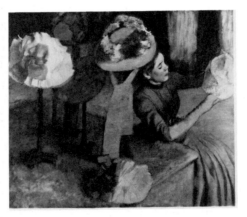

95. Degas. *The Millinery Shop*. 1885.

The vividness of Degas' portrayal of these women as workers is enhanced by the pictures' evocation of commerce—the aura of buying and selling, the abruptness of

97. Degas. *At the Milliner's.* 1882.

encounters, the plethora of goods, the hardy, sensuous appetites. Abundance is palpable in a work like *The Millinery Shop,* in which a luscious and varied array of hats is spread out for the spectator's pleasure. Two pastels, both entitled *At the Milliner's* (figs. 97, 98), also provide images of the quintessential good bourgeois life. Big, beautiful hats spill over surfaces; handsome women enjoy their reflections in mirrors; young milliners busily stitch merchandise for eager customers. These invoke the rush of newly constructed streets, the liveliness of cafés, the pleasure of promenaders, the enthusiasm of shoppers. The motion of the street practically invades the images as one's vision slides down the pitched diagonal of a work like *At the Milliner's* (fig. 8). The

98. Degas. *At the Milliner's*. Ca. 1883.

8. *At the Milliner's*.

immediacy of the city is also felt in the way Degas locates the spectator *in* the shops, *at* the worktables, *in front of* the mirrors, *pressed into* the hats, unlike our views of the laundry

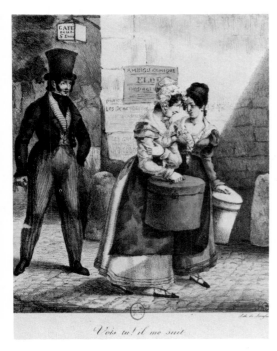

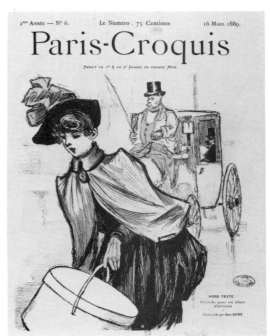

99. L. B. *Vois-tu! il me suit.* [Look! He is following me.] 1823.

100. Henri Boutet. Cover, *Paris-Croquis.* 1889.

shops where we, like Zola's passersby in *The Dram Shop,* look in from the street.

Although Degas painted milliners inside their shops, like laundresses they were a fixture of the Paris streets, easily identifiable by the large, round hatboxes they carried. References to them almost always include that box along with expressions of delight in the women's charm. Early in the nineteenth century colored lithographs show the milliner in a playful but—from a middle-class point of view—compromised situation. In *Look! He is following me* (fig. 99) two young milliners, hatboxes in tow, are being pursued by a foppish-looking young man. They are standing outside a café on the rue Saint-Denis, the traditional terrain of prostitutes in Paris. Increasingly through the century, images of street-chic milliners decorated magazine covers and posters. In 1889 an elegantly caped and capped milliner was shown gingerly toting her large box while behind her sat a top-hatted gentleman in a carriage (fig. 100). In the same year a frankly co-

*The Bathers*

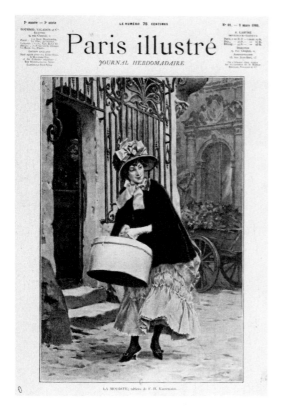

101. Frederik-Hendrik Kaemmerer.
*La Modiste*. 1889.

102. Anonymous. *Ouvrière en Mode*. 1892.

quettish modiste appeared on the cover of *Paris Illustré* (fig. 101). She clasps a large hatbox as she trips along in pointed, high-heeled shoes in front of a café with the same implications as the rue Saint-Denis. Through the end of the century and into our own, many prints, paintings, and posters use young milliners as insignias of sensual pleasure and romantic adventure; one forever sees them making their way with their packages through the city, either with or near a man, in the vicinity of a bar, on a well-known street, or near a kiosk advertising cafés and dances (fig. 102).

Throughout the nineteenth century there were also many depictions of milliners in their shops. Usually they are situated amid a flurry of activity. Frequently, a man visits among them (fig. 103).[7] Some interiors simply show the women at work (fig. 104), but in the shops, as in the streets,

103. Feillet. *Magasin de Modes*. 1825.

104. Gavarni. [At the Milliner's.] 1838.

105. Gavarni. *Ma santée est autant bonne que . . .*
[My health is as good as . . .]

the predominant mood is flirtation. Gavarni's lithograph *My health is as good as . . .* is a good example (fig. 105). In it two girls are earnestly at work composing a letter to a lover.[8]

The view of the milliner as primarily an object of sexual desire also appears in contemporary pseudohistories like Octave Uzanne's *The Modern Parisienne* (1894). While telling us

nothing about the work life of the milliners, Uzanne notes their dress and their ability to ingeniously disguise their frayed clothing. They were, he says "the aristocracy of the workwomen of Paris, the most elegant and distinguished." But even if they had artistic characteristics and were sensitive, they were also, according to Uzanne, disorderly and careless; indeed, they were said to be a rowdy, vulgar bunch who loved café-concerts, particularly the songs of Polin, Yvette Guilbert, and Anna Thibault. Uzanne adds that in the streets "they thoroughly enjoy being followed, hearing remarks made to them, receiving all with shrieks of laughter."[9]

Arsène Alexandre, describing milliners in *Les Reines de l'aiguille, modistes et couturières* (Queens of the Needle-trade, Milliners and Dressmakers, 1902), concurs with Uzanne. These women were a noisy bunch, he claims, "suffused with the intrepid gaiety of Paris." Their heads were full of love and marriage. All they did was chatter and gossip.[10] Both histories flirt with the (male) reader, dangling a fantasy life of sex and pleasure before him. All complications vanish in this "never-never land" of male fantasy. For neither writer was the milliner's existence as a worker important. Far more compelling was her "charm."

From a series of articles by the right-wing journalist Charles Benoist, published in *Le Temps* in 1895, we learn some interesting data about the milliners' lives (and also about middle-class attitudes toward them). There were three categories of milliners: apprentices, finishers, and trimmers. All three, according to Benoist, were privileged workers, and the most fortunate could ultimately go into partnership with the owner of a shop. Work conditions, however, were poor. Benoist notes that the women worked twelve hours a day and fifteen to twenty during peak season. Since fashion was a notoriously seasonal business, they could also be devastated by a three- to four-month period of unpaid unemployment. "When the summer slack season came," wrote Zola in his

novel *Ladies' Delight,* "a gust of panic blew through the [store]." He wasn't exaggerating. It was this long period of annual unemployment that forced many women into prostitution.[11]

The night shift, the *veillée,* was another devastating aspect of millinery work (and of the sewing trades in general). A woman about to go home at 7:00 P.M. was frequently told she had to remain until midnight or 1 A.M. Often she lived an hour or more from the shop and so had to spend the night at work. The shops were not well heated; food was inadequate; and the women, reports Benoist, often lost their appetites completely. Perhaps worst of all, from Benoist's point of view, was that if a woman was married, her husband spent the evenings she was at work in a café.[12]

In *Le Travail des femmes au XIX^e siècle* (Women's Work in the Nineteenth Century, 1873), Paul Leroy-Beaulieu notes that "of all the needle workers [the milliners were] the most favored in regard to salaries." However, he continues, during the fashion season (four months of the year), their work conditions were ghastly. They labored fifteen to eighteen hours a day, sometimes only sleeping two hours a night or going without sleep entirely.[13]

Significantly, I think, a number of writers felt that the worst aspect of the milliners' condition was coming into contact with rich people and coveting what they possessed. Even the relatively liberal republican Jules Simon was particularly insistent on this point, asserting that the "spectacle of luxury" was debilitating and dangerous to the young worker. From the other end of the political spectrum, Benoist agreed: "the woman who works in luxury items begins to desire for herself the beautiful things she makes for the rich."[14] This, commentators said, was what led her to prostitution.

How do Degas' paintings of milliners mesh with the picture just presented? In *The Millinery Shop* (fig. 95) we regard a seductive woman only insofar as a milliner in the

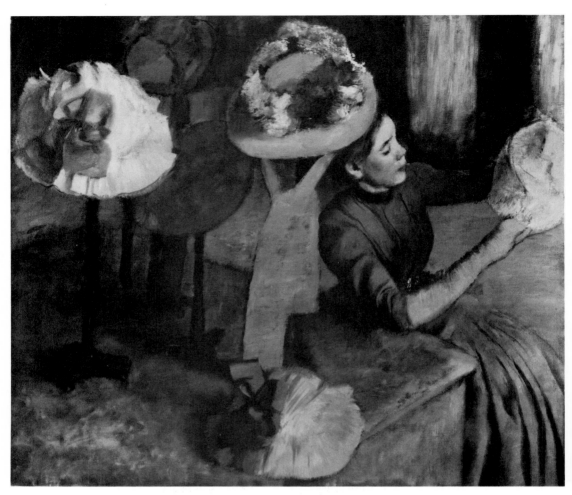

95. *The Millinery Shop.*

1880s implicitly signified seduction. Degas' painting in every way precludes such a connotation. The modiste is downstaged by the gorgeous hats. The composition also angles her out of our vision and, therefore, our grasp. The fragmentation of forms and the disorienting location of what we would expect to be the main "player" produces an elusive and confusing narrative. All the prints and paintings that we have considered by other artists are fundamentally different. The milliner on the cover of *Paris Illustré* (fig. 101), for example, is overtly coy and charming. The space she inhabits

parallels ours; we can enter easily. The subject of the painting is obvious. Degas, however, prosaicized the milliner by disrupting expectations of her sexual availability. And, as we have seen, although the milliner continued to be desired and available in the late nineteenth century, she was less obviously marked as an immoral person; she merged with all women, a source of social anxiety but also a sign of her increased independence.

Degas' milliners, then, are not conventionally seductive nor do they seem discomforted by their work conditions. But they are in fact working. As with the artist's images of laundresses, contemporary critics saw the stereotypes and not the working women. In his study of Degas, Gustave Coquiot opens his chapter "*Chez les Modistes*" with: "The milliners form a very delightful group of Parisian coquettes." Coquiot goes on to gossip about their backgrounds: they were married but left their husbands; they were the girlfriends of senior officers in the army; they were teachers fallen on bad times; they used to work in large department stores but were fired; they were the lovers of painters, writers, and musicians whom they were supporting until success made this unnecessary. Paul-André Lemoisne also underlines the titillating content of the milliner's persona and groups her with prostitutes and laundresses, suggesting that Degas was attracted by "their strangeness . . . by that appearance of a free animal." Georges Rivière writes that "the milliners are neither pretty, elegant or lovable." Indeed, he says they are ugly. Yet he continues, "there is no truth without ugliness, ugliness alone expresses reality."[15] "Ugliness," "animal liberty," and loose morals are concepts we have encountered before; they were all associated with the working poor and, for our purposes, particularly with working-class women.

Degas' milliners, then, like his dancers and laundresses, acknowledged prevailing prejudices. They signified sexuality, but they also refused that signification. If we look again

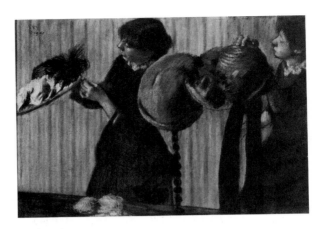

96. *The Milliner's Shop.*

at *The Millinery Shop* or *The Milliner's Shop*, (fig. 95, 96), we observe what appear to be charming and wistful women adorning or admiring their creations. The hats themselves may suggest contemporary notions of female vanity and co-quettishness, and so we may be privy in these images to the fantasies of lower-class women for the expensive finery they made but could not afford. We may be watching those very moments of desire that drove them, at least in the eyes of middle-class observers to prostitution. At the same time, however, each woman is absorbed in her work or her thoughts. She is simultaneously accessible and aloof; her sexuality, both to herself and to others, was in the process of redefinition.

The significance of Degas' milliner paintings in the context of contemporary redefinitions of social-sexual behavior is deepened by his commentary on brothel prostitutes. This can be seen clearly in his images of bathers.

Years ago, a student asked me why Degas' bathers were forever washing themselves. What was so dirty about them? I politely dismissed the question, attributing its wrongheadedness to the young man's naiveté. The more I have studied these paintings, however, the more I have realized that this

question is key to their meaning. If we take seriously both how Degas worked and what these images meant to his contemporaries, then the images become something other than abstract configurations of dazzling color and compelling form.

We know that Degas always drew from life and then proceeded to "make up" his compositions. No matter how often he worked from models posing in his studio, his ultimate pictorial source after about 1865 was always a lived social experience—at the racetrack, at the opera, in a café, on the streets, in brothels. In other words, irrespective of the dwindling narrative intricacies of the bather images and the increasing emphasis on expressive form, these scenes must have been rooted in a social event. Furthermore, the nudes are not simply nudes in the traditional sense; they are not models posed against nondescript backgrounds, nor are their settings idyllic and symbolic. They are women washing and drying themselves in very specific locations. Whether one looks at the Hillstead or Musée d'Orsay *The Tub* (figs. 106, also see color plates, 123), *The Morning Bath* (fig. 107), or *Woman at Her Toilet* (fig. 113), the room observed contains some combination of an upholstered chair covered with a towel or dressing gown, a tub, a dressing table, a water pitcher, a bed and, occasionally, a curtained window.

What kind of room is this? It cannot be a bathroom, since such conveniences hardly existed at the time in Paris. Sometimes it appears to be a bedroom, at other times a dressing room. But it is certainly not a working-class woman's bedroom, for in all the paintings the location of the tub, far from a water source, presupposes a servant. A working-class woman would have washed near a tap in order to avoid lugging heavy water urns. In a poor woman's flat, this tap would either have been in the kitchen (if there was one) or downstairs, outside in the courtyard. In the latter case, the woman would have gone to a public bath when she wanted

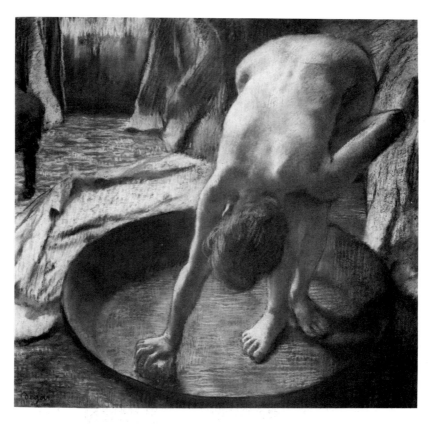

106. Degas. *The Tub*. 1886.

to wash her entire body and only would have done a superficial washing daily.[16]

Was Degas, then, depicting a middle-class woman's bedroom? Such a woman would certainly have had a servant to bring the water to her bedroom, where her washbasin would have been. If she were more prosperous, her apartment would have had a dressing room with an armchair, footstool, mirror, and dressing table; in an adjacent room, there might even have been an enamel, metal, or faience tub.[17]

But Degas, in his daily life, would not have had access to middle-class women's bedrooms. Little is known about his sex life, but if what we suspect might lead us to brothels

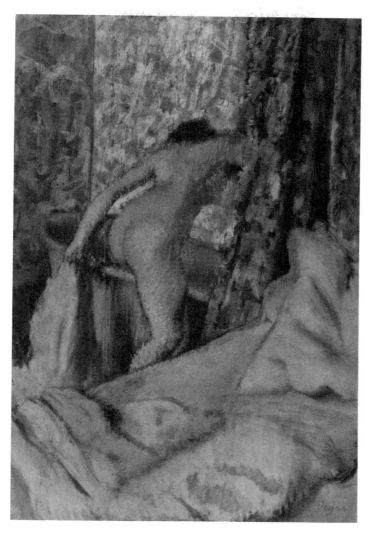

107. Degas. *The Morning Bath*. Ca. 1890.

or backstage at the Opéra, it does not lead us to the bedrooms
of bourgeois women. He never married, and there is no
substantive data pointing to romantic liaisons with women
of his own class. Moreover, even if he *had* been familiar with
the dressing rooms of middle-class women, contemporary
ideological assumptions would have precluded his painting

them. Although art galleries of the time were full of images of bathing women, they took the forms of Dianas, Susannahs, and courtesans.[18] No precedent existed for depicting middle-class women washing themselves, because such a conceptualization was absent from contemporary thought. Goddesses might bathe in front of a spectator and so might nymphs or courtesans, but never a middle-class woman. In countries like France, a bourgeois woman's physicality did not seem to exist. In Zola's *Nana,* for example, Count Muffat might enter Nana's dressing room and surprise the half-naked girl as she was drying herself, but in twenty years of marriage he had never seen his own wife naked.[19]

What was important were a middle-class woman's domestic and spiritual attributes. "The clergy," wrote Theodore Zeldin, "generally spoke of the husband as having sexual urges and the wife as submitting to them." "It is only a few years," noted Paul Valéry as late as 1938, "since the only mortals acquainted with the nude . . . were the doctor, the painter and the frequenter of houses of ill repute."[20] In the late nineteenth century, it would have been indecorous, if not obscene, to depict a middle-class woman naked.

Furthermore, whereas to our eyes, Degas was depicting a normal and mundane event when drawing women at their baths, to nineteenth-century eyes this was anything but normal. French scientists and doctors may have emphasized the importance of cleanliness, especially after the cholera epidemics of 1832 and 1849, but they did not advise taking baths. On the contrary, they warned against them; early in the century women were specifically advised not to take a bath more than once a month. Too many baths, it was said, weakened sexual desire, led to infertility, and withered beauty. In 1853, after a miscarriage, the Empress Eugénie wrote to her sister, "You asked me about the cause of my accident. I swear to you that I don't know, nor does anybody else. It is true that I took a warm bath (not hot), but according to the two

doctors, the misfortune had occurred earlier."[21] Another rea-
son baths were discouraged was due to inhibitions about
nudity: the potential for water to act as a mirror was seen as
particularly dangerous for young girls.[22] A final reason to
discourage women from bathing in Paris was the water itself.
For, despite the extraordinary renovations in drainage ac-
complished by Haussmann in the 1850s and 1860s, it was
feared, and still is, that water in Paris is unhealthy.[23] For all
these reasons, plus the distance one had to walk to get water
of even questionable quality, bathing could not be considered
a commonplace activity among middle-class women. As late
as 1900, writes Alain Corbin, "a good bourgeois Parisian
woman contented herself with a periodic footbath."[24]

Prostitutes, on the other hand, had to bathe. Venereal
disease was common, and precaution required registered
prostitutes both to have regular vaginal examinations and to
take frequent baths. It is more than likely that each regulated
prostitute's room was replete with tub (often of the foot-
basin variety), water pitcher, and towels.[25] Corbin, for ex-
ample, describes the following event in the salon of a brothel:
"after having extended his hand to the elect of his senses, the
visitor leaves the salon in the company of the Madame's
assistant, mounts the stairs along with the selected girl and
waits while she washes herself before going to him." Bathing
was so unquestionably associated with prostitutes that the
nineteenth-century authority on prostitution Alexandre-
Jean-Baptiste Parent-Duchâtelet was certain that it was baths
that caused the plumpness of prostitutes in general; another
nineteenth-century authority attributed the infertility of
courtesans to bathing.[26]

Bathtubs, then, in late nineteenth-century France, far
from being ordinary accoutrements of middle-class life, were
a sign of the prostitute.[27] In fact, women and tubs were the
centerpiece of a contemporary pornographic formula. One
example is the stereoscopic photograph *The Bath* of about

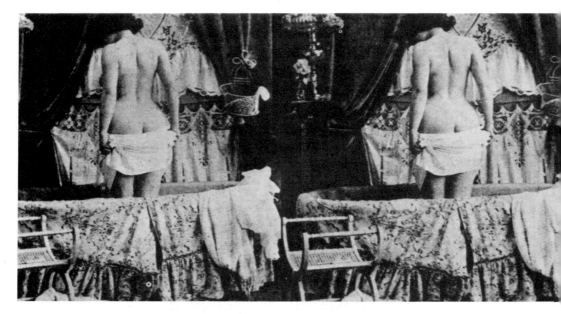

108. Anonymous. *The Bath*. Ca. 1875.

1875 (fig. 108). The room is layered with cloth: heavy material drapes the sides of the windows while lace is pleated across them and calico forms a skirt around the entire circumference of the large tub, over the side of which hangs a towel. The contrast of layered cloth and nudity is unmistakably affecting. A more delicate and elegant decor accompanies a slimmer young woman posed on the side of a tub in the 1904 postcard *Before the Bath* (fig. 109). Her unlaced boots are provocatively placed nearby, and once again a variety of contrasting fabrics sets off her nudity. Felicien Rops' study of a nude of about 1900 is even more direct (fig. 110). A large woman, either getting into or coming out of a tub, looks at us brazenly; her petticoat lies discarded to the right. Through a diaphanous piece of drapery thrown across her we see her black stockings—the very insignia, especially in conjunction with utter nakedness, of the prostitute.

Although Degas' pastels and paintings of bathers are never so explicit as the images just cited, some of his monotypes are quite specific. In the monotype *Admiration* (fig. 111), a woman, seen from the back, fairly swoons thigh-high in

109. Anonymous. *Before the Bath*. 1904.　110. Felicien Rops. [Nude.] Ca. 1900.

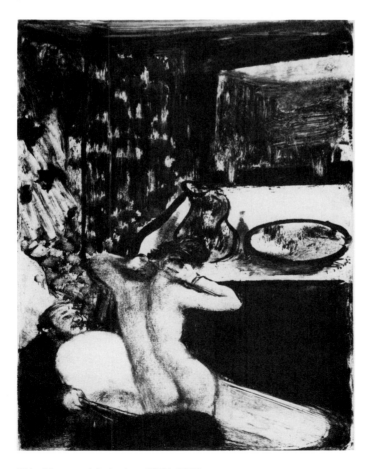

111. Degas. *Admiration*. 1877–1880.

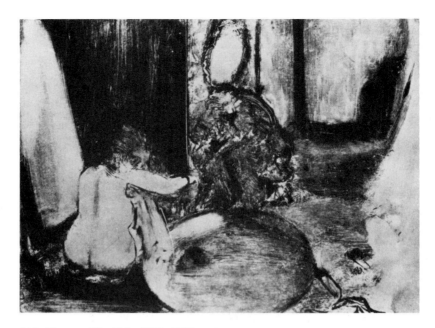

112. Degas. *The Tub*. 1878–1880.

a tub of water; an enthralled male admirer crouched at the foot of the tub gazes up at her; drapery and clothing fill the left corner of the room. Although this print is cataloged simply as a nude rather than as a brothel scene, the dealer Ambroise Vollard recognized its setting and used it to illustrate de Maupassant's story of a brothel, *The Tellier Establishment*(1881).[28] A telling companion is offered by Degas' monotype *The Tub* (fig. 112), in which a naked woman sits on a low stool or pillow drying herself alongside a shallow round tub; an almost illegible male figure huddles in an armchair opposite. When we look at Degas' pastel *Woman at Her Toilet* (fig. 113), we find a nearly identical image except that the man on the chair has metamorphosed into a pile of garments. Another print by Degas that indicates an overt relationship to prostitution is *Woman Combing Her Hair* (fig. 114). The setting is by now familiar: a woman, naked except for black stockings; a tub; piles of drapery; and, again, a man

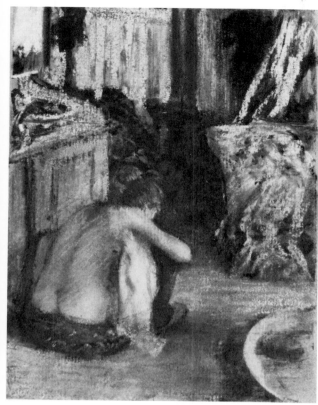

113. Degas. *Woman at Her Toilet.*
Ca. 1895.

114. Degas. *Woman Combing Her Hair.*
1877–1879.

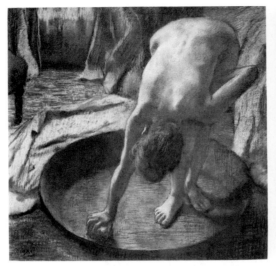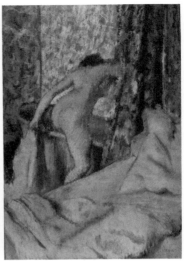

106. *The Tub.*

107. *The Morning Bath.*

sitting on a chaise lounge watching her as she combs her hair. If we consider how integral a part of prostitutional behavior washing was, it is not surprising to discover how predictably titillating was the view of "the desired" washing.

It is in this context that Degas' bathers should be seen. *The Tub* (fig. 106), with its rhythmic swellings and precise anatomical outlines, carries all the traces of prostitutional display—the drapes, the chair, the towel, even part of a bed. The same, and more, is true of *The Morning Bath* (fig. 107), in which a woman has gone directly from bed to tub. Nor do the bather scenes that include a maid preclude the brothel milieu; maids were an obvious part of the hierarchy of the brothel. They were such a commonplace that Huysmans, in his novel about a prostitute entitled *Marthe* (1876), casually describes a prostitute climbing the stairs with a client and when she reaches her room, "a maid opened the door and effaced herself in order to permit the pair to pass."[29] Consider also the similarities between the anonymous soft-porn photograph *The Tub and the Sponge* and Degas' *After the Bath* (figs. 115, 116). In both, the contrast between clothed and naked is suggestive and potentially arousing. And the display of anatomy along with the evident pleasure of the women wash-

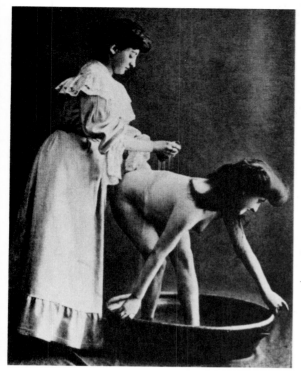

115. *The Tub and the Sponge.* Ca. 1900.

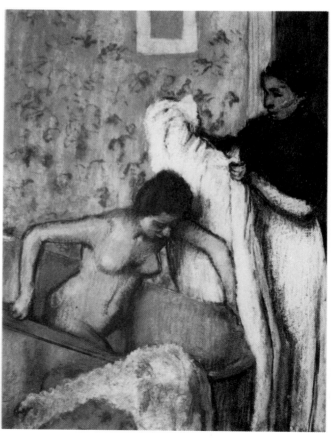

116. Degas. *After the Bath.* 1883.

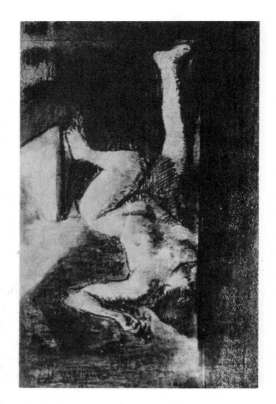

117. Degas. *Woman Drying Herself.* 1880.

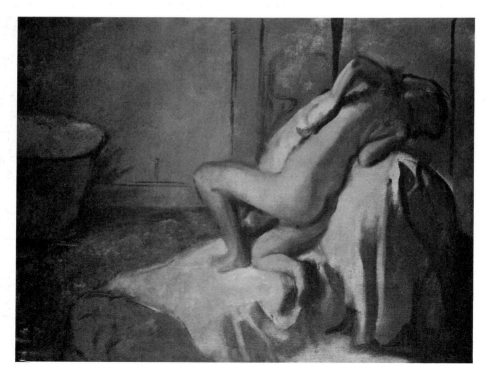

118. Degas. *After the Bath, Woman Drying Herself.* 1896.

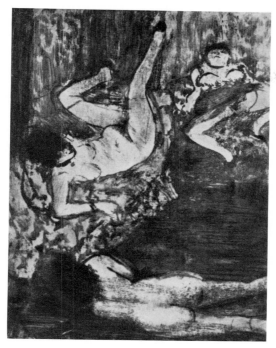

119. Degas. *Relaxation*. 1879–1880.

ing or being washed or dried is a subject of each work. The content in Degas' picture is prosaicized, but the titillating traces are there.

Some of Degas' most enigmatic bathing scenes begin to come clear when viewed in the context of the brothel. In *Nude with a Yellow Curtain* (1880, Private Collection),[30] *Woman Drying Herself,* and *After the Bath, Woman Drying Herself* (figs. 117, 118, also see color plates), the bathers are extremely contorted. Works like these have fueled Degas' reputation as a misogynist. There is, I think, a very different kind of content in these puzzling images from the intentional depiction of inelegant and awkward movement. For example, in *Woman Drying Herself,* a figure, during a moment of what looks like private abandon, sprawls on the ground in front of a fireplace and kicks up her legs. Her pose is strikingly close to those of figures in a number of brothel monotypes who are lying indolently on couches and masturbating (fig. 119).[31] It seems quite likely that the contorted bodies in a

120. Jules Laurens. Drawing after *Une Peinture Indienne [sic] dans le Palais des Quarante-Colonnes, à Ispahan*. 1860.

number of Degas' bather images that do not generally include tubs, far from straining disinterestedly or exemplifying Degas' misogyny, represent women who are experiencing intense physical pleasure.[32]

Additional support for this interpretation may be found in Notebook 18, which Degas used between 1859 and 1864. In it he made a copy after a Persian painting that had appeared in an article by the comte de Gobineau (fig. 120).[33] In the drawing a voluptuous figure sprawls against a large cushion in a landscape. To the figure's right kneels a self-contained figure with a hand tentatively outstretched; to the left are two jugs. Degas' copy is much more generalized than the original, although he concisely captured the gestural outlines. The Persian miniature followed a set formula meant to describe sexual ecstasy; the vessels to the left are for wine, which facilitated the attainment of that pleasure. The figure to the right is the female partner of the couple, the sprawling figure is male—the opposite of what a Westerner would have expected.[34] One does not know whether Degas was aware of this reversal, or even of the sexual content in general, since

the text of the article does not discuss the visual images at all.[35] We may either assume that he "knew" something of the drawing's content or a remarkable coincidence exists between it and works he did years later like *After the Bath, Woman Drying Herself*.[36] For, ecstasy, I would suggest, is the subject of both.

Degas' contemporaries knew that his bathers were prostitutes. The clearest and most scornful description was written in 1886 by Huysmans, who stated that the pastels were a "piercing damnation of some women who enjoy the deviated pleasures of their sex, a curse which makes them violently irrational as they humiliate themselves announcing to all the world the damp horror of a body that no bath can ever clean." And the critic Félix Fénéon described these figures as stretching and washing "in disreputable furnished rooms in the vilest retreats."[37] It is significant that, according to Corbin, prostitution had become "a burning subject between 1876 and 1884." It "was implicated in the great political and social debates of the moment. . . . [There were] virulent campaigns which really began to look like crusades."[38] Without doubt, related to these discussions was the appearance between 1876 and 1881 of four important works of fiction about prostitutes: Huysmans' *Marthe* in 1876, Edmond de Goncourt's *The Prostitute Elisa* in 1877, Zola's *Nana* in 1880, and de Maupassant's *The Tellier Establishment* in 1881.

Where did Degas' pastels of bathers enter the debate on prostitution or, more generally, on changing sexual mores? They do *not* depict the unregulated or occasional prostitute, for we have seen that the decor of the rooms announce that they are in brothels. Or are they? The content of these works can best be understood by comparing them to the monotypes, which had been designed explicitly as brothel subjects. Quite a bit changed on the road between the explicitness of the monotypes and the generalizations of the pastels and paintings. In Degas' *The Tub* (fig. 106), what had been the

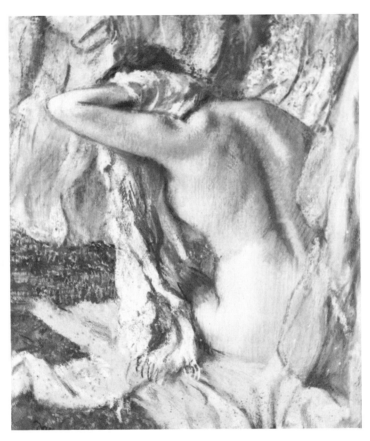

121. Degas. *After the Bath*. 1885.

exaggerated, even vulgar gestures in *Woman Combing Her Hair, Admiration,* or *Relaxation* became a generalized lyrical outline evoking a warm and familiar sensuality. In *The Tub* we are invited to focus on monumental, expressive form and invitingly textured surfaces. What in the monotypes had been an explicit narrative became in the pastels a distilled instant. One no longer reads the tale; one *sees* the painting.

In addition, Degas' pastels have wandered so far from the conventional path of objectification that the women can actually be described as self-absorbed. Instead of depicting the nude in a specific brothel setting or as a Venus-like of-

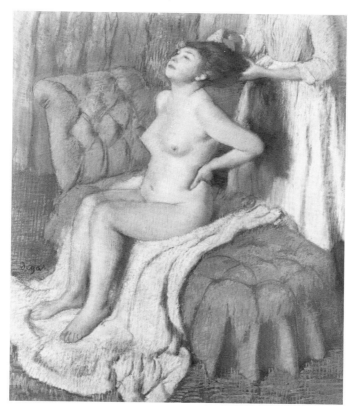

122. Degas. *A Woman Having Her Hair Combed.* Ca. 1885.

fering for an imagined male spectator, Degas presents her as
she might experience herself. In *After the Bath* (fig. 121), for
example, one observes a lushly painted woman, surrounded
by voluminous, richly colored and textured draperies,
stretching her robust arm to rub the back of her neck. Al-
though the view from the back may be seen as dehumanizing,
one may also read it as an invitation to focus empathetically
on the woman's own experience of her body, cradled in com-
fort, leaning into her confidently rubbing hand. The sensuous
delight of caring for one's body or, better still, of having
someone else care for it, is also evident in *A Woman Having
Her Hair Combed* (fig. 122). This mature woman's pleasure

is almost palpable. Because of the absence of explicit sexual gestures and complex narratives, and the presence of private pleasure, in the latter images the rooms seem ordinary—"any woman's" room. And the prostitute has metamorphosed into any working woman, or even middle-class woman. Here we see the ultimate result of the sexual ambiguity discussed earlier. It is not possible to say precisely who this woman is, because she is not precisely anybody.

It is significant, I think, that no group of paintings by Degas is as consistently labeled misogynist as his bather images. When they were exhibited in the last Impressionist exhibition (among those shown were figures 106, 122, and 123) Huysmans wrote:

[Degas] brought to his study of nudes a careful cruelty, a patient hate. . . . He must have wished to take revenge, to hurl the most flagrant insult at his century by demolishing its most constantly enshrined idol, woman, whom he debases by showing her in her tub, in the humiliating positions of her intimate ablutions. . . . [He gives to her] a special accent of scorn and hate.

And Fénéon commented:

. . . crouching, gourd-like women fill the bathtubs. . . . One with her chin on her breast is scratching the nape of her neck; another, her arm stuck to her back, and twisted a half circle is rubbing her behind with a dripping sponge. . . . Hair falling down over her shoulders, breasts over her hips, belly over her thighs, limbs over their joints, all of this makes this ugly woman—seen from above lying on her bed with her hands pressed to her hams—look like a series of rather swollen cylinders joined together. A woman seen from the front, on her knees is drying herself, with her thighs wide open and her head sunk over the loose flesh of her torso.[39]

This is extremely strong language. Although today these images may strike us as bold and unusually intimate for the

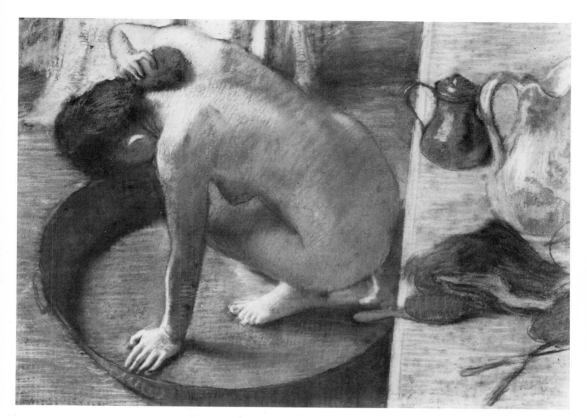

123. Degas. *The Tub*. 1886.

time, one would hardly call them "ugly," "debased," "humiliating," "cruel," or "hateful." This vocabulary is all the more striking when juxtaposed with the admiration elicited at the time by the nudes of Renoir or Bouguereau. Certainly, Renoir's *Little Blue Nude* (fig. 124) is prettier than Degas', and Bouguereau's nymphs in *Nymphs and Satyr* (fig. 125) are more seductive, but to my eye, at least, they seem a mixture of silly, benign, and innocuous. They are also nameless, by implication idealized and universal. This universality is not to be confused with our "any woman" mentioned above, for she was a contemporary person who had to be dealt with specifically and in history. Universalizing by definition denies specificity and history and, in the case of women, objectifies them. In both the Renoir and Bouguereau, the nudes behave

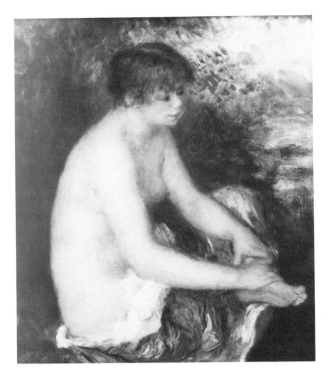

124. Renoir. *Little Blue Nude*. 1879–1880.

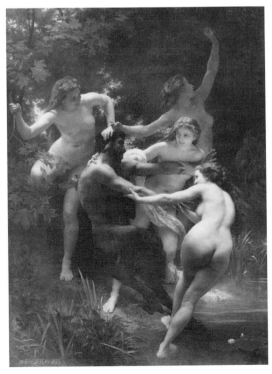

125. Adolphe-William Bouguereau.
*Nymphs and Satyr*. 1873.

according to social codes of long standing—they play to the male viewer completely. As John Berger has put it:

The absurdity of . . . male flattery reached its peak in the public academic art of the nineteenth century. Men of state, of business, discussed under paintings like this [read Bouguereau's *Nymphs and Satyr*]. When one of them felt he had been outwitted, he looked up for consolation. What he saw reminded him that he was a man.[40]

Why were Degas' nudes thought to be so "debased" and "humiliating" by comparison? We may answer that it was perhaps his very prosaicizing that was so alarming. For if his bathers were seen as middle-class women, then they were simply indiscreet and rude. But I suspect that what triggered these intensely negative responses were the images' ambiguity, the untidiness of what they signified. The viewer was unable to know *who* exactly the depicted woman was and, therefore, who *he* was. Was she a streetwalker? Did she work in a brothel? Was she a working girl? Was she perhaps even his wife, who with more leisure time on her hands and with attractions like department stores and matinees in the center of the city could herself be found in the streets as unescorted and "free" as any working girl?[41]

For all of these reasons, contemporary anger toward these images may well have been a displacement onto Degas of his male audience's rage toward the depicted women and— by extension—toward changing contemporary definitions of women, sexuality, and class. We have seen how the milliner no longer fit the "safe" image of coquette; she was presented as a working woman and as an occasional, unregistered prostitute. So too had the old-fashioned registered prostitute and the middle-class wife begun to slip out of conventional sexual stereotypes. In the images of bathers we have, yet again, Degas' disarming and powerful evocation of a "terrible" modernity—that confusing reality in which one could no

longer tell who people were precisely or what, therefore, the accepted, and correct, mode of behavior was. The bather images, like the discontinuous–mode racing works and the ballet, laundress, and milliner images, assume that life is contradictory; they do not ignore the anguish or the excitement implicit in ambiguity. Insofar as the paintings admitted and expressed that ambiguity, they drew the spectator into a demystified and subversive vision that struggled against contemporary stereotypes and habitual responses. They spoke to the capacity in human beings to cope with instability and uncertainty.

# CONCLUSION

Ambiguity and contradiction in Degas' images have been the major themes of this book. In my opinion, ambiguity is potentially a powerful critical tool, because it forces the spectator into active participation rather than passive consumption. Since no single interpretation is imposed, the viewer must choose. This I take to be a radical invitation. Certainly it was ambiguity that drew me to Degas' art. The work showed two sides: what Degas and many of his contemporaries longed to hold onto, the past and privilege, and what they had no control over, the present and change.

Small wonder that workers play such a large part in these paintings, for they were major catalysts of change in the nineteenth century. Certainly there are elements of caricature and objectification in Degas' depictions of them; he could not but share pictorial norms and acquiesce to contemporary social pressures. But he countered these inclinations with others. He observed workers caught up in their daily tasks and routines; and he constructed his compositions out of a modernist vocabulary. He dramatically cropped and fragmented figures, compressed spaces, neutralized overtly intense emotions and, in sum, produced elusive narratives with detached, somewhat cool players. In this way he propelled his laundresses, milliners, and dancers out of the realm of bourgeois fantasy and into a more complex and less alienated social reality. He dignified his workers through this process of seeing, just as with other vocabularies Courbet and Manet did the same. Degas' workers are not the "masses," the "pop-

ulace," of the early part of the century; rather, they are the "people," the workers after June 1848. Insofar as Degas' work embodied change, it contributed to it as well. For although events may occur, if a culture is not ready to assimilate them, they might just as well not have happened. The more people who "see" the event, "take it in," so to speak, the more it in effect has taken place. Furthermore, when workers and the social tensions that accompanied them are not present in Degas' genre work—as in the majority of his racing paintings—the work seems empty, even monotonous. When they are at the center, it is, and was in the eyes of contemporaries— "ugly," "dislocated," "nervous," "terrible"—in other words, modern.

That the "field of maneuvers" in Degas' paintings was women is perhaps the most daring strategy of all, for to paint working women was to go straight to the heart of social agitation, exactly where ideologies about the working class and sexuality intersected. There was at least some safety in objectification; you could wink at a sexy laundress, marvel at the muscles of a hardy bricklayer. But to paint workers simply as people—that was demystifying in the extreme.

Why Degas painted this reality, what enabled him to see it, is impossible to know. One wonders nonetheless. Why did people like Karl Marx, Thomas Carlyle, and Charles Dickens see what others did not when the horror of industrialization as it developed in the nineteenth century was there for all to see? What enabled Balzac, so like Degas in many ways, to penetrate beyond appearances, beyond ideology to the degrading broken promises and wild adventures of modern life?

Balzac knew he had this ability; he put the following meditation into the mouth of one of his characters:

I used to go and study the manners and customs of the faubourg, its inhabitants and their characters. As badly dressed as a workingman,

taking no heed of convention, I aroused no suspicion. I was able to mingle with them, watch them bargaining and disputing as they left work. My observation had become intuitive; it penetrated the soul, though not neglecting the body, or rather it grasped external details so well that it at once pierced beyond them. It endowed me with the faculty of living the life of the person I was observing. . . . To what do I owe this gift? Is it second sight? Is it one of those qualities whose abuse might lead to madness? I have never investigated the source of this power; I simply possess it and use it.[1]

Degas would not have had the self-consciousness to make the same statement. Of course, Balzac did not either; a character in a novel did. Still, one wonders why these men were so endowed (or so afflicted).

I have some thoughts about the catalysts in Degas' case. For one thing, he had a profound empathy for skilled work. He was an assiduous and painstaking craftsperson who deeply admired those qualities in others. Daniel Halévy described an encounter of Degas' with stonemasons:

In the street that led from his studio to our house the sidewalks were being rebuilt. The stonemasons shaped the granite with axe strokes as sculptors do to achieve an exact, sometimes delicate shape. Degas would talk to the masons, handle the chips, and hold them up to focus on their form in the light.[2]

In notebook 30, used between 1877 and 1883, Degas made a note to observe bakers: "On the bakery, the bread: series on journeymen bakers, seen in the cellar itself or through the air vents from the street."[3] Perhaps it was this respect for skilled labor that prompted his preference for ironers over washerwomen.

Another explanation for Degas' demystifying and humanizing vision may lie in his own sexual inhibitions, which may have precluded his sexualizing working women in ways that other men of his background did. With the unusual

exception of his brothel monotypes, Degas almost never dealt overtly with sexual content in his work.[4] One can speculate that he was discomforted by intimate relationships with women (whether of his own class or another), since there is no evidence that he ever had any. In fact, his relationships with women in general were unusual. Those to whom he attached himself were either unavailable to him sexually or were socially inappropriate. First there was his aunt, his father's sister, the Baroness Bellelli; later there were inaccessible women such as Mme Halévy, Mme Straus, Mme Howland, and Mary Cassatt; or ballet dancers with whom a man like Degas might flirt but with whom he would probably not establish a public alliance. Guilt and paralysis in the realm of sexual love were probably Degas' unhappy lot. Such a man might well find some comfort in a sublimated relationship, observing lower-class women like laundresses, milliners, dancers, or café singers.

To my mind, the most enticing of the possible explanations for Degas' critique of contemporary society was his own ambiguous position in society. A poignant and embittering consequence of the pull between the pre-industrial, genteel (for the rich) past and the burgeoning modernism of the Paris in which Degas lived was social ambiguity, an inability to define oneself socially. Who could say precisely whether he or she was an artisan or a laborer; an aristocrat or a haute bourgeois; middle or working class? Edgar Degas knew that confusion intimately. His family had aristocratic roots, variously spelling their name "de Gas," "De Gas," and "Degas."[5] As early as 1789, they had invested in commerce; the painter's grandfather was a grain merchant when he fled France for Naples in 1793. There he opened a bank, which became the family business and which Degas' father inherited and continued. Even if the family was no longer technically or practically aristocratic when Degas was growing up, most of its members retained the "de" before their names as well

as certain other aristocratic habits and pretensions. Degas' sister married into Italian nobility, the family was nationalistic and enthusiastically supported the military, republicanism was distasteful to them, and they tried to maintain both city and country residences. And one of Degas' nieces at least, Jeanne Fevre, was positively obsessed with her family's genealogy, a sure sign of upper-class social anxiety.[6]

Many people described Degas as aristocratic. Jeanne Fevre called him "above all a born artist and aristocrat." William Rothenstein, the English painter, said that "in spite of his baggy clothes [he] looked the aristocrat that he was." And Pierre Cabanne, the modern historian, depicted Degas' world as that of "the old French aristocracy." Perhaps the poet Valéry expressed it best when he wrote about his acquaintance Degas that he "belonged to that delightful class of connoisseurs who take an obstinate pleasure in their own narrow-mindedness, are merciless to any novelty that is merely new, their minds full of Racine and old music . . . 'classicists' to the point of ferocity . . . people who are now, alas, a vanished race."[7]

Others, however, labeled him bourgeois. Gustave Coquiot called him "precise, hard, dry; he has a horror of movement, of agitation . . . a notary in public and private." Gauguin also referred to him as "a notary, a bourgeois of the time of Louis-Philippe." Van Gogh wrote to Emile Bernard that Degas "has resigned himself to be nothing personally but a public official with a horror of going on a spree." Even Degas said of himself, "I [lead] an ordered life, more so than anyone excepting Bouguereau. . . . I am thirsting for order."[8]

Degas' character was shaped by a mixture of social traits. The family money he inherited was banking money, and although banking in France did not take on the dimensions of risk it had in England and America until much later, still it was liquid money, open to the vicissitudes of the market

in a way land was not. On this level, then, Degas' experience was unstable and peculiarly modern. How much so became palpably clear in 1874 when his family's finances failed. Degas took on their debts as well as the tension that accompanied no longer having financial security or clear social status. This status anxiety was shared by more than a generation of aristocrats.

Degas' appetites and prejudices reflected his mixed social background. With other aristocrats, he defended the army and was very nationalistic as well as anti-Semitic. Remembering Degas as being rather taciturn at dinner one night, Daniel Halévy mused: "Had he spoken, it would no doubt have been in defense of the army . . . whose traditions and virtues he held so high." On another occasion Halévy remembered Degas' "extraordinarily eloquent comments on the subject of France." Degas' love of his country sounded clarion clear when he wrote to Daniel's father, Ludovic, and said, "there is only one country, it is ours, Monsieur."[9]

Degas' elitism also produced his distaste for the "public" who came to the Salons or those who clapped at the wrong moment during concerts. "Art for the people," he burst out one day, "how dreary." And he preferred exclusive hotels.[10] However, he gently mocked the dandyism of his friend Albert Cavé, and he befriended Camille Pissarro, the one Jew among the Impressionists. He was also <u>fascinated</u> by modern inventions such as photography, innovative printing methods, and trams. And although he tried to maintain his cultivated tastes by going regularly to the Opéra, by traveling to Dieppe and Ménil-Hubert (where his friends the Valpincons lived in Normandy), and by taking the waters at Cauterets (one of the most stylish spas in France), he also simply saw the world around him. What's more, he relished that world. Admittedly, it is reported that Degas did not like horseless carriages, because they went too fast. But when he was in the United States he certainly enjoyed the modern

wagon-lits with their "apple-pie bed[s]." And this is the man who wrote with excitement about New York: "What a degree of civilization! Steamers coming from Europe arrive like omnibuses at the station. We pass carriages, even trains on the water."[11] If Degas liked his friends' salons and the Opéra foyers, that didn't keep him from the mixed society in the cafés and restaurants of Montmartre or the café-concerts of both the Champs-Elysées and the boulevards.

One of the most telling signs of Degas' social conflicts was his attitude toward being an artist, that is, toward the exhibition, sale, and reception of his work. His predicament was typical of artists of the time. As early as 1856, at age twenty-two, he expressed disdain for the commercialism of the art world:

It seems to me that today if one wants to make art seriously and make a little original corner for oneself, or at least maintain one's innocence, it is necessary to strengthen oneself through solitude. There's too much "can-can" going on. Paintings seem to be like bets on the stock-exchange judging from the excitement of the people eager to win.[12]

In the 1870s, however, when his family's fortune collapsed, Degas seems to have become a part of the "can-can" himself, albeit in his own eccentric way, for he wrote a steady stream of letters to his friend the artist Tissot about money and dealers. In September 1871 he commented: "They tell me you are earning a lot of money. Do give me some figures. . . . Give me some idea of how I too could gain some profit from England." From New Orleans in 1872: "And you [Tissot], what news is there since the 700 pounds? You with your terrible activity would be capable of drawing money out of this crowd of cotton brokers and cotton dealers, etc." And from Paris in 1873:

Here Durand-Ruel assures me of his devotion and swears he wants everything I do. But Agnew really intrigues me. . . . [People] urge

me to place myself in his redoubtable hands. Did you tell him the picture I described to you from back there was coming? In a word, entertain me with some juicy ideas and some veritable sums of money.[13]

Despite these monetary interests, one still hears in the 1890s of Degas' contempt for art-world commerce and propaganda: "Degas spoke of this to me recently with extraordinary vehemence," wrote Pissarro to his son Lucien, "and he made no exceptions when he expressed his hatred for [artists] advertising themselves."[14] But Degas had to "advertise" himself. All artists did. The evaporation of state patronage and the concomitant development of a bourgeois audience transformed artists into businessmen or sent them in search of some. It was in this business atmosphere, no doubt, that Degas referred to his own paintings as *articles*[15] and maintained a continuing financial arrangement with the dealer Paul Durand-Ruel.

Degas was also disdainful of contemporary modes of exhibiting. He said to his friends the Halévys: "If I were hung in the Luxembourg [the museum of contemporary art], I'd feel as though I were being arrested."[16] He told the English painter Rothenstein to "show in color shops, in restaurants—anywhere but at the brothels that picture shows are."[17] Despite Degas' snobbism, however, he competed in the same economic market as did the others, and he made concessions to that market in his work.

Yes, Degas loved the past, but somewhere he knew that that was precisely what it was. He was a man caught in the social tides of his time. Through personal and social circumstances beyond his control, he was left more and more bereft of his former class position and the power it implied. Not only did he know that the world was changing but also he knew that the social influence of people like himself was shrinking. He was in the position shared by myriad aristo-

cratic and wealthy people who were displaced by capitalism
and its values; he had irreparably lost status. Degas exem-
plified the claim of Richard Hofstadter, a twentieth-century
American historian, that people lose a sense of authority in
the world not merely through a "shrinkage in their means
but through the changed pattern in the distribution of def-
erence and power."[18]

No longer rich and powerful and—most important—
no longer thoroughly committed to the rituals of such a
life, Degas was a socially ambiguous person. Status anxiety
may have been the cause of his intense nationalism and anti-
Semitism, his constant hypochondria and bitter humor, his
nervousness, and the shape and meaning of his paintings.
Because he had little at stake in the prejudices of a particular
social group, his curiosity could extend beyond the limits set
by social commitment. Perhaps he could see more than most
of his contemporaries, in part because he was socially no-
madic. His location outside conventional social and emo-
tional structures contributed to his profound loneliness, but
it may also have contributed to the richly ambiguous and
dialectical nature of his realism.

*Notes*
*Bibliography*
*Index*

# Notes

In the interest of maintaining the flow of the text, various sources have been grouped together under one note number. Page numbers from these sources will follow the sequence of citations in the text.

## INTRODUCTION

1. Cited by Walter Benjamin in "Paris—Capital of the Nineteenth Century," *Reflections* (New York: Harcourt, Brace, Jovanovich, 1979), p. 151.

2. Some of the most interesting and original discussions of the meaning and implications of the display mentality in the nineteenth century were made by Benjamin. See his *Charles Baudelaire: A Lyric Poet in the Era of High Capitalism* (London: New Left Books, 1973), esp. part 2, "The Flaneur"; see also his "Paris," pp. 146–162.

3. T. J. Clark, in his book *The Painting of Modern Life: Paris in the Art of Manet and His Followers* (New York: Knopf, 1985) raises similar issues. Clark is particularly interested in questions of class and in the ever-shifting ideological alliances that characterized the molten society of Paris from the 1860s to the 1880s. A major difference between Clark's book and this one is that the sexual ideologies produced and maintained at the time are central to the motivations of my work and peripheral to his.

4. The concept of ideology is being used here in a specifically Marxian sense. In that sense the term refers to an outlook or set of ideas—consciousness—that is class-determined and that advances the interests of the dominant class. Marx put it well:

> In every epoch the ideas of the ruling class are the ruling ideas, that is, the class that is the ruling *material* power of society is at the same time its ruling *intellectual* power. The class having the means of material production has also control over the means of intellectual production. The ruling ideas are nothing more than the ideal expression of the dominant material relationships grasped as ideas, hence of of the relationships which make one class the ruling one and therefore the ideas of its domination. The individuals who comprise the ruling class possess among other things consciousness and thought. Insofar as they rule as a class and determine the extent of a historical epoch, it is self-evident that they do it in its entire range. Among other things they rule also as thinkers and producers of ideas and regulate the production and distribution of the ideas of their age. Their ideas are the ruling ideas of the epoch (Karl Marx, *The German Ideology,* in Lloyd Easton and Kurt H.

Guddat, eds., *Writings of the Young Karl Marx* [New York: Doubleday, 1967], p. 438).

Because these ideas are shared by all members of society, they are extremely potent. Yet, they distort the fundamental material realities of daily life. In fact, they set these realities on their head and make the distortions seem normal. For example, in a capitalist culture, private property appears natural, when it is not; wages seem that which is due labor, when they are not; wages and profit seem to be in a rational relationship to each other, when they are not.

Of course, these notions are partially true—and there's the dilemma. Insofar as we believe them, we also reproduce and maintain them as cultural givens. What this book tries to address is how Degas' work functions in relationship to those ideas.

For a particularly compelling discussion of ideology see Louis Althusser, "Ideology and Ideological State Apparatuses," in *Lenin and Philosophy and Other Essays,* trans. Ben Brewster (London: New Left Books, 1971), pp. 127–186.

5. Paul H. Tucker in his book, *Monet at Argenteuil* (London: Yale University Press, 1982) discusses this phenomenon, esp. in chap. 2, pp. 27–56. See also Clark, *Painting of Modern Life,* chap. 3, pp. 147–205.

6. Jeanne Gaillard, *Paris la ville 1852–1870* (Paris: Champion, 1977), p. 246, cited in Alain Corbin, *Les Filles de noce: Misère sexuelle et prostitution 19ᵉ et 20ᵉ siècles* (Paris: Aubier-Montaigne, 1978), p. 302.

7. Emile Zola, *L'Assommoir,* trans. Leonard Tancock (Harmondsworth: Penguin, 1970), pp. 392–393.

8. See Max Horkheimer's essay, "Traditional and Critical Theory," in Matthew J. O'Connell, trans., *Critical Theory* (New York: Seabury, 1972), pp. 188–243, for an extensive discussion of this idea.

9. My approach in this book is in contrast to Theodore Reff's in *Degas: The Artist's Mind* (New York: Harper and Row, 1976). Reff analyzes Degas and his work in the context of contemporary literature and art and, as the title suggests, tries to elucidate how Degas' personality, taste, and background shaped his work. I will be trying to understand what his work signified to others.

10. Frederick Engels, Margaret Harkness, excerpted in Maynard Solomon, ed., *Marxism and Art* (New York: Knopf, 1974), pp. 68–69.

## 1: THE RACING PAINTINGS

1. Other examples in this group executed between 1865 and 1890 can be found in Paul-André Lemoisne, *Degas et son oeuvre,* 4 vols. (Paris: P. Brame et C. M. de Hauke, 1946), nos. 446, 502, 597, 597bis, 761, 764 850, 852, 859, 878, 939, 1001.

2. Halévy himself describes just such an event in his *Carnets* (Paris: Calmann-Levy, 1935), 1:206. Halévy (1834–1908) was a well-known librettist and playwright who collaborated with Henri Meilhac, Jacques Offenbach, and Georges Bizet. Degas' close friendship with Halévy began at the Lycée Louis-le-Grand and lasted until the Dreyfus affair.

3. See other examples in Lemoisne, *Degas,* nos. 140–142, 387, 495, 649.

4. Albert Boime, *The Academy and French Painting in the Nineteenth Century* (London: Phaidon, 1971), pp. 43, 66; Philippe Grunchec, *Le Grand Prix de peinture; Les Concours des Prix de Rome de 1797 à 1863* (Paris: Ecole Nationale Supérieure des Beaux-Arts, 1983), pp. 433, 436.

5. *"Équivoques"; Peintures françaises du XIX^e siècle* (Paris: Musée des Arts Décoratifs, 1973), unpag.

6. Grunchec, *Le Grand Prix,* pp. 432, 437, 430, 436.

7. Degas' notebooks are reproduced in Theodore Reff, *The Notebooks of Edgar Degas,* vols. 1, 2 (Oxford: Clarendon Press, 1976). See Notebook 3, 2:19, and Reff's commentary in 1:44; Reff's comments on Degas' sources, 1:55; Notebook 13, 2:3, and Reff's commentary in 1:78–79; for copies after de Dreux, see Notebook 13, 2:60, 61, 65, 66, 68, 118.

8. Jean-Marie Mayeur, *Les Débuts de la Troisième République, 1871–1898* (Paris: Éditions du Seuil, 1973), p. 11; Daniel Halévy, *The End of the Notables,* trans. Alain Silvera and June Guicharnaud (1930; Middletown: Wesleyan University Press, 1974), pp. 133, 125; Mayeur, *Débuts,* p. 27.

9. Degas made a number of comparable photographs with models obviously posed in front of backdrops. See his *Apotheosis of Homer* (1885, Archives, Bibliothèque Nationale); *Mme Howland* (ca. 1887, Mme Louis Joxe Collection, Paris); *Degas and Ernest Chausson* (ca. 1895–1896, printed by Jean-Loup Charmet); and, perhaps most remarkably, the eight photographs entitled *Dancer from the Corps de Ballet* (ca. 1875 or 1896 [see below, chap. 2 n. 23], Archives, Bibliothèque Nationale). All are reproduced in Antoine Terrasse, *Degas et la photographie* (Paris: Denoel, 1983), figs. 2, 8, 10, 26–33.

10. For an extensive discussion of this phenomenon, see Karl Marx on alienation in "Estranged Labor," *Economic and Philosophic Manuscripts of 1884,* trans. Martin Milligan, ed. and intro. Dirk J. Struik (New York: International Publishers, 1964), pp. 106–119. See also "The Chapter on Money," *Grundrisse; Foundations of the Critique of Political Economy,* trans. Martin Nicolaus (New York: Vintage Books, 1973), pp. 113–238.

11. At the time of his death, Degas owned one painting and two drawings by Brown and eighteen prints each by Brown and de Dreux; the subjects were all horses. See H. G. E. Degas, *Collection Edgar Degas* (Paris: Galerie Georges Petit, 1918).

12. Albert de Saint-Albin, *Les Courses de chevaux en France* (Paris: Hachette, 1890), p. 358; Jean-René-André Trarieux, *Si les Chevaux pouvaient parler* (Paris: Stock, 1926), pp. 19–20.

13. Joseph-Antoine Roy, a recent chronicler of the Jockey Club, wrote that "at that date Chalons-sur-Marne was a great center for troops practicing maneuvers, and that the presence of Jockey Club members—who to a great extent were officers—in this Salon made one think of the field of maneuvers" (*Histoire du Jockey Club de Paris* [Paris: M. Rivière, 1958], p. 71).

14. Whereabouts unknown; Frick Collection Reference Library, New York.

15. See Degas' Notebook 16, p. 38, in Reff, *Notebooks,* vol. 2 and Reff's commentary in 1:91; for the copies after Meissonier, see Notebook 20, pp. 29, 31; Notebook 22, pp. 123, 127; Notebook 23, p. 41, all in vol. 2 and Reff's comments in 1:20.

16. Informative commentaries on French nineteenth-century taste can be found in Francis Haskell, *Rediscoveries in Art: Some Aspects of Taste, Fashion and Collecting in England and France* (Ithaca: Cornell University Press, 1976), esp. chaps. 3–5; and in H. White and C. White, *Canvases and Careers* (New York: John Wiley and Sons, Inc., 1965), esp. chap. 2, pp. 39 ff.

17. See T. J. Clark, "The Bar at the Folies-Bergère," in M. Bertrand and E. T. Gargan eds., *The Wolf and the Lamb: Popular Culture in France* (Saratoga: Anma Libri, 1977), pp. 233–252, for a fascinating social analysis of attendance at the café-concerts in Paris in the 1860s, 1870s, and 1880s. Clark augmented and refined the argument in his book *The Painting of Modern Life,* pp. 205–268.

18. The history of the *pari mutuel* is extremely interesting and can be read about in detail in All Right, *Les Coulisses du pari mutuel* (Paris: de Chaix, 1891). For other attitudes toward the *paris,* one might consult Saint-Georges [Louis Pierre Ernest, Baron de Caters], *Les Courses de chevaux* (Paris: P. Lafitte et Cie, 1912); Saint-Albin, *Les Courses;* and Fernand-Gabriel Laffon, *Le Monde des courses* (Paris: Librairie illustrée, 1887).

19. Crafty [Victor Géruzez], *Paris à cheval* (Paris: E. Plon, 1889), p. 333. Crafty wrote and illustrated a number of other books on horseracing, including *La Chasse à courre* (1888), *La Chasse à tir* (1887), and *L'Equitation puerile et honnête* (1886). He also wrote *Paris à bois* (1890) and *Snob à l'exposition* (1867).

20. Saint-Albin, *Les Courses,* p. 23.

21. Ibid., pp. 283, 354.

22. Crafty, *Paris à cheval,* pp. 337, 338, 351, and passim.

23. Saint-Albin, *Les Courses,* p. 213; All Right, *Les Coulisses,* p. 97.

24. Roy, *Histoire du Jockey Club,* pp. 80, 60, 75, 57.

25. Ibid., pp. 86–93, 92.

26. Admittedly, few critics in the nineteenth century noted these characteristics, but Ernest Chesneau did; see his "Le Japon à Paris," *Gazette des Beaux-Arts* 18 (September 1878): 391–392.

27. Daniel Catton Rich, *Degas* (New York: Harry N. Abrams, 1951), p. 70.

28. Gabriel Weisberg, *Japonisme: Japanese Influence on French Art 1854–1910* (Cleveland: Cleveland Museum of Art, 1975), p. 49.

29. In *Orientalism* (New York: Vintage, 1979), Edward Said offers a searing critique of the way in which the West has conceptualized (and therefore treated) the East. Said claims that the comparative method of this conceptualization is prejudicial, for the West sees itself as the ideal against which the East—the "other"—is set. In Said's words: "Such comparitism is rarely descriptive; most often, it is both evaluative and expository. . . . Whether this comparative attitude is principally a scholarly necessity or whether it is disguised ethnocentric race prejudice, we cannot say with absolute certainty. What we can say is that the two work together in support of each other" (pp. 149–150).

In terms of art, an extremely interesting example of the comparative view of the East appears in the article "Grèce et Japon" by E. Pottier, in *Gazette des Beaux-Arts* 2d Ser., 32, (1890): 105–132. Pottier goes to great lengths to assert the similarities between Greek and Japanese art. He attempts to prove his point by showing that the two arts share such characteristics as the contours of forms, the folds of drapery, the silhouettes of figures. He points out the "secret solidarity" between these two apparently different peoples. And he even asks if perhaps the "races" did not have some contact originally. In other words, to make the Japanese acceptable, Pottier underlines what he found identical in them to the West.

30. E. J. Hobsbawm, *The Age of Capital 1848–1875* (New York: Scribner, 1975), p. 149; Meron Medzini, *French Policy in Japan During the Closing Years of the Tokugawa Regime* (Cambridge: Harvard University Press, 1971), pp. 49–52; David Thomson, *Democracy in France Since 1870* (Oxford: Oxford University Press, 1969), p. 305.

31. Joseph-Arthur, Comte de Gobineau, *Essai sur l'inégalité des races humaines* (Paris: Librairie de Paris, 1854), 1:491, 455–456, 505.

32. Rudolf Lindau, *Un Voyage autour du Japon* (Paris: Hachette, 1864), pp. 2–3, 235, 35. Edmond de Goncourt quotes this book at length in *Outamaro, Le Peintre des maisons vertes* (Paris: Bibliothèque-Charpentier, 1891), p. 106. Sharon Flescher, in her extremely informative *Zacharie Astruc: Critic, Artist, and Japoniste (1833–1907)* (New York: Garland, 1978), notes that Astruc also used Lindau's book extensively when preparing his articles on *japonisme* in the early 1860s; see pp. 335, 371–373.

33. Pierre Leroy-Beaulieu, *The Awakening of the East,* trans. Richard Davey (New York: McClure, Phillips and Co., 1900), pp. 171, 87; Marquis de Moges, "Voyage en Chine et au Japon," *Le Tour du monde* (1860), 1:170; Lindau, *Un Voyage,* p. 32.

34. Chesneau, "Le Japon à Paris," pp. 389–390. The reference to the rue du Sentier may be an additional racial slur, referring to Jews who lived and worked on that and neighboring streets in the second and ninth arrondissements.

35. E. de Goncourt, *Outamaro,* pp. 156, 163.

36. Emile Zola, *Ladies' Delight,* [Au Bonheur des Dames], trans. April Fitzlyon (1882; London: Calder, 1958), p. 394.

37. Michael Justin Wentworth, in his interesting article entitled "Tissot and Japonisme" (*Japonisme in Art* [Tokyo: Committee for the Year 2001, 1980]), discusses this painting, calling its method "superficially anthropological" and its winter-garden background "nothing more than Japanese art as an ingredient of fashionable taste" (p. 131).

38. Ronald Pickvance, notes the "agglomeration of Japanese props" as well as the painting's generally European style in "Monet and Renoir in the Mid-1870s," *Japonisme in Art,* p. 158.

39. It is significant, I think, that the question of form never comes up in discussions of the nineteenth-century French taste for objects from the Near East or North Africa. In works by Théodore Chassériau, Jean-Léon Gérôme, and Samuel-Auguste-Eugène Fromentin, it is always the subject matter (almost invariably of a sexual nature) that is considered "Eastern." Michel Melot recently suggested in a fascinating article that

perhaps the French sensitivity to Japanese form, rather than subject matter, was related to France's more distant and disinterested relationship to Japan compared with its more exploitative relationship to North Africa. He also suggested that to see only material details and subject in a painting is seeing in terms of what one can possess, whereas perceiving form in a work is perceiving what is more intrinsic to a foreign culture on its own terms ("Questions au Japonisme," *Japonisme in Art*, pp. 256–257).

My own understanding of the meaning and function of Japanese form in French art results from lengthy discussions with Carol M. Zemel, whose incisive and original observations helped me to revise completely my understanding of the material.

40. Chesneau, "Le Japon à Paris," p. 390; Théodore Duret, "L'Art japonais," *Gazette des Beaux-Arts* 26 (1882):118, 126, 130–131; Louis Gonse, *L'Art japonais* (Paris: Librairies-impriméries réunies, 1886), p. 100; E. de Goncourt, *Outamaro*, pp. 31–32.

41. For appreciation of these characteristics see Gonse, *L'Art japonais*, pp. 84, 67; Paul Mantz, "Exposition de l'art japonais," *Gazette des Beaux-Arts* 27, 2d ser. (May 1883), p. 410; Duret, "L'Art japonais," p. 120; E. de Goncourt, *Outamaro*, p. 41. Also see Philippe Burty, "Japonisme," *Le Renaissance littéraire et artistique* (July 1872), 1:106; Flescher, *Astruc*, p. 358; Armand Silvestre, Preface to *Recueil d'estampes gravées à l'eau forte* (Paris: Galerie Durand-Ruel, 1873), p. 23.

42. Edmond Duranty, *La Nouvelle Peinture* (1876; Paris: Floury, 1946), p. 39; Joris-Karl Huysmans, "L'Exposition des Indépendants en 1881," *L'Art moderne* (Paris: G. Charpentier, 1883), p. 248; Duret, "L'Art japonais," p. 125; Chesneau, "Le Japon à Paris," pp. 391–392; Burty, "Le Salon," *Le Rappel*, June 15, 1870, p. 3; Huysmans, "L'Exposition des Indépendants en 1880," *L'Art moderne*, p. 133.

43. Paul Veron, in *Journal Amusant*, May 25, 1872, cited in G. H. Hamilton, *Manet and His Critics* (New York: Norton, 1969), p. 156.

44. Duranty, *La Nouvelle Peinture*, trans. Linda Nochlin, in *Impressionism and Post-Impressionism 1874–1904* (Englewood Cliffs, N.J.: Prentice-Hall, 1966), pp. 5–6. Duranty's vocabulary is remarkably close to Chesneau's evocation of the Japanese influence on Bracquemond's work, especially in the emphasis on dissymmetry, the challenging of perspective, and the creation of disequilibrium.

45. Huysmans, "L'Esposition . . . 1880," pp. 130–131, 249–250; Georges Rivière article on the third "Exposition des Impressionistes" in *L'Impressioniste*, no. 1 (April 6, 1877) cited in Lemoisne, *Degas*, I:240; Charles Baudelaire, "The Painter of Modern Life" (ca. 1859–1860), *Selected Writings on Art and Artists*, trans. P. E. Charvet (Harmondsworth: Penguin, 1972), p. 403.

46. Hobsbawm, *Age of Capital*, p. 193; Edmond and Jules de Goncourt, *Pages from the Goncourt Journal*, ed. and trans. Robert Baldick (Oxford: Oxford University Press, 1978), p. 62.

47. For extensive discussions of the mental illnesses produced by modern society, see Georg Simmel, "The Metropolis and Mental Life" (1903), *On Individuality and Social Forms* (Chicago: University of Chicago Press, 1971), and Emile Durkheim's classic *Suicide* (1897; New York: The Free Press, 1966), esp. bk. 2, chap. 5. In this context Sigmund Freud's extensive work on hysteria is also of particular importance. See Josef Breuer and Sigmund Freud, *Studies on Hysteria* (1893–1895), in *The Standard Edition of*

*the Complete Psychological Works,* trans. James Strachey et al., 24 vols. (London: Hogarth Press, 1960), vol. 2.

48. Melot, in "Questions," p. 252, offers an interesting and similar interpretation of the use of Japanese forms by French artists: "Because of the conventional and quasi-ritualistic aspect that Japanese images assume in Western eyes, and because the quality of exoticism conferred on the images both the idealization inherent in things foreign, as well as the authority of the Real, they had the power of transgressing what was forbidden to iconography by Christian civilization." Melot, however, is referring specifically to certain prostitutional themes; I have in mind the realization of the disequilibrium of modern social life.

49. Edgar G. H. Degas, *Letters,* ed. Marcel Guérin, trans. Marguerite Kay (1945; Oxford: B. Cassirer, 1947), pp. 21, 31, 21.

50. Georg Lukács, "The Zola Centenary," *Studies in European Realism* (1940; New York: Grosset and Dunlap, 1964), p. 86.

51. "La Dame au clair obscur social," Duranty, in *Paris-Journal,* May 8, 1870, cited in Lemoisne, *Degas,* 1:62, 233.

52. Fernand Laffon wrote that the starter was the jockey's enemy because he frequently fined jockeys; see *Le Monde des courses,* p. 79.

53. See Guys' *Scene at the Races* (ca. 1860, Musée du Petit Palais, Paris). Both the Guys and Morin are reproduced in Carol Duncan, *The Pursuit of Pleasure: The Rococo Revival in French Romantic Art* (New York: Garland, 1976), nos. 71, 75.

54. Emile Zola, *Nana,* trans. George Holden (1880; Harmondsworth: Penguin, 1972), p. 345. Another excellent example can be found in Gustave Flaubert's *Sentimental Education,* trans. Robert Baldick (1869; Harmondsworth: Penguin, 1969), pp. 204–211.

55. See especially Lemoisne, *Degas,* nos. 281 and 75; other examples of works in which women are painted in a perfunctory manner are nos. 76, 258, 262, 387, 461, 850, 859, 889.

56. Examples are Tōshūsai Sharaku's *The Actor Otani Oniji III as Edohei* (ca. 1794, color woodcut, Metropolitan Museum of Art), reproduced in Colta Feller Ives, *The Great Wave* (Boston: New York Graphic Society, 1974), p. 90; and Katsukawa Shunko's *Actor Ichikawa Komazo II* (ca. 1768, Tokyo National Museum), reproduced in Sadao Kikuchi, *A Treasury of Japanese Wood Block Prints: Ukiyo-e,* trans. Don Kenny (New York: Crown, 1969), p. 67.

57. Similar effects can be found in Manet's *On the Beach* (1873, Musée d'Orsay) and Monet's use of a shadow on a woman's face in *On the Beach, Trouville* (1870, Tate Gallery, London), but neither, it seems to me, does as much violence to the human form as Degas' image.

58. See Lemoisne, *Degas,* no. 184, for the work before cleaning. For a fascinating unraveling of the meaning of this painting, see William Wells, "Who was Degas' Lyda?" *Apollo* 95, n.s. (February 1972), 129–134.

59. My understanding of "looking" as an act of power was incalculably deepened by an unpublished paper by Deborah Bershad entitled "Degas' 'Woman with Binoculars'" (State University of New York, Binghamton, 1980). Bershad discusses at length

the many ways in which seeing embodies power and how the use of binoculars and the camera facilitated the implementation of that power. She cites Michel Foucault's extensive discussion of this phenomenon in *Discipline and Punish,* trans. A. Sheridan (New York: Pantheon, 1979), esp. pt. 3, chap. 3. See in addition E. Ann Kaplan, *Women in Film: Both Sides of the Camera* (New York: Methuen, 1983), esp. chap. 1.

60. Denis Poulot, *Le Sublime ou le travailleur comme il est en 1870, et ce qu'il peut être,* intro. Alain Cottereau (1870; Paris: Découverte/Maspero, 1980), p. 261; Edmond and Jules de Goncourt, *The Goncourt Journals 1851–1870,* ed. and trans. Lewis Galantière (New York: Doubleday, Doran, 1937), p. 47.

61. Zola, *Ladies' Delight,* p. 97.

62. George Moore, *Confessions of a Young Man* (London: W. Heinemann, 1928), pp. 142–143.

63. Corbin, *Les Filles de noce,* pp. 192–193.

64. See Lemoisne, *Degas,* nos. 179, 268, 269.

65. Georg Lukács, "Balzac: *The Peasants,*" *Studies in European Realism,* p. 22.

## 2: AT THE BALLET

1. Two very useful studies are Lillian Browse's pioneering work *Degas Dancers* (London: Faber and Faber, 1949), and Linda Muehlig, *Degas and the Dance* (Northampton: Smith College Museum of Art, 1979). Muehlig pays very close attention to the nineteenth-century interpretation of steps and poses.

2. Ivor Guest, *The Divine Virginia* (New York: M. Dekker, 1977), p. v; Boris Kochno, *Le Ballet en France du quinzième siècle à nos jours* (Paris: Hachette, 1954), p. 123. The high point of dance in nineteenth-century France was from 1830 to 1850, the period of the Romantic ballet. Memorable ballets created then were *La Sylphide, Ondine,* and *Giselle;* outstanding dancers were Marie Taglioni, Fanny Elssler, and Carlotta Grisi. See Lillian Moore, *Artists of the Dance* (New York: Thomas Y. Crowell, Company, 1938), p. 75.

3. From Lemoisne's *Degas* alone, one learns that Degas painted and drew about six hundred ballet works. Approximately forty-five major ones went to the dealer Durand-Ruel. The rest went primarily to individual buyers, each averaging about two works. The largest individual purchaser was H. O. Havemeyer; other buyers included Henri and Alexis Rouart, Albert Hecht, Jean-Baptiste Faure, Ernest May, Ambroise Vollard, Jacques-Emile Blanche, Gustave Caillebotte, Jacques Doucet, Théodore Duret, and Daniel Halévy. These works were clearly in demand, as were the racing paintings.

4. August Bournonville, *My Theater Life* (Middletown: Wesleyan University Press, 1979), pp. 554–555.

5. A raked stage sloped from the back to the footlights with a gradient that varied from one and a half to four degrees. It was intended to aid the illusion of scenes painted in perspective and to give the actors upstage greater visibility to the audience. Its use began in the 1530s in Italy and continued in Europe and America until the turn of the century, according to Phyllis Hartnoll, ed., *The Oxford Companion to the Theatre* (Lon-

don: Oxford University Press, 1961), p. 914. I received additional information from my colleague Don Boros, Professor of Theater, State University of New York, Binghamton.

6. Georges Montorgueil, *Paris Dansant* (Paris: T. Belin, 1898), pp. 210–211; "Montorgueil (Octave Lebesque, dit Georges)," *Grand Larousse encyclopédique* (Paris: Larousse, 1963), 7:499.

7. Edmond About, "L'Exposition de Baudry," *Le Siècle,* August 29, 1874, reprinted in *Les Peintures de l'Opéra de Paris de Baudry à Chagall* (Paris: Arthena, 1980), pp. 36–37.

8. Ivor Guest, *The Ballet of the Second Empire* (London: A. and C. Black, 1953), 1:15–16.

9. Ibid., p. 15; Gustave Coquiot, *Degas* (Paris: Librairie Ollendorff, 1924), p. 73.

10. Halévy, *Carnets,* 1:12.

11. Charles Garnier, *Le Nouvel Opéra de Paris* (Paris: Ducher, 1878), reprinted in *Les Peintures de l'Opéra,* pp. 85, 89.

12. Two of the works Degas exhibited then were *The Dancing Class* (fig. 53) and *The Rehearsal of the Ballet on the Stage of 1873* (Lemoisne, *Degas,* no. 400). For an extensive and intricate discussion of the dating of these early depictions of the ballet, see Ronald Pickvance, "Degas's Dancers: 1872–6," *Burlington Magazine* 105 (1963), pp. 256–266.

13. Degas frequented the older Opéra on the rue Le Peletier before it burned down in the autumn of 1873, and many of the drawings he subsequently used for his ballet images derive from those visits. Nevertheless, since it was Garnier's building that he frequented after 1875, the way in which he deployed the earlier drawings may be seen as an interpretation of his daily visits to the new building and the world he encountered there.

14. Roqueplan's remark is cited in Coquiot, *Degas,* p. 73; Bernay's in Guest, *Ballet of the Second Empire,* I:8–9; and Degas' sonnet in Degas, *Letters,* p. 264.

15. Guest, *Ballet of the Second Empire,* I:18.

16. Ibid., I:22, 26; 2:66; Moore, *Artists of the Dance,* pp. 131, 96, 79, 155.

In the 1870s the Mante family lived in the same building as Degas. See A. S. Godeau, "Louis-Amedée Mante: Inventor of Color Photography?" *Portfolio* 3, 1 (January–February 1981): 43. See also Louise Robin-Challan, *Danse et danseuses a l'Opéra de Paris 1830–1850,* Thèse de Troisième Cycle de l'Université de Paris VII, 1983, for social analysis of an earlier period which is, nonetheless, relevant to this study.

17. Georges Duveau, *La Vie ouvrière en France sous le Second Empire* (Paris: Gallimard, 1946), pp. 334, 339.

18. "Corps de ballet" meant the whole company of dancers. The first and second quadrilles defined the hierarchy of dancers in the corps de ballet at the Paris Opéra. See Horst Koegler, *Concise Oxford Dictionary of Ballet* (Oxford: Oxford University Press, 1977), pp. 132–133, 430; Gaston Vuillier, *A History of Dancing* (New York: D. Appleton and Co., 1898), pp. 373–374.

19. Duveau, *La Vie ouvrière,* pp. 327–328. I arrived at the 121 to 486 francs a year

by multiplying 243 days (6 days a week for 9 months, taking into consideration at least 3 months unemployment) by 50 centimes (equaling 121.5 francs) and then by 2 francs (equaling 486 francs). For a more recent analysis than Duveau's of Parisian salaries during the nineteenth century, see Jacques Rougerie, "Remarques sur l'histoire des salaries à Paris au XIX$^e$ siècle," *Le Mouvement Sociale,* no. 63 (1968), pp. 71–108.

20. Renoir was the only artist of the group who came from a genuinely poor background; his father was a tailor. Degas' family was in banking, liquor, and cotton; Manet's had inherited wealth and came from a long tradition in government service; Sisley's father exported artificial flowers to South America; Monet's family owned a grocery store. See the very interesting discussion on the subject of the Impressionists' class background in White and White, *Canvases and Careers,* chap. 4, esp. pp. 112–114, 129–130.

21. A. P., article on the third "Exposition des Impressionistes," in *Le Petit Parisien,* April 7, 1877, cited in Lemoisne, *Degas,* I:242; Paul Mantz, "L'Exposition des Indépendants," *Le Temps,* April 23, 1881, reprinted in Pierre Cabanne, *Edgar Degas,* trans. M. L. Landa (New York: P. Tisné, 1958), p. 93; Jules Claretie, "M. Paul Renouard et l'Opéra," *Gazette des Beaux-Arts* 23 (May 1881): 436.

22. Degas, *Letters,* p. 16.

23. My dating of the photograph is based on a comment made by W. M. Rossetti in 1876 in response to seeing some works by Degas at the Deschamps Gallery, London. He wrote: "Degas sends several pictures of ballet-rehearsals, as well as a number of photographs somewhat less exclusively devoted to the backstairs of Terpsichore. The pictures are surprisingly clever pieces of effect, of odd turns of arrangement, and often of character, too pertinaciously divested of grace" (*Academy,* April 29, 1876, cited in Pickvance, "Degas's Dancers," p. 265). For other dating, see Terrasse, *Degas,* pp. 46–47.

24. For the fan, see Lemoisne, *Degas,* no. 564; for the monotypes, see Eugenia P. Janis, *Degas Monotypes* (Cambridge, Mass.: Harvard University Press, 1968), checklist nos. 206–209, 211–215, 218–231.

25. Linda Nochlin, *Realism* (Harmondsworth: Penguin, 1971), p. 265.

26. I am indebted to the dance critic Barbara L. Newman for her help in reading the steps, gestures, and behavior of the dancers in Degas' paintings; her most recent publication is *Striking a Balance* (Boston: Houghton Mifflin, 1982).

27. For other examples, see Lemoisne, *Degas,* nos. 418, 471, 483, 574, 627, 650, 938.

28. Jacques, article on the third "Exposition des Impressionistes," in *Homme Libre,* April 12, 1877, cited in ibid., 1:242.

29. I use "his" advisedly in this sentence, because I believe that the male spectator participated more fully than did the female in the imagery (and imagined life) of the ballerina. For other examples of this disclosure, see Lemoisne, *Degas,* nos. 324, 362, 398, 400, 408, 512, 530, 559, 573, 653, 661, 700, 820, 853.

30. See Pickvance, "Degas's Dancers," pp. 256–258.

31. In 1874 Burty described one of the depictions of the ballet by Degas in the

first Impressionist exhibition as "un tout petit tableau" (*La République française,* April 25, 1874, cited in Pickvance, "Degas's Dancers," p. 257).

32. The connection between Degas and paintings of *la vie élégante* was first suggested to me by Carol Duncan. In particular, see Duncan's *The Pursuit of Pleasure,* pp. 73–74, 78, 110–111.

33. Reproduced in Mary Clarke and Clement Crisp, *Ballet Art from the Renaissance to the Present* (New York: Clarkson N. Potter, 1978), p. 58.

34. Louis-Sebastian Mercier, *Tableaux de Paris, 1782–1788,* cited in Louis Chevalier, *Laboring Classes and Dangerous Classes in Paris During the First Half of the Nineteenth Century,* trans. Frank Jellinek (1958; Princeton: Princeton University Press, 1981), p. 385; Balzac, cited in Chevalier, ibid., p. 386; see also pp. 336, 372, 394. I do not at all mean to discount here the caricatural aspect of the homeliness of Degas' figures. In Degas' Notebooks—for example, nos. 4, 17, and 34 (see Reff, *Notebooks,* vol. 2)—one finds caricatures of daily life and of political leaders, as well as caricatures by others. In Notebooks 21 (p. 4) and 23 (p. 44) (see Reff, ibid.), he mentions the Swiss philosopher and physiognomist Johann Caspar Lavater; Degas was also an enthusiastic collector of Daumier and Gavarni. Clearly, caricature as an expressive device was important to him. It is no accident, however, that his uses of caricature coincided with his depictions of lower-class people.

35. Charles Ephrussi, article on the "Exposition des Artistes Indépendants," in *Gazette des Beaux-Arts,* May 1, 1880, cited in Lemoisne, *Degas,* 1:248, and translated in Cabanne, *Edgar Degas,* p. 93 (biographical information on Ephrussi can be found in Jean S. Boggs, *Portraits by Degas* [Berkeley and Los Angeles: University of California Press, 1962], p. 117); Albert Wolff, article on sixth "Exposition des Impressionistes," in *Le Figaro,* April 10, 1881, cited in Lemoisne, *Degas* 1:249, and translated in Cabanne, *Edgar Degas,* p. 93; Paul Mantz, on same "Exposition," *Le Temps,* April 23, 1881, cited in Lemoisne, *Degas,* p. 250, translated in Cabanne, *Edgar Degas,* p. 93; Huysmans, "L'Exposition 1880," *L'Art Moderne,* p. 132.

36. L. Halévy, cited in Guest, *Ballet of the Second Empire,* 1:12. *Coryphée* designates a minor soloist in a ballet company. See Koegler, *Concise Oxford Dictionary of Ballet,* p. 133.

37. Comte de Maugny, cited in Guest, *Ballet of the Second Empire,* 1:16–17.

38. Reproduced in Gabriel P. Weisberg, *The Realist Tradition: French Painting and Drawing 1830–1900* (Bloomington: Indiana University Press, 1981), p. 68.

39. This is not true of all of Millet's work; notable exceptions are *The Sower* (1850, Museum of Fine Arts, Boston) and *The Man with the Hoe* (1859–1862, on loan from a private collection to California Palace of the Legion of Honour, San Francisco). For quite different but overlapping social analyses of Millet's work, see Robert Herbert, "City vs. Country: The Rural Image in French Painting from Millet to Gauguin," *Artforum* 8 (February 1970), 44–55; and T. J. Clark, *The Absolute Bourgeois* (Greenwich: New York Graphic Society, 1973), chap. 3.

40. T. J. Clark, *Image of the People* (Greenwich: New York Graphic Society, 1973), chap. 6, looks at the other side of that response when he analyzes Parisian antipathy in

1851 toward Courbet's *The Stonebreakers* (1849, whereabouts unknown), *The Burial at Ornans* (1849–1850, Louvre), and *Peasants of Flagey* (1855, Musée des Beaux-Arts, Besançon); see esp. pp. 133–154. My own formulation of the ways in which drawing and composition do and do not capture work has evolved through numerous discussions with Linda Nochlin. See her extensive discussion of Breton in her review of the exhibition "The Realist Tradition, French Painting and Drawing 1830–1910," *Burlington Magazine* 123 (April 1981), 263–269.

41. See Theodore Reff's extensive discussion of Degas' interest in the work of Ingres, Delacroix, and Daumier in *Degas: The Artist's Mind*, pp. 37–89. Degas owned approximately 400 Daumier prints and 2,000 by Gavarni.

42. Cited in Benjamin, *Charles Baudelaire*, p. 100.

43. Browse, *Degas Dancers*, p. 370.

44. Comte Fleury and Louis Sonolet, *La Société du Second Empire* (Paris: A. Michel, n.d. [1917]), 4:279, 275–276; Guest, *Ballet of the Second Empire*, 1:16.

45. Journal entry for February 13, 1874, E. and J. de Goncourt, *Pages from the Goncourt Journal*, p. 206; Frédéric Chevalier, article on the third "Exposition des Impressionistes," in *L'Artiste*, May 1877, cited in Lemoisne, *Degas*, 1:243; Huysmans, "Le Salon de 1879," *L'Art moderne*, p. 12.

46. A. P., "Beaux-Arts," *Le Petit Parisien*, April 7, 1877, cited in Lemoisne, *Degas*, 1:242; Jacques, article on third "Exposition des Impressionistes," in *Homme libre*, April 12, 1877, cited in ibid., p. 242; Charles Ephrussi, article on "Exposition des Artistes Indépendants," *Gazette des Beaux-Arts*, May 1, 1880, cited in ibid., p. 248; Huysmans, articles on "Exposition des Impressionistes," 1886, cited in ibid., p. 252; Huysmans, "L'Exposition . . . 1881," *L'Art Moderne*, p. 248.

47. Georges Rivière, *Mr. Degas, Bourgeois de Paris* (Paris: Floury, 1935), p. 103; Charles Baudelaire, "Some French Caricaturists," *Selected Writings*, p. 218.

48. Louis Lazare, *La France et Paris* (Paris, 1892), p. 14, cited in David H. Pinkney, *Napoleon III and the Rebuilding of Paris* (Princeton: Princeton University Press, 1958), p. 154; Hobsbawm, *The Age of Capital*, p. 167.

49. Theodore Reff, "Degas and the Dance," *Edgar Degas* (New York: Acquavella Galleries, 1978), unpaginated [p. 6].

## 3: IMAGES OF LAUNDRESSES

1. Charles Sterling and Margaretta M. Salinger, *French Paintings* (Greenwich: New York Graphic Society, 1967), 3:77–78.

2. E. and J. de Goncourt, *Pages from the Goncourt Journal*, p. 206.

3. A problem of vocabulary should be clarified at the outset. Among laundresses there are washerwomen and ironers. In English we frequently use the word "laundress" to indicate either. The same is true in French, but with a twist. *Blanchisseuse* is the generic term for laundress, but the same word also means washerwoman, only; *repasseuse* means ironer only.

4. Octave Uzanne, *The Modern Parisienne* (1894; London G. P. Putnam's Sons, 1912), pp. 71–72.

5. Ibid., p. 70; Georges Montorgueil, *Le Café Concert* (Paris: "L'Estampe originale," 1893), p. 6.

6. For examples of negative critical responses, see Alexandre Zévaès, *Zola* (Paris: Editions de La Nouvelle Revue critique, 1945), pp. 60–61. *L'Assommoir* was Zola's first best-seller and firmly established the publishing firm of Charpentier, according to F. W. J. Hemmings, *Emile Zola,* 2d ed. (Oxford: Clarendon Press, 1966), p. 126. Georges Charpentier, one might note, was Renoir's great patron and the husband and father of the Mme Charpentier shown with their children in Renoir's 1878 painting (fig. 31).

7. Zola, *L'Assommoir,* pp. 159, 154.

8. Painted respectively by Edouard Elmerich (Salon, 1865), Olympe Lavalard (Salon, 1866), Fernand Pelez (Salon, 1880), Joseph Caraud (Salon, 1872), and Marie Petiet (Salon, 1882).

9. For the Lhermitte, see Photograph Collection, Frick Art Reference Library, New York.

10. Among the few exceptions are the quite robust women in works by Bonvin and Armand Gautier. In Bonvin's *Woman Ironing* (1858, Philadelphia Museum of Art), an absorbed young woman irons a shirt. Her own self-indulgence, or another's attention to her, has provided a glass with a flower at her left, balanced on the right by what is probably a water bowl. Bonvin's technique is a version of conventional nineteenth-century realism with a heavy dose of nostalgia for seventeenth-century Dutch genre painting. It is a sober image of domestic virtue.

Gautier's *The Ironer,* probably dating from the late 1850s (Musée des Beaux-Arts, Caen), depicts a more intense scene. The colors are bright, and the paint is laid down in almost as vibrant a way as the woman's body is thrown into her work. Both works are reproduced in Weisberg, *The Realist Tradition,* p. 68.

11. See Jean-Baptiste Greuze's *Laundress* (engraved by J. Danzel and reproduced in Fred Bertrich, *Kulturgeschichte des Waschens* [Düsseldorf: Econ, 1966], p. 72) for an eighteenth-century prototype of this image.

12. *Le Charivari,* April 12, 1859, p. 22. I would like to thank David Kunzle, professor of Art History at UCLA, for bringing this print to my attention.

13. *Le Charivari,* May 25, 1876, p. 114. Once again I am indebted to Professor Kunzle for showing me this print and many others of laundresses.

14. George A. Sala, *Paris Herself Again, 1878–1879* (New York: Scribner and Welford, 1880), 1:58.

15. Henri Meilhac and Ludovic Halévy, *La Cigale,* adapted for American stage by J. H. Delafield (New York: Happy Hours Company, 1879), p. 62.

16. Arthur Bailly, *L'Industrie du blanchissage et les blanchisseries* (Paris: J.-B. Baillière et fils, 1896), p. 124; Marcel Frois, *Les Blanchisseries—Hygiène pratique du blanchissage* (Paris: H. Dunod et E. Pinat, 1910), pp. 46, 96.

17. For an interesting discussion of this layout, see Howard Saalman, *Haussmann: Paris Transformed* (New York: G. Braziller, 1971), pp. 114–115, 26–27.

18. Anne Hollander, *Seeing Through Clothes* (New York: Viking, 1978), p. 132.

19. Frois, *Les Blanchisseries*, p. 111; René Gonnard, *La Femme dans l'industrie* (Paris: Colin, 1906), p. 125.

20. Gonnard, *La Femme dans l'industrie*, pp. 247, 102; Theodore Zeldin, *France 1848–1945* (Oxford: Clarendon Press, 1973), 1:684, 122, 69.

21. Gonnard, *La Femme dans l'industrie*, p. 126.

22. Frois, *Les Blanchisseries*, pp. 49, 51–63, 96–97.

23. Ibid., p. 100.

24. I am indebted to Louis Chevalier's *Laboring Classes*, in the preceding and following sections; this quote is from p. 223; Victor Hugo, *Les Misérables*, cited in ibid., p. 408; Eugène Buret, *De la Misère des classes laborieuses en Angleterre et en France* (1840), also cited in Chevalier, p. 360.

25. Chevalier, *Laboring Classes*, p. 336. Chevalier says very specifically that "quite definitely after the June Days of 1848, the popular classes in Paris were no longer called 'populace,' but became 'the people,' and the terms 'savages,' 'barbarians,' and 'vagrants' were no longer used to describe them" (p. 372; see also pp. 394–395).

26. Poulot, *Le Sublime*, p. 7.

27. Benjamin, "Paris," p. 160.

28. Zeldin, *France 1848–1945*, 1:198–199.

29. Cited in Benjamin, *Charles Baudelaire*, p. 22; E. and J. de Goncourt, *Pages from the Goncourt Journal*, p. 365 (entry of June 27, 1891); Daniel Halévy, *My Friend Degas*, trans. Mina Curtiss (Middletown: Wesleyan University Press, 1964), pp. 99–100.

30. Edith Thomas, *The Women Incendiaries*, trans. James and Starr Atkinson (New York: G. Braziller, 1966), pp. 176–177.

31. There are twenty-eight if one includes a work called *Laundress with a Toothache* (ca. 1870–1872; Dreyfus Collection, Paris); see Lemoisne, *Degas*, vol. 2, no. 278.

32. For images of washerwomen, see Lemoisne, *Degas*, nos. 410, 960, 961, 1418, 1419, 1420, 1420bis, and H. G. Edgar Degas, *Catalogue des Tableaux, pastels et dessins par Edgar Degas et provenant de son atelier* (Paris: Galerie Georges Petit, I: May 6–8, 1918; II: December 11–13, 1918; III: April 7–9, 1919; IV: July 2–4, 1919), nos. 128, 357.

For images of ironers, see Lemoisne, *Degas*, nos. 216, 276, 277, 329, 356, 361, 685–687, 776, 785, 786, 846; *Catalogue des Tableaux*, nos. 268, 269; and J. Adhémar and Françoise Cachin, *Degas, The Complete Etchings, Lithographs and Monotypes* (New York: Viking, 1975), etching no. 32 and monotype no. 55; also *Ironer* (ca. 1869; Jeu de Paume, Paris), not cataloged in either Lemoisne or *Catalogue des Tableaux*.

33. See also Lemoisne, *Degas*, nos. 276, 277, 329, 356, 361, 685, 846, and *Catalogue des Tableaux*, nos. 268, 269.

34. See also Lemoisne, *Degas*, nos. 686, 776, 786, and Adhémar and Cachin, *Degas*, etching no. 32.

35. Degas, *Letters*; Degas to Tissot, November 19, 1872, p. 19 and p. 18; Degas to Henri Rouart, December 5, 1872, p. 25.

36. Notebook 28 was used in the home of Ludovic Halévy. It was one of two published originally in Edgar Degas, *Album de dessins*, preface by Daniel Halévy (Paris:

Quatre Chemins-Editart, 1949). Halévy wrote in that preface: "The scene represented shows the musician Reyer courting a laundress." Reff assigned this notebook the number 28 and dated it 1877. See Reff, *Notebooks*, 1:127–128.

37. Notebook 27, p. 43, reproduced in Reff, *Notebooks*, vol. 2. Reff first pointed out the sexual imagery of the signature in *Degas: The Artist's Mind*, pp. 39–40.

38. Huysmans, "L'Exposition . . . 1880," p. 134; Coquiot, *Degas*, pp. 125–126.

39. Although some recent writers such as Pierre Cabanne (in *Edgar Degas*) have noted the presence of the wine bottles, by and large they have been ignored. Earlier writers, however, such as Gustave Coquiot and Georges Rivière, not only noticed the wine but were disdainful and condescending toward its social implications. See, for example, Rivière, *Mr. Degas*, p. 107, and Coquiot, *Degas*, p. 125.

40. Huysmans, "L'Exposition . . . 1880," *L'Art Moderne*, p. 131; Gustave Geffroy, "Degas," *L'Art dans les deux mondes*, December 20, 1890, p. 46; Georges Rouault, *Souvenirs intimes* (Paris: E. Frapier, 1926), p. 98; Rivière, *Mr. Degas*, p. 149 (although Rivière's book was published in 1935, he knew and wrote about Degas in the 1870s).

## 4: THE BATHERS

1. *Le Journal*, April 24, 1895; cited in Theodore Zeldin, *France, 1848–1945*, 2:546.

2. Hollis Clayson, assistant professor of Art History, Northwestern University, has made an extensive study of the prostitutional discourse of the 1880s, and its relationship to high art; for particular work on Degas, see her article "Avante-garde and Pompier Images of 19th Century French Prostitution: The Matter of Modernism, Modernity and Social Ideology," *Modernism and Modernity* (Halifax: Nova Scotia Press, 1983). In 1984 Professor Clayson completed a dissertation at UCLA entitled "Representations of Prostitution in France during the Early Years of the Third Republic."

3. The word for milliner in French is *modiste;* for a young or beginning milliner, *midinette* is often used.

4. For an interesting recent commentary on this ambiguous situation in an American late-nineteenth early-twentieth-century context, see Kathy Peiss, "'Charity Girls' and City Pleasures: Historical Notes on Working-Class Sexuality, 1880–1920," in Ann Snitow, Christine Stansell, and Sharon Thompson, eds., *Powers of Desire: The Politics of Sexuality* (New York: Monthly Review Press, 1983), pp. 74–87.

5. Louis Artus, *Les Midinettes* (Paris: E. Paul, 1912), p. 9.

6. For the Durand-Ruel painting, see Lemoisne, *Degas*, no. 1023; for the Metropolitan Museum of Art work, see ibid., no. 705.

7. It was not at all uncommon to find visibly upper-class men visiting and lounging in ateliers in which specifically feminine activities like dress- and hatmaking were taking place, as both nineteenth-century prints and early twentieth-century plays (such as Alfred Desfossez's *Les Midinettes of 1904* or Artus' *Les Midinettes*) show. We also know, for example, that Manet and Mallarmé passed many an afternoon in couturier salons with Méry Laurent (see Anne C. Hanson, *Edouard Manet* [Philadelphia: Philadelphia Museum of Art, 1966], p. 175).

8. The letter reads: "Ma santée est autant bonne qu'ils est posible quels soit étant separée de tout ce que jois de plus chère; je ne cherche pas à decrire ce que j'ai soufert. De puis nottre triste separation. Figure toi mon ange que les larmes de ton amie nont tarié que lorsque j'ai en le bonneure d'êttre tirée de l'enxieté ou jetais parré raport à ta santée." The letter in its entirety is full of grammatical and spelling errors and is itself a gauge of middle-class condescension toward the young milliners.

9. Uzanne, *La Femme à Paris,* pp. 86, 75–76, 78.

10. Arsène Alexandre, *Les Reines de l'aiguille, modistes et couturières* (Paris: T. Belin, 1902), pp. 6, 134, 8. It is worth noting that Alexandre usually wrote about art. His works include *Botticelli* (Paris: Rieder, 1929), *Claude Monet* (Paris: Les Editions Bernheim-Jeune, 1921), and *Histoire de la peinture militaire en France* (Paris: H. Laurens, 1890). He also wrote a preface to the catalog for the posthumous sale of the Henri Rouart Collection; Rouart was one of Degas' closest friends. Alexandre's style of writing is always conversational and informal.

11. Charles Benoist's articles were published together in his book *Les Ouvrières de l'aiguille à Paris* (Paris: L. Chailley, 1895); see pp. 87–88, 94, 116. See also Zola, *Ladies' Delight,* p. 146.

12. Benoist, *Les Ouvrières,* pp. 23, 35–37. The implication somehow was that detainment at work was the milliner's fault.

13. Leroy-Beaulieu, *Le Travail des femmes au XIX$^e$ siècle* (1873; Paris: Charpentier et Cie, 1888), pp. 111, 221.

14. Jules Simon, *L'Ouvrière,* 9th ed. (1861; Paris: Hachette et Cie., 1891), p. 216; Benoist, *Les Ouvrières,* p. 204.

15. Coquiot, *Degas,* pp. 130, 131; Lemoisne, *Degas,* 1:132; Rivière, *Mr. Degas,* p. 149.

16. See Pierre Villoteau, *La Vie parisienne à la Belle Époque* (Geneva: Cercle du bibliophile, 1968), pp. 427–428.

17. Ibid., p. 427; Maurice Allem, *La Vie quotidienne sous le Second Empire* (Paris: Hachette, 1948), p. 155.

18. For a description and analysis of this tradition, see Beatrice Farwell, "Courbet's 'Baigneuses,' and the Rhetorical Feminine Image," in Thomas B. Hess and Linda Nochlin, eds., *Woman as Sex Object* (New York: Newsweek, 1972), pp. 64–79, and the same author's "Manet's Bathers," *Arts Magazine* 54 (May 1980), 124–133. In the former Farwell wrote explicitly, "It is perhaps not too much to suggest that the entire output of intimate bathing scenes by Degas . . . were [*sic*] inspired by this tradition of 'bather' prints" (p. 71).

19. Zola, *Nana,* p. 148.

20. Zeldin, *France 1848–1945,* 1:297; Paul Valéry, *Degas, Manet, Morisot,* trans. David Pall (New York: Pantheon, 1960), p. 47.

21. Erna Olafson Hellerstein, Karen M. Offen et al., eds., *Victorian Women: A Documentary Account of Women's Lives in 19th Century England, France and the United States* (Stanford: Stanford University Press, 1981), p. 208.

22. Alain Corbin, *Le Miasme et la jonquille: L'Odorat et l'imaginaire social, 18$^e$–19$^e$ siècles* (Paris: Aubier-Montaigne, 1982), pp. 43, 209, 210.

23. Louis Chevalier, in *Laboring Classes,* notes that in the 1820s and 1830s, "Paris was described as a sick city, an impossible city, an accursed city; and much of the denunciation was directed against the sewers, drains and hospitals" (p. 206). He goes on to discuss the water problems in the city and to what extent water was a carrier of sickness. He even makes an important connection between drainage and prostitution by pointing out that Parent-Duchâtelet as a public administrator investigated sewers and prostitution alike (p. 48). To this day, there is a lingering feeling in Paris that its water is unhealthy—to wit, the habitual use of bottled water.

24. Corbin, *Le Miasme,* p. 211.

25. The distinction "regulated" is important here, because an unregulated prostitute could not be similarly controlled, and one could not be sure whether she was clean or not. For our purposes, what is important is that there was a specific, recognizable symbology associated with the regulated brothel prostitute, and Degas utilized that symbology.

26. Corbin, *Les Filles,* p. 126; idem, *Le Miasme,* pp. 209, 318 nn. 14, 15.

27. Corbin notes that a bidet was used fairly regularly by the end of the century, but that tubs, an English import, were primarily a mark of snobbery, and little else, when used by the middle classes (*Le Miasme,* p. 211).

28. This deluxe edition of *La Maison Tellier* appeared in 1934.

29. Joris-Karl Huysmans, *Marthe* (orig. *Marthe, Histoire d' une fille,* 1876), in *Down Stream,* trans. Samuel Putnam (New York: H. Fertig, 1975), p. 29.

30. Lemoisne, *Degas,* no. 606.

31. See Eugenia P. Janis, *Degas Monotypes* (Cambridge: Harvard University Press, 1968), nos. 72–75.

32. To be sure, images of prostitutes masturbating in a brothel are images of events meant to arouse the clients. It was a common practice of brothel salons for the women to gesture and talk in suggestive ways in order to win the attention of a prospective client. What I am suggesting here, however, is that those provocative acts are transformed in some of the bather pastels into self-gratifying acts. For examples see Lemoisne, *Degas,* nos. 854, 1104, 1113bis, 1117, 1233, 1234.

33. For Degas' drawing, see Notebook 18, p. 197, reproduced in Reff, *Notebooks,* vol. 2; see Reff's commentary, 1:99. Degas did a number of drawings in this notebook after prints in *Le Tour du monde,* a magazine that intended to be informative on ethnographic issues; today, however, its scientism seems quite prejudiced. In this context it should be noted that the comte de Gobineau wrote the notoriously racist tract *Essai sur l'inégalité des races humaines.*

34. Islamicist Irene A. Bierman, assistant professor of Art History, UCLA, informed me of the content of this image; she added that despite the French caption, the image is Persian, not Indian.

35. In the 1880s and 1890s Degas was an avid reader of the *Thousand and One Nights,* in which men frequently behave in ways that we in the West associate with women. See Degas, *Letters,* pp. 126, 140, for references to the book and the enormous pleasure he took in it. A few quotations from *The Book of the Thousand Nights and One Night,* trans. from the French translation of Dr. J. C. Mardrus by Powys Mathers (1839–

1842; London: Routledge and Kegan Paul, 1964), vol. 1, indicate what I mean by altering behavioral expectations: "For a year I [a man] remained broken by my heart's grief, with the tears ever in my eyes" (p. 12). "Therefore he had rejoiced as if his heart would break" (p. 26). " . . . but he had two sons as fair as twin moons. . . . Many persons journeyed to Egypt . . . from far countries solely for the pleasure of feasting their eyes on the beauty of [one of the boys]" (p. 127). Sexual pleasure is shared and described equally by both parties in this book; see p. 255.

36. Other examples of this sort of image are in Lemoisne, *Degas,* nos. 606, 854, 1079, 1082, 1104, 1117, 1234. Degas also made a photograph of a woman in exactly the same pose as this bather in about 1895–1896 (J. Paul Getty Museum, Malibu; reproduced in Terrasse, *Degas et la photographie,* pl. 25). This image adds the apparent palpability of the photographically "real" to an already complicated conceptual framework.

37. Joris-Karl Huysmans, "Du dilettantisme, Puvis de Chavannes, Gustave Moreau, Degas" (1886), in *Certains* (Paris: G. Cres et Cie., 1929), p. 25; Félix Fénéon, *Les Impressionistes en 1886* (Paris: Publications de la Vogue, 1886), p. 10.

38. Corbin, *Les Filles,* p. 315.

39. Huysmans, "Du dilettantisme," pp. 22–23; Fénéon, *Les Impressionistes,* pp. 9–10.

40. John Berger, *Ways of Seeing* (Harmondsworth: Penguin, 1972), p. 57.

41. See Corbin, *Les Filles,* pp. 309–310.

CONCLUSION

1. Quoted in Chevalier, *Laboring Classes,* pp. 376–377.

2. D. Halévy, *My Friend Degas,* p. 66.

3. Translated in Nochlin, *Impressionism and Post-Impressionism,* p. 63.

4. See Janis, *Degas Monotypes,* for a fascinating discussion of these images and their meanings.

5. For a discussion of the various spellings of the name, see Lemoisne, *Degas,* 1:223.

6. Jeanne Fevre traces the aristocratic roots of the Degas family back to the thirteenth century. See her *Mon Oncle Degas* (Geneva: P. Cailler, 1949), p. 14.

7. Ibid., p. 13; William Rothenstein, *Men and Memories: A History of the Arts 1872–1922* (New York: Tudor Publishing Company, n.d. [1937]), p. 103; Pierre Cabanne, "L'Amitié de Degas et de Valernes," *De Valernes et Degas* (Carpentras: Musée de Carpentras, 1963), unpaginated; Valéry, *Degas, Manet, Morisot,* p. 23.

8. Coquiot, *Degas,* p. 7; Paul Gauguin, *Paul Gauguin's Intimate Journals* (Bloomington: Indiana University Press, 1958), p. 131; Vincent van Gogh to Emile Bernard, August 1888, in *The Complete Letters of Vincent van Gogh,* vol. 3 (New York: New York Graphic Society, 1958), no. B14; Degas *Letters,* p. 26.

9. For examples of Degas' respect for the army, see D. Halévy, *My Friend Degas,* pp. 101, 73; Degas, *Letters,* p. 160; Walter Richard Sickert, *A Free House! or the Artist*

*as Craftsman; Being the Writings of Walter Richard Sickert,* ed. Osbert Sitwell (London: Macmillan, 1947), p. 153. Other instances of Degas' patriotism have been noted in D. Halévy, *My Friend Degas,* pp. 53, 73; Rothenstein, *Men and Memories,* p. 159; and Degas, *Letters,* esp. pp. 18, 21, 24, 160. The artist's anti-Semitism is best known because of his break with Ludovic Halévy during the Dreyfus Affair, but it was also evident in his great enthusiasm for the newspaper *La Libre Parole,* which was explicitly anti-Semitic.

10. D. Halévy, *My Friend Degas,* p. 103; for further accounts of these attitudes see ibid., pp. 58–59; and Degas, *Letters,* pp. 23, 97–98.

11. Jeanne Raunay, "Degas: Souvenirs anecdotiques," *La Revue de France,* April 1, 1931, p. 481; Degas, *Letters,* p. 17.

12. Reff, *Notebooks,* Notebook 6, 1:49–50.

13. Degas, *Letters,* pp. 11–12, 18, 33.

14. Camille Pissarro to Lucien Pissarro, June 18, 1891, in *Letters to His Son Lucien,* trans. Lionel Abel, ed. John Rewald with assistance of Lucien Pissarro (Santa Barbara: Peregrine Smith, 1981), p. 221.

15. In *Grand Larousse de la langue française* (Paris: Librairie Larousse, 1971), 1:257, *article* is given four definitions; the only one applicable to Degas' usage is the fourth: "chacun des objets qu'un commerçant peut fournier" [each of the objects that a merchant sells].

16. D. Halévy, *My Friend Degas,* p. 63. The Musée du Luxembourg was established in the Palais du Luxembourg in 1818; it moved to the Orangerie in 1886 and in 1937 formally ended as an institution. Its collection became part of the Palais d'Art Moderne, built for the 1937 Exposition Universelle. For additional information on the Musée du Luxembourg, see Geneviève Lacambre with Jacqueline de Rohan-Chabot, *Le Musée du Luxembourg en 1874* (Paris: Editions des Musées Nationaux, 1974), esp. Lacambre's introduction.

17. Rothenstein, *Men and Memories,* p. 336.

18. Richard Hofstadter, *The Age of Reform* (New York: Knopf, 1955), p. 135.

# Bibliography

SOURCES 1850 – ca. 1920

Alexandre, Arsène. *Les Reines de l'aiguille, modistes et couturières.* Paris: T. Belin, 1902.

All Right. *Les Coulisses du pari mutuel.* Paris: de Chaix, 1891.

Artus, Louis. *Les Midinettes.* Paris: E. Paul, 1912.

Astruc, Zacharie. "L'Empire du soleil levant." *L'Etendard,* February 27 and March 23, 1867.

―――― . "Le Japon chez nous." *L'Etendard,* May 26, 1868.

Bailly, Arthur. *L'Industrie du blanchissage et les blanchisseries.* Paris: J.-B. Baillière et fils, 1896.

Barron, Louis. *Paris pittoresque 1800–1900.* Paris: L.-H. May, n.d. [1900].

Baudelaire, Charles. "The Painter of Modern Life." *Selected Writings on Art and Artists.* Trans. P. E. Charvet. Harmondsworth: Penguin, 1972, 390–435. (Originally 1863.)

―――― . "Some Foreign Caricaturists." *Selected Writings on Art and Artists.* Harmondsworth: Penguin, 1972, 232–243. (Originally 1857.)

―――― . "Some French Caricaturists." *Selected Writings on Art and Artists.* Harmondsworth: Penguin, 1972, 209–231. (Originally 1857.)

Benoist, Charles. *Les Ouvrières de l'aiguille à Paris.* Paris: L. Chailley, 1895.

*Bibliothèque musicale du Théâtre de l'Opéra.* Paris: Librairie des bibliophiles, 1878.

Bournonville, August. *My Theatre Life 1848–1878* Middletown: Wesleyan University Press, 1979. (Originally 1848–1878.)

Burty, Philippe, "Exposition Universelle de 1878, Le Japon ancien et le Japon moderne." *L'Art* 15 (1878), 241–264.

―――― . [Series of Articles.] *La Renaissance littéraire et artistique,* vol. 1: "Japonisme I" (May 11, 1872), 25–26; "Japonisme II" (June 15, 1872), 59–60; "Japonisme III" (July 6, 1872), 83–84; "Japonsime IV" (July 27, 1872), 106–107; "Japonisme V" (August 10, 1872), 122–123; vol. 2: "Japonisme VI" (February 8, 1873), 3–5.

―――― . "Le Salon." *Le Rappel,* May–June, 1870.

*Cassell's Illustrated Guide to Paris.* Paris: Cassell and Company, 1884.

*Catalogue des metiers.* Cabinet des Estampes, Bibliothèque Nationale, Paris.

*Catalogue des moeurs.* Cabinet des Estampes, Bibliothèque Nationale, Paris.

Cavailhon, Edouard. *Le Seize Mai Hippique.* Paris: de G. Balitout, 1887.

―――― . *Les Haras de France: Les Haines contre les courses.* 2 vols. Paris: E. Dentu, 1886.

Champfleury. "La Mode des Japonaiseries." *La Vie parisienne,* November 21, 1868,

862–863. Reprinted in Geneviève and Jean Lacambre, eds. *Le Réalisme*. Paris: Hermann, 1973, 143–145.

Champsaur, Felicien. *L'Amant des danseuses*. Paris: E. Dentu, 1888.

*Le Charivari,* 1860–1878.

Charles, Etienne. "Les Mots de Degas." La Renaissance de l'Art français et des Industries deluxes, 1 (April 1918), 3–7.

Chesneau, Ernest. "Le Japon à Paris." *Gazette des Beaux-Arts* 18 (September 1878), 385–397.

Claretie, Jules. "M. Paul Renouard et l'Opéra." *Gazette des Beaux-Arts* 23 (March 1881), 435–455.

Crafty [Victor Géruzez]. *Paris à cheval*. Paris: E. Plon, 1889.

Daudet, Alphonse. *Thirty Years of Paris and of My Literary Life*. Trans. Laura Ensor. London: G. Routledge and Sons, 1888.

Dayot, Armand. *Le Second Empire: 2 Decembre, 1851–4 Septembre, 1870*. Paris: E. Flammarion, n.d. [189?–1900].

Degas, Hilaire-Germain-Edgar. *Album du dessins*. Preface by Daniel Halévy. Paris: Quatre Chemins Editart, 1949. (Originally 1877.)

————. *Catalogue des tableaux, pastels et dessins par Edgar Degas et provenant de son atelier*. 4 vols. Paris: Galerie Georges Petit, 1918–1919.

————. *Collection Edgar Degas*. 3 vols. Paris: Galerie Georges Petit, 1918.

————. *Dix-neuf Portraits de Degas par lui-même*. Paris: M. Guérin, 1931.

————. *Letters*. Ed. Marcel Guérin. Trans. Marguerite Kay. Oxford: B. Cassirer, 1947. (Originally 1945.)

Deldevez, E.-M.-E. *Mes Memoires*. Le Puy: Marchessou fils, 1890.

Desfossez, Alfred. *Les Midinettes*. Paris: C. Joubert, 1904.

Drumont, Eduoard-Adolphe. *Mon Vieux Paris*. Paris: E. Flammarion, 1897.

Duranty, Edmond. *La Nouvelle Peinture*. Paris: Floury, 1946. (Originally 1876.)

————. [Untitled article.] *Paris-Journal,* May 8, 1870.

Duret, Théodore. "L'Art japonais." *Gazette des Beaux-Arts* 26 (1882), 113–131.

Ephrussi, Charles. [Article on "Exposition des Artistes indépendants."] *Gazette des Beaux-Arts* 21 (1880).

Fénéon, Félix. *Les Impressionistes en 1886*. Paris: Publication de la Vogue, 1886.

Flaubert, Gustave. *Sentimental Education*. Trans. Robert Baldick. Harmondsworth: Penguin, 1969. (Originally 1869.)

Fleury, Comte, and Louis Sonolet. *La Société du Second Empire*. 4 vols. Paris: A. Michel, 1911–1924.

Fouque, Octave. *Histoire du Théâtre-Ventadour: 1827–1879*. Paris: G. Fischbacher, 1881.

Fournel, Victor. *Esquisses et croquis parisiens*. Paris: E. Plon et Cie, 1876.

*Les Français peints par eux-mêmes,* 5 vols. Paris: L. Curmer, 1840–1842.

Frois, Marcel. *Les Blanchisseries—Hygiène et pratique du blanchissage*. Paris: H. Dunod et E. Pinat, 1910.

Gauguin, Paul. *Paul Gauguin's Intimate Journals*. Bloomington: Indiana University Press, 1958. (Originally *Avant et Après,* Leipzig: Kurt Wolff, 1918.)

Gautier, Théophile. *Souvenirs de théâtre d'art et de critique*. Paris: G. Charpentier, 1883.

Gavarni. *L'Oeuvre célèbre de Gavarni*. Paris: J. Hetzel, n.d. [184?]

Geffroy, Gustave. "Degas." *L'Art dans les deux mondes*, December 20, 1890, 46–48.

Gobineau, Joseph-Arthur, Comte de. *Essai sur l'inégalité des races humaines*. 2 vols. Paris: Librairie de Paris, 1854.

——— . "Voyage en Perse: Fragments: 1855–1858." *Le Tour du monde* 2 (1860), 17–48.

Goncourt, Edmond de. *Elisa*. Trans. Margaret Crosland. New York: H. Fertig, 1975. (Originally *La Fille Elisa*, 1877.)

——— . *Outamaro, Le Peintre des maisons vertes*. Paris: Bibliothèque-Charpentier, 1891.

Goncourt, Edmond, and Jules de Goncourt. *Journal, Mémoires de la vie littéraire*. Ed. R. Ricatte. 22 vols. Monaco: Impr. nationale, 1956. (Originally 1887–1896.)

——— . *Manette Salomon*. 2 vols. Paris: Librarie internationale, 1868.

Gonnard, René. *La Femme dans l'industrie*. Paris: Colin, 1906.

Gonse, Louis. *L'Art japonais*. Paris: Librairies-imprimeries réunies, 1886.

Guérin, Marcel. *Forain: Lithographe*. Paris: H. Floury, 1910.

——— . *J.-L. Forain Aquafortiste*. Paris: H. Floury, 1912.

*Guide de l'étranger dans Paris et ses environs*. Paris: Hotel-du-Louvre, 1874.

*Guide par les principaux écrivains et artistes de la France*. Paris: Librairie internationale, 1867.

Halévy, Ludovic. *Autumn Manoeuvers: Stories and Sketches*. Trans. Mary Ford. New York: Books for Libraries Press, 1970. (Originally 1897.)

——— . *The Cardinal Family*. Trans. George B. Ives. Philadelphia: G. Barrie and Son, 1897.

——— . *Carnets*. Intro. and notes Daniel Halévy. 2 vols. Paris: Calmann-Lévy, 1935. (Written between 1862 and 1870.)

——— . *Notes et Souvenirs: 1871–1872*. Paris: Calmann-Lévy, 1889.

Hitomi, I. *Dai Nippon: Le Japon: Essai sur les moeurs et les institutions*. Paris: L. LaRose, 1900.

Huart, Adrien. *The Illustrated Comic Guide to Paris during the Exhibition of 1878*. London: Richardson and Best, 1878.

Huysmans, Joris-Karl. "Du dilettantisme, Puvis de Chavannes, Gustave Moreau, Degas." *Certains*. Paris: G. Cres et Cie, 1929, 7–25. (Originally 1889.)

——— . "L'Exposition des Indépendants en 1880." *L'Art moderne*. Paris: G. Charpentier, 1883, 97–139.

——— . "L'Exposition des Indépendants en 1881." *L'Art moderne*. Paris: G. Charpentier, 1883, 247–282.

——— . "Le Salon de 1879." *L'Art moderne*. Paris: G. Charpentier, 1883, pp. 7–95.

——— . *Marthe*. In *Down Stream*. Trans. Samuel Putnam. New York: H. Fertig, 1975. (Originally 1876.)

*Illustrated London News*. 1869–1873.

*L'Illustration: Journal universel*. 1864–1873.

*Le Journal Amusant*. 1865–1880.

Laffon, Fernand-Gabriel. *Le Monde des courses*. Paris: Librairie illustrée, 1887.

Lafond, Paul. *Degas*. 2 vols. Paris: H. Floury, 1918.

Larousse, Pierre. *Grand Dictionnaire Universel du dix-neuvième siècle*. 17 vols. Paris: Administration du grand dictionnaire universel, 1865–1890.

Lehaguez, M. *Le Nouveau Paris et ses environs*. Paris: Bernardin-Bechet, 1870.

Leroy-Beaulieu, Paul. "De l'Etat moral et intellectuel des populations ouvrières. Paris: Librairie Guillaumin et Cie, 1868.

——— . *Le Travail des femmes au XIXᵉ siècle*. Paris: Charpentier et Cie, 1888. (Originally 1873.)

Leroy-Beaulieu, Pierre. *The Awakening of the East*. Trans. Richard Davey. New York: McClure, Phillips and Co., 1900.

Lindau, Rudolf. *Un Voyage autour du Japon*. Paris: Hachette et Cie, 1864.

McCabe, James D., Jr. *Paris by Sunlight and Gaslight*. Philadelphia: National Publishing Company, 1869.

Mahalin, Paul. *Ces Demoiselles de l'Opéra*. 2d ed. Paris, 1887.

Mahérault, M. J. F. *L'Oeuvre de Gavarni*. Paris: Librarie des bibliophiles, 1873.

Mantz, Paul. [Article on the "Exposition des Indépendants."] *Le Temps,* April 23, 1881.

——— . "Exposition de l'art japonais." *Gazette des Beaux-Arts* 27, 2d ser. (May 1883), 400–410.

Marx, Karl. *Capital*. Vol. 1: *The Process of Capitalist Production*. Trans. Samual Moore and Edward Aveling. New York: International Publishers, 1967. (Originally 1867.)

——— . *Civil War in France*. New York: International Publishers, 1972. (Originally addresses, 1871. Published with introduction by Frederick Engels, 1891.)

——— . *The Eighteenth Brumaire of Louis Bonaparte*. New York: International Publishers, 1963. (Originally 1852.)

Maugny, Comte de. *Souvenirs du Second Empire: La Fin d'une société*. Paris: E. Kolb, 1890.

Maupassant, Guy de. *Bel-Ami*. Chicago: Laird and Lee, 1891. (Originally 1885.)

——— . "Madame Tellier's Establishment." *The Collected Novels and Stories of Guy de Maupassant*. Ed. Ernest Boyd. New York: A. A. Knopf, 1922. (Originally 1881.)

Meilhac, Henri, and Ludovic Halévy. *La Cigale*. New York: Happy Hours Company, 1879.

Moges, Marquis de. "Voyage en Chine et au Japon." *Le Tour du monde* 1 (1860), 129–176.

*Le Monde illustré.* 1865–1880.

Montemont, A. E. *Guide universel et complet de l'etranger dans Paris*. Paris: Garnier frères, 1875.

Montorgueil, Georges. *Le Café Concert*. Paris: "L'Estampe originale," 1893.

——— . *Paris Dansant*. Paris: T. Belin, 1898.

Moore, George. *Confessions of a Young Man*. London: W. Heineman, 1928.

——— . *Impressions and Opinions*. London: D. Nutt, 1891.

——— . "Memories of Degas." *Burlington Magazine* 32 (1918), 22–29, 63–65.

——— . *Reminiscences of the Impressionist Painters*. Dublin: Maunsell, 1906.

Morisot, Berthe. *The Correspondence of Berthe Morisot.* Ed. Denis Rouart. Trans. Betty W. Hubbard. New York: E. Weyhe, 1959.

Nittis, Joseph de. *Notes et souvenirs du peintre Joseph de Nittis.* Paris: Ancien Maison Quantin, Libraries-impriméries réunies, 1895.

P., A. "Beaux-Arts." *Le Petit Parisien,* April 7, 1877.

*Paris Illustré.* 1879–1890.

Pottier, E. "Grèce et Japon." *Gazette des Beaux-Arts* 32, 2d ser. (1890), 105–132.

Poulot, Denis. *Le Sublime ou le travailleur comme il est en 1870, et ce qu'il peut être.* Intro. Alain Cottereau. Paris: Découverte/Maspero, 1980. (Originally 1872.)

*Recueil d'estampes gravées à l'eau-forte.* Preface by Armand Silvestre. Paris: Maisons Durand-Ruel, 1873.

Redon, Odilon. *A Soi-même: Journal 1867–1915.* Paris: H. Floury, 1922.

Richard, Jules. *Le Salon militaire de 1886.* Paris: J. Moutonnet, 1886.

Rivière, Georges. [Article on the 3d "Exposition des Impressionistes."] *L'Impressioniste,* No. 1, April 6, 1877.

Robiquet, Jean. *L'Oeuvre inédit de Gavarni.* Paris: H. Floury, 1912.

Rod, Edouard. *Les Idées morales du temps present.* Paris: Perrinet Cie, 1892.

Rouart, Henri. *Rapport sur les armes portatives.* Paris: Imprimérie Nationale, 1880.

———— . *Catalogue des tableaux anciens . . . et des tableaux modernes.* Paris: A. Marty, 1912.

Saint-Albin, Albert de. *Les Courses de chevaux en France.* Paris: Hachette et Cie, 1890.

Saint-Georges [Louis Pierre Ernest, Baron de Caters]. *Les Courses de chevaux.* Paris: P. Lafitte et Cie, 1912.

Sala, George Augustus. *Paris Herself Again 1878–1879.* 2 vols. New York: Scribner and Welford, 1880.

"Salon de 1868." *Le Meridional,* June 24, 1868.

Seilhac, Léon de. *L'Industrie de la couture et de la confection à Paris.* Paris: F. Didot et Cie, n.d. [1897].

Silvestre, Armand. [Article on the 4th "Exposition des Impressionistes."] *La Vie moderne,* April 24, 1879.

Simon, Jules. *L'Ouvrière.* 9th ed. Paris: Hachette et Cie, 1891. (Originally 1861.)

Thiébault-Sisson. "Edgar Degas, l'homme et l'oeuvre." *Le Temps,* May 18, 1918, 3.

*Le Tour du monde.* 1855–1865.

Uzanne, Octave. *The Modern Parisienne.* New York: G. P. Putnam's Sons, 1912. (Originally 1894.)

Veuillot, Louis. *Les Odeurs de Paris.* 9th ed. Paris: Palme, 1867.

Vuillier, Gaston. *A History of Dancing.* New York: D. Appleton and Co., 1898.

Wolff, Albert. [Column.] *Le Figaro,* April 3, 1876.

———— . [Column.] *Le Figaro,* April 11, 1879.

———— . [Article on 6th "Exposition des Impressionistes."] *Le Figaro,* April 10, 1881.

Yriarte, Charles. *Paris Grotesque: Les Célébrités de la rue.* Paris: Dupray de la Maherie, 1864.

Zola, Emile. *L'Assommoir.* Trans. Leonard Tancock. Harmondsworth: Penguin, 1970. (Originally 1876.)

_____ . *Ladies' Delight*. Trans. April Fitzlyon. London: Calder, 1958. (Originally 1882.)

_____ . *Nana*. Trans. George Holden. Harmondsworth: Penguin, 1972. (Originally 1880.)

## SOURCES ca. 1920–1985

Abbott, Berenice. *The World of Atget*. New York: Horizon Press, 1964.

Adhémar, J., and F. Cachin. *Degas, The Complete Etchings, Lithographs and Monotypes*. New York: Viking Press, 1975.

Allem, Maurice. *La Vie quotidienne sous le Second Empire*. Paris: Hachette, 1948.

Althusser, Louis. *For Marx*. Trans. Ben Brewster. London: Verso, 1979. (Originally 1965.)

_____ . *Lenin and Philosophy and Other Essays*. Trans. Ben Brewster. London: New Left Books, 1971.

Barleben, Ilse. *Kleine Kulturgeschichte der Wäschepflege*. Düsseldorf: Henkel, 1951.

Benjamin, Walter. *Charles Baudelaire: A Lyric Poet in the Era of High Capitalism*. London: New Left Books, 1973.

_____ . "Paris—Capital of the Nineteenth Century." *Reflections*. Trans. Edmund Jephcott. Ed. Peter Demetz. New York: Harcourt Brace Jovanovich, 1979, 146–162.

Berger, John. *Ways of Seeing*. Harmondsworth: Penguin, 1972.

Berger, Klaus. *Japonismus in der Westlichen Malerei, 1860–1920*. Munich: Prestel-Verlag, 1980.

Berman, Marshall. *All that is Solid Melts into Air*. New York: Simon and Schuster, 1981.

Bertrich, Fred. *Kulturgeschichte des Waschens*. Düsseldorf: Econ, 1966.

Blanche, Jacques-Emile. "Bartholomé et Degas." *L'Art vivant* 6 (February 15, 1930), 154–156.

_____ . *Propos de Peintre, De David à Degas*. Paris: Emile-Paul frères, 1919.

Bled, Victor du. "Le Ballet de l'Opéra." *La Revue musicale,* special number entitled *Le Ballet au XIX^e siècle,* December 1, 1921, 95–109.

Boggs, Jean S. *Portraits by Degas*. Berkeley and Los Angeles: University of California Press, 1962.

Boime, Albert. *The Academy and French Painting in the Nineteenth Century*. London: Phaidon, 1971.

*The Book of the Thousand Nights and One Night*. Trans. from French trans. of Dr. J. C. Mardrus by Powys Mathers. London: Routledge and Kegan Paul, 1964. (Originally 1839–1842.)

Bouvet, Charles. *L'Opéra*. Paris: A. Morance, 1924.

Bowness, Alan. "Manet and Mallarmé." *Philadelphia Museum Bulletin* 62 (April 1967), 213–221.

Broude, Norma. "Degas' 'Misogyny.'" *Art Bulletin* 59 (March 1977), 95–107.

*Paintings of Horses by John Lewis Brown*. New York: Durand-Ruel Galleries, 1925.

Browse, Lillian. *Degas Dancers*. London: Faber and Faber, 1949.

Cabanne, Pierre. *Edgar Degas*. Trans. M. L. Landa. New York: P. Tisné, 1958.

——— . "L'Amitié de Degas et de Valernes." *De Valernes et Degas*. Carpentras: Musée de Carpentras, 1963, unpaginated.

*Cafés, Bars, Restaurants*. 2 vols. Cabinet des Estampes, Bibliothèque Nationale, Paris, n.d.

Callen, Anthea. "Faure and Manet." *Gazette des Beaux-Arts* 83 (March 1974), 157–178.

*Catalogue des peintures, pastels, sculptures impressionistes*. Paris: Musée du Louvre, 1958.

Chevalier, Louis. *Laboring Classes and Dangerous Classes in Paris During the First Half of the Nineteenth Century*. Trans. Frank Jellinek. Princeton: Princeton University Press, 1981. (Originally 1958.)

——— . *Montmartre du plaisir et du crime*. Paris: R. Laffont, 1980.

Chisaburō, Yamada. "Exchange of Influences in the Fine Arts Between Japan and Europe." *Japonisme in Art*. Tokyo: Committee for the Year 2001, 1980, 11–18.

Clark, T. J. *The Absolute Bourgeois*. Greenwich: New York Graphic Society, 1973.

——— . "The Bar at the Folies-Bergère." M. Bertrand and E. T. Gargan, eds. *The Wolf and the Lamb: Popular Culture in France*. Saratoga: Anma Libri, 1977.

——— . "The Conditions of Artistic Creation." *Times Literary Supplement*, May 24, 1974, 561–562.

——— . *Image of the People*. Greenwich: New York Graphic Society, 1973.

——— . "Manet's 'Olympia' in 1865." *Screen*, 21/1 (Spring 1980), 18–41.

——— . *The Painting of Modern Life; Paris in the Art of Manet and His Followers*. New York: Knopf, 1985.

Clarke, Mary, and Clement Crisp. *Ballet Art from the Renaissance to the Present*. New York: Clarkson N. Potter, Inc., 1978.

Clayson, Hollis. "Avant-Garde and Pompier Images of 19th Century French Prostitution: The Matter of Modernism, Modernity and Social Ideology." *Modernism and Modernity*. Halifax: Nova Scotia Press, 1983.

Cobban, Alfred. *A History of Modern France*. 3 vols. Harmondsworth: Penguin, 1961.

Coquiot, Gustave. *Degas*. Paris: Librairie Ollendorff, 1924.

Corbin, Alain. *Les Filles de noce: Misère sexuelle et prostitution, 19ᵉ et 20ᵉ siècles*. Paris: Aubier-Montaigne, 1978.

——— . *Le Miasme et la jonquille: L'Odorat et l'imaginaire social, 18ᵉ–19ᵉ siècels*. Paris: Aubier-Montaigne, 1982.

Courthion, Pierre, and Pierre Cailler. *Portrait of Manet by Himself and his Contemporaries*. Trans. Michael Ross. New York: Roy Publishers, 1960.

Davidoff, Leonore. "Class and Gender in Victorian England: The Diaries of Arthur J. Munby and Hannah Cullwick." *Feminist Studies* 5/1 (Spring 1979), 87–141.

*Degas' Racing World*. New York: Wildenstein and Company, Inc., 1968.

Dolléans, Edouard, *Histoire du mouvement ouvrier*. 3 vols. Paris: A. Colin, 1936–1953.

*Alfred de Dreux and his French Contemporaries*. New York: Alfred Seligman, 1938.

Duncan, Carol. *The Pursuit of Pleasure: The Rococo Revival in French Romantic Art*. New York: Garland, 1976.

Dupeux, Georges. *La Société française 1789–1960*. Paris: Librairie A. Colin, 1964.

Duveau, Georges. *La Vie ouvrière en France sous le Second Empire*. Paris: Gallimard, 1946.

*"Equivoques"; Peintures françaises du XIXᵉ siècle*. Paris: Musée des Arts Décoratifs, 1973.

Farwell, Beatrice. "Courbet's 'Baigneuses' and the Rhetorical Feminine Image." T. B. Hess and L. Nochlin, eds. *Woman as Sex Object*. New York: Newsweek, 1972.

———. "Manet's Bathers." *Arts Magazine* 54 (May 1980), 124–133.

Fevre, Jeanne. *Mon Oncle Degas*. Geneva: P. Cailler, 1949.

Flescher, Sharon. *Zacharie Astruc: Critic, Artist and Japoniste (1833–1907)*. New York: Garland, 1978.

Forbes Magazine Collection. *War a la mode*. n.d.

Foucault, Michel. *The Archaeology of Knowledge*. Trans. A. M. Sheridan Smith. New York: Harper and Row, 1971.

———. *Discipline and Punish*. Trans. Alan Sheridan. New York: Vintage, 1979.

———. *The History of Sexuality*. Vol. 1: *An Introduction*. Trans. Robert Hurley. New York: Pantheon Books, 1980.

Freud, Sigmund. *The Standard Edition of the Complete Psychological Works*. 24 vols. Trans. James Strachey et al. London: Hogarth Press, 1960.

Fryer, Peter, ed. *The Man of Pleasure's Companion: A Nineteenth Century Anthology of Amorous Entertainment*. London: Barker, 1968.

Gay, Peter. *Art and Act*. New York: Harper and Row, 1976.

Gernsheim, H., and A. Gernsheim. *The History of Photography*. New York: McGraw-Hill, 1969.

Godeau, A. S. "Louis-Amedée Mante: Inventor of Color Photography?" *Portfolio* 3, 1 (January–February 1981), 40–45.

Goncourt, Edmond, and Jules de Goncourt. *Pages from the Goncourt Journal*. Ed. and trans. Robert Baldick. Oxford: Oxford University Press, 1978.

Graña, C. *Bohemian versus Bourgeois: French Society and the French Man of Letters in the Nineteenth Century*. New York: Basic Books, 1964.

*Grand Larousse de la langue française*. 7 vols. Paris: Larousse, 1971–1978.

*Grand Larousse encyclopédique*. 10 vols. Paris: Larousse, 1960–1964.

Grunchec, Philippe. *Le Grand Prix de peinture; Les Concours des Prix de Rome de 1797 à 1863*. Paris: Ecole Nationale Supérieure des Beaux-Arts, 1983.

Guest, Ivor. *The Ballet of the Second Empire 1847–1858; 1858–1870*. 2 vols. London: A. and C. Black, 1953.

———. *The Divine Virginia*. New York: M. Dekker, 1977.

Halévy, Daniel, *The End of the Notables*. Trans. Alain Silvera and June Guicharnaud. Middleton: Wesleyan University Press, 1974. (Originally 1930.)

———. *My Friend Degas*. Trans. Mina Curtiss. Middletown: Wesleyan University Press, 1964. (Originally 1960.)

———. *Pays parisiens*. Paris: B. Grasset, 1932.

Hamilton, George Heard. *Manet and His Critics*. New York: Norton, 1969.

Hanson, Anne Coffin. *Edouard Manet: 1832–1883*. Philadelphia: Philadelphia Museum of Art, 1966.

———. *Manet and the Modern Tradition*. New Haven: Yale University Press, 1977.

Haskell, Francis. *Rediscoveries in Art: Some Aspects of Taste, Fashion and Collecting in England and France*. Ithaca: Cornell University Press, 1976.

Hellerstein, Erna Olafson, Karen M. Offen, et al., eds. *Victorian Women: A Documentary*

*Account of Women's Lives in 19th Century England, France and the United States.* Stanford: Stanford University Press, 1981.

Hemmings, F. W. J. *Emile Zola.* 2d ed. Oxford: Clarendon Press, 1966.

Herbert, Robert L. "City vs. Country: The Rural Image in French Painting from Millet to Gauguin." *Artforum* 8 (February 1970), 44–55.

Hess, Thomas B., and Linda Nochlin, eds. *Woman as Sex Object.* New York: Newsweek, 1972.

*Highlights of the Turf.* New York: Knoedler Art Galleries, 1948.

Hillairet, Jacques. *Dictionnaire historique des rues de Paris.* Paris: Editions de minuit, 1963.

Hobsbawm, E. J. *The Age of Capital 1848–1875.* New York: Scribner, 1975.

Hofstadter, Richard. *The Age of Reform.* New York: Alfred Knopf, 1955.

Hollander, Anne, *Seeing Through Clothes.* New York: The Viking Press, 1978.

Honour, Hugh. *Chinoiserie: The Vision of Cathay.* New York: Dutton, 1961.

Horkheimer, Max. *Critical Theory.* Trans. Matthew J. O'Connell. New York: Seabury Press, 1972.

Hudson, Derek. *Munby, Man of Two Worlds.* Great Britain: Gambit, 1974.

*Japonisme in Art.* Tokyo: Committee for the Year 2001, 1980.

Janis, Eugenia Parry. *Degas Monotypes.* Cambridge: Harvard University Press, 1968.

Jean, Philippe. "Evariste de Valernes." Interview with Eunice Lipton. June 21, 1978, Carpentras.

Jeanniot, Georges. "Souvenirs sur Degas." *La Revue universelle.* October 15 and November 1, 1933, 152–174, 280–304.

Joly, Anne. "Sur Deux Modèles de Degas." *Gazette des Beaux-Arts* 69 (May–June 1967), 373–374.

Kaplan, E. Ann. *Women in Film: Both Sides of the Camera.* New York: Methuen, 1983.

Kemp, Tom. *Economic Forces in French History.* London: Dobson, 1971.

Kikuchi, Sadao. *A Treasury of Japanese Wood Block Prints: Ukiyo-e.* Trans. Don Kenny. New York: Crown Publishers, 1969.

Kochno, Boris. *Le Ballet en France du quinzième siècle à nos jours.* Paris: Hachette, 1954.

Lacambre, Geneviève with Jacqueline de Rohan-Chabot. *Le Musée du Luxembourg en 1874.* Paris: Editions des Musées Nationaux, 1974.

Landes, David. "French Entrepreneurship and Industrial Growth in the 19th Century." *Journal of Economic History* 19 (1949), 45–61.

———. *The Unbound Prometheus.* London: Cambridge University Press, 1969.

Landy, Pierre. *Rencontres franco-japonaises.* Paris: Osaka, 1970.

Lemoisne, Paul-André. *Degas et son oeuvre.* 4 vols. Paris: P. Brame et C. M. de Hauke, 1946.

———. *Gavarni peintre et lithographe.* Paris: H. Floury, 1924.

Lethève, J. *Daily Life of French Artists in the 19th Century.* Trans. Hilary E. Paddon. New York: Praeger, 1972. (Originally 1968.)

Levy, Darlene Gay, Harriet B. Applewhite, and Mary D. Johnson, eds. *Women in Revolutionary Paris 1789–1795.* Urbana: University of Illinois Press, 1979.

Lipton, Eunice. "Deciphering a Friendship: Edgar Degas and Evariste de Valernes."

*Arts Magazine* 55 (June 1981), 128–132.

———— . "Degas' Bathers: The Case for Realism." *Arts Magazine* 54 (May 1980), 93–97.

———— . "The Laundress in Late 19th Century French Culture: Imagery, Ideology and Edgar Degas." *Art History* 3 (September 1980), 295–313. Reprinted in F. Frascina and C. Harrison, eds. *Modern Art and Modernism*. New York: Harper and Row, 1982.

Longrigg, Roger. *The History of Horse Racing*. London: Stein and Day, 1972.

Lukács, Georg. *History and Class Consciousness: Studies in Marxist Dialectics*. Trans. Rodney Livingstone. Cambridge: MIT Press, 1972. (Originally 1922.)

———— . *Studies in European Realism*. New York: Grosset and Dunlap, 1964. (Originally 1940.)

Marchand, H. *The French Pornographers: The Erotic History of France*. New York: Book Awards, 1965.

Maur, Karin V. "Edmond de Goncourt et les artistes de la fin du XIX*ᵉ* siècle." *Gazette des Beaux-Arts* 72 (November 1968), 214–228.

Mayeur, Jean-Marie. *Les Débuts de la Troisième République, 1871–1898*. Paris: Editions du Seuil, 1973.

Medzini, Meron. *French Policy in Japan During the Closing Years of the Tokugawa Regime*. Cambridge: Harvard University Press, 1971.

Melot, Michel. "Questions au Japonisme." *Japonisme in Art*. Tokyo: Committee for the Year 2001, 1980, 239–258.

Mercier, André. "Il y aura bientôt 70 ans le maître Edgar Degas venait à Carpentras voir son ami Evariste de Valernes." *Le Provençal*, January 31, 1963.

Mitsuru, Sakamoto. "The Westernization of 'Ukiyo-e' at the End of the Tokugawa Era." *Japonisme in Art*. Tokyo: Committee for the Year 2001, 1980, 19–25.

Montrosier, Eugène. *Les Artistes modernes*. Vol. 2: *Les Peintres militaires; Les Peintres de nu*. Paris: H. Launette, n.d.

Moore, Lillian. *Artists of the Dance*. New York: Thomas Y. Crowell, 1938.

*Berthe Morisot and Her Circle*. Toronto: Art Gallery of Toronto, 1952.

Mosse, W. E. *Liberal Europe: The Age of Bourgeois Realism, 1848–1875*. London: Thames and Hudson Ltd., 1974.

Muehlig, Linda D. *Degas and the Dance*. Northampton: Smith College Museum of Art, 1979.

Newhall, Beaumont. "Degas Photographe Amateur: Huit Lettres inédites." *Gazette des Beaux-Arts* 61, 6th ser. (1963), 61–64.

———— . *The History of Photography from 1839 to the Present Day*. New York: Museum of Modern Art, 1979.

Nicholson, Benedict. "Degas as a Human Being." *Burlington Magazine* 105 (1963), 239–241.

Nochlin, Linda. *Impressionism and Post-Impressionism 1874–1904*. Englewood Cliffs: Prentice-Hall, 1966.

———— . *Realism*. Harmondsworth: Penguin, 1971.

Nora, F. "Degas et les maisons closes." *L'Oeil,* 219 (October 1973), 26–31.

*Les Peintures de l'Opéra de Paris de Baudry à Chagall.* Paris: Arthena, 1980.

Perrot, Michelle. *Les Ouvriers en grève.* 2 vols. Paris: Mouton, 1974.

Pickvance, Ronald. "Degas's Dancers: 1872–6." *Burlington Magazine* 105 (1963), 256–266.

————. "'L'Absinthe' in England." *Apollo* 77 (May 1963), 395–398.

————. "Monet and Renoir in the Mid-1870s," *Japonisme in Art.* Tokyo: Committee for the Year 2001, 1980, 157–165.

Pinkney, David H. *Napoleon III and the Rebuilding of Paris.* Princeton: Princeton University Press, 1958.

Pissarro, Camille. *Letters to His Son Lucien.* Trans. Lionel Abel. Ed. with assistance of Lucien Pissarro by John Rewald. Santa Barbara: Peregrine Smith, 1981.

Plessis, Alain. *De la Fête impériale au mur des fédérés 1852–1871.* Paris: Editions du Seuil, 1973.

Raunay, Jeanne. "Degas: Souvenirs anécdotiques." *La Revue de France.* March 15, 1931, 263–282 (pt. 1); April 1, 1931, 469–483 (pt. 2); April 15, 1931, 619–632 (pt. 3).

Reff, Theodore. *Degas: The Artist's Mind.* New York: Harper and Row, 1976.

————. "Degas and the Dance." *Edgar Degas.* New York: Acquavella Galleries, Inc., 1978.

————. "Degas, Lautrec and Japanese Art." *Japonisme in Art.* Tokyo: Committee for the Year 2001, 1980, 189–213.

————. *The Notebooks of Edgar Degas.* 2 vols. Oxford: Clarendon Press, 1976.

————. "Some Unpublished Letters of Degas." *Art Bulletin* 50 (March 1968), 87–94.

Rewald, John. *History of Impressionism.* New York: Museum of Modern Art, 1961.

————. "The Realism of Degas." *Magazine of Art* 39 (January 1946), 13–17.

Rich, Daniel Catton. *Degas.* New York: Harry N. Abrams, 1951.

Rivière, Georges. *Mr. Degas, Bourgeois de Paris.* Paris: Floury, 1935.

Robin-Challon, Louise. "Danse et Danseuses à l'Opéra de Paris, 1830–1850." Thèse de Troisième Cycle de l'Université de Paris VII, 1983.

Rogers, Maria. "The Batignolles Group: Creators of Impressionism." M. C. Albrecht, J. H. Barnett, and M. Griff, eds. *The Sociology of Art and Literature.* New York: Praeger, 1970, 194–222.

Rothenstein, William. *Men and Memories: A History of the Arts 1872–1922.* New York: Tudor Publishing Company, n.d. [1973].

Rouart, Denis. "Relationship of Degas with Rouart Family." Interview with Eunice Lipton, July 14, 1977, Paris.

Roualt, Georges. *Souvenirs intimes.* Paris: E. Frapier, 1926.

Rougerie, Jacques. "Remarques sur l'histoire des salaires à Paris au XIX$^e$ siècle." *Le Mouvement Sociale* 63 (1968), 71–108.

Roy, Joseph-Antoine. *Histoire du Jockey Club de Paris.* Paris: M. Rivière, 1958.

Saalman, Howard. *Haussmann: Paris Transformed.* New York: G. Braziller, 1971.

Said, Edward W. *Orientalism.* New York: Vintage, 1979.

Sartre, Jean-Paul. *Search for a Method.* Trans. Hazel E. Barnes. New York: Vintage, 1968. (Originally "Question de Méthode," *Critique de la raison dialectique,* 1960.)

Schapiro, Meyer. *Modern Art*. New York: G. Braziller, 1978.

Schapiro, Michael. "Degas and the Siamese Twins of the Café-Concert: The Ambassadeurs and the Alcazar d'Été." *Gazette des Beaux-Arts* 95 (April 1980), 153–164.

Scharf, Aaron. *Art and Photography*. Baltimore: Penguin, 1969.

Sickert, Walter Richard. *A Free House! or The Artist as Craftsman; Being the Writings of Walter Richard Sickert*. Ed. Osbert Sitwell. London: Macmillan, 1947.

Sloane, Joseph C. *French Painting Between the Past and the Present*. Princeton: Princeton University Press, 1951.

Snitow, Ann, Christine Stansell, Sharon Thompson, eds. *Powers of Desire: The Politics of Sexuality*. New York: Monthly Review Press, 1983.

Sorlin, Pierre. *La Société française*. Vol. 1: *1840–1914*. Paris: Arthaud, 1967.

Steingraber, Erich. "'La Repasseuse': Zur frühesten Version des Themas von Edgar Degas." *Pantheon* 32 (January 1974), 47–53, 76–77.

Steinhauser, Monika. *Die Architektur der Pariser Oper*. Munich: Prestel-Verlag, 1969.

Sterling, Charles, and Margaretta M. Salinger. *French Paintings. A Catalogue of the Collection of the Metropolitan Museum of Art*. 3 vols. Greenwich: New York Graphic Society, 1955–1967.

Terdiman, Richard. *The Dialectics of Isolation: Self and Society in the French Novel from the Realists to Proust*. New Haven: Yale University Press, 1976.

Terrasse, Antoine. *Degas et la photographie*. Paris: Denoël, 1983.

Thomas, Edith. *The Women Incendiaries*. New York: G. Braziller, 1966. (Originally 1963.)

Thompson, E. P. *The Poverty of Theory and Other Essays*. New York: Monthly Review Press, 1978.

Thomson, David. *Democracy in France Since 1870*. Oxford: Oxford University Press, 1969.

———. *France: Empire and Republic 1850–1940*. New York: Harper and Row, 1968.

Tōru, Haga. "The Diplomatic Background of Japonisme: The Case of Sir Rutherford Alcock." *Japonisme in Art*. Tokyo: Committee for the Year 2001, 1980, 27–42.

Trarieux, Jean-René-André. *Si les Chevaux pouvaient parler*. Paris: Stock, 1926.

Tucker, Paul. *Monet at Argenteuil*. London: Yale University Press, 1982.

Valéry, Paul. *Degas, Manet, Morisot*. Trans. David Pall. New York: Pantheon Books, 1960. (Originally 1938.)

Vanier, Henriette. *La Mode et ses métiers: Frivolités et luttes des classes, 1830–1870*. Paris: Colin, 1960.

Villoteau, Pierre. *La Vie parisienne à la Belle Époque*. Geneva: Cercle du bibliophile, 1968.

Vollard, Ambroise. *Degas: An Intimate Portrait*. Trans. Randolph T. Weaver. New York: Greenberg, 1927.

Waldberg, Patrick. *Eros in la belle epoque*. Trans. Helen R. Lane. New York: Grove Press, 1969.

Walkowitz, Judy. "The Making of an Outcast Group: Prostitutes and Working Women in 19th Century Plymouth and Southampton." Martha Vicinus, ed. *A Widening Sphere*. Bloomington: Indiana University Press, 1977, 72–93, 284–288.

Weisberg, Gabriel P. *Japonisme: Japanese Influence on French Art, 1854–1910*. Cleveland: Cleveland Museum of Art, 1975.

—————. *The Realist Tradition: French Painting and Drawing 1830–1900*. Bloomington: Indiana University Press, 1981.

Wells, W. "Who Was Degas' Lyda?" *Apollo* 95, n.s. (February 1972), 129–134.

Wentworth, Michael Justin. "Tissot and Japonisme." *Japonisme in Art*. Tokyo: Committee for the Year 2001, 1980, 127–143.

Weston, Elizabeth A. "Prostitution in Paris in the Later Nineteenth Century: A Study of Political and Social Ideology." Ph.D. diss., The State University of New York, Buffalo, 1979.

White, Harrison and Cynthia White. *Canvases and Careers*. New York: John Wiley and Sons, Inc., 1965.

Williams, Raymond. "Base and Superstructure in Marxist Cultural Theory." *New Left Review* 82 (1973), 3–16.

—————. *The Country and the City*. New York: Oxford University Press, 1973.

—————. *Culture and Society*, 1780–1950. New York: Harper and Row, 1966.

—————. *The Sociology of Culture*. New York: Schocken Books, 1982.

Zeldin, Theodore. *France, 1848–1945*. Vol. 1: *Ambition, Love and Politics;* vol. 2: *Intellect, Taste and Anxiety*. Oxford: Clarendon Press, 1973; 1977.

Zévaès, Alexandre. *Zola*. Paris: Editions de La Nouvelle Revue critique, 1945.

# Index

*Color illustrations are indicated by plate number,*
*black-and-white illustrations by page number.*